Richard Newton
and English caricature in the 1790s

To Kenneth Monkman

Richard Newton

and English caricature in the 1790s

David Alexander

The Whitworth Art Gallery,
TheUniversity of Manchester
in association with Manchester University Press

Distributed exclusively in the USA and Canada by St. Martin's Press

Copyright © David Alexander 1998

Published by The Whitworth Art Gallery, The University of Manchester,
in association with Manchester University Press,
Oxford Road, Manchester M13 9PL, UK
and Room 400, 175 Fifth Avenue, New York, NY 10010, USA

Distributed exclusively in the USA and Canada by
St. Martin's Press, Inc., 175 Fifth Avenue, New York, NY 10010, USA

British Library Cataloguing-in-Publication data
A catalogue record for this book is available from the British Library.

Library of Congress Cataloging-in-Publication data applied for

ISBN 0 7190 54796 *hardback*
 0 7190 5480X *paperback*

Design and production by Christopher Lord, Manchester, UK
Printed in Great Britain by Shanleys, Bolton

Contents

List of illustrations vi

List of abbreviations x

Foreword *Professor Diana Donald* 1

Preface and acknowledgements 4

Richard Newton and English caricature in the 1790s

1 Newton's watercolour of a caricature exhibition 7
2 The development of the satirical print in England 10
3 Newton's early years 14
4 The rise of William Holland 16
5 Newton's first years with Holland 24
6 Newton during Holland's imprisonment, 1793-4 34
7 The mainstay of Holland's business, 1794-6 42
8 Newton as an independent publisher, 1797-8 49
9 Newton's posthumous reputation 55

Colour plates 66

Captions to the colour plates 115

Appendix: Chronological checklist of prints by and after Newton 140
 Index of titles in checklist 161

Chronology of events in Newton's lifetime 170

Select bibliography 172

Index 174

Illustrations

Works are etchings by Newton, hand-coloured, and published by William Holland, unless otherwise stated.

Figures

1 *Holland's Exhibition Room*, *c*. autumn 1794, watercolour; British Museum

2 *Caricatures ... from the Collection of William Holland ... Vol. 1*, title page; Kenneth Monkman

3 James Gillray, *Very Slippy Weather*, uncoloured etching (after the Rev. James Sneyd), published by H. Humphrey, 1808

4 James Gillray, *An Excrescence*, uncoloured etching, published by H. Humphrey, 20 December 1791

5 *The Tar and the Jordan*, uncoloured etching, ?November 1791

6 *Grand Battle at Cambridge*, watercolour; K. Monkman

7 *Grand Battle at Cambridge, 1792 ...*, uncoloured etching, frontispiece to *The Battle between Doctor Farmer and Peter Musgrave ...* , 1792; Governing Body of Emmanuel College, Cambridge

8 ? Newton after F. G. Byron, *A Batch of Peers*, 6 January. 1792

9 F. G. Byron, *English Slavery* (detail of the head of George III); 19 July 1791

10 *A Blow-up at Breakfast!*, 20 May 1792; British Museum

11 James Gillray, *The Hopes of the Party* (detail of the head of George III); 19 July 1791

12 *Resurrection Men*, etching and aquatint, 1 October 1792; K. Monkman

13 *Affrighted Travellers*, etching and aquatint, 10 October 1792; K. Monkman

14 *A Doctor in Purgatory!*, after G. M. Woodward, aquatint by J. Hassell, 11 November 1792; K. Monkman

15 James Gillray, *John Bull's Progress*, published by H. Humphrey, 3 January 1793

16 *A Peep into the State Side of Newgate*, 12 July 1793; Omek Marks

17 *Promenade in the State Side of Newgate*, 5 October 1793; British Museum

18 *An Old Grudge*, published by Newton, ?1794; K. Monkman

19 *Babes in the Wood*, 1 March 1794; D. Alexander

20 *Yorick feeling the Griset's Pulse*, 3 March 1794, from the volume dated 1795; Laurence Sterne Trust, Shandy Hall, Coxwold, York

21 *Yorick feeling the Grisets Pulse*, etching and aquatint, 1 January 1797, from the volume dated 1792; Laurence Sterne Trust

22 *The Dance in the Kitchen at Amiens*, etching and aquatint, 1 January 1797, from the volume dated 1792; Laurence Sterne Trust

23 'Invented by W. Holland', *Destruction/A Wicked Attorney's Coat of Arms*, 1 December 1794; British Museum

24 *A Curtain Lecture*, 29 May 1794; K. Monkman

25 *On a Journey to a Courtship in Wales*, 16 June 1795; D. Alexander

26 *Too Much of One Thing ...*, September 1795, uncoloured etching; K. Monkman

27 James Gillray, *Exaltation of Faro's Daughters*, published by H. Humphrey, 12 May 1796

28 *The Progress of a Lawyer*, 10 July 1795; K. Monkman

29 A *Will o'th' Wisp*, November 1794; The Print Room, London

30 *The Devil's Darling*, 5 May 1797; British Museum

31 *The Inexhaustable Mine*, 22 June 1797; British Museum

32 *Darby and Joan or the Dance of Death*, published by Newton, 7 April 1797; British Museum

33 *Learning to Make Apple Dumplings*, published by Newton, 27 November 1797; British Museum

34 *Treason!!!*, published by Newton, 19 March 1798; British Museum

35 *Poor Sawney in Sweetbriars*, May 1797; K. Monkman

36 *R. Newton takes warranted Strong Likeneses[s] For Half a Guinea ...',* handbill; British Museum

37 Thomas Rowlandson, *Launching a Frigate*, etching after Newton, published by T. Tegg, 1 February 1809; The Print Room, London

Colour plates (between pp. 66–114)

1 *September in London – all our friends out of Town!!!,* 21 September 1791; British Museum

2 *A Crop Shop*, 8 October 1791; Andrew Edmunds, London

3 *A Forcible Appeal for the Abolition of the Slave Trade*, 2 April 1792; A. Edmunds

4 *The Combustible Breeches*, 11 May 1792; Benjamin Lemer

5 *A Proclamation in Lilliput*, 22 May 1792; B. Lemer

6 *Tasting a Norfolk Dumpling*, 1 June 1792; A. Edmunds

7 *A Bugaboo!!!*, 2 June 1792; B. Lemer

8 *Content and Discontent*, 1 July 1792; B. Lemer

9 *One Too Many*, 10 November 1792; K. Monkman

10 *Liberty and Equality*, 20 November 1792; B. Lemer

11 *A Real San Culotte!!*, published by Newton, December 1792;
 British Museum

12 *The Progress of a Player*, 11 February 1793; British Museum

13 *Fast-Day!*, etching and aquatint, 19 April 1793; British Museum

14 *Making a Freemason!*, 25 June 1793; A. Edmunds

15 *Interested Love*, September 1793; two impressions: etching
 with handcolouring; K. Monkman; etching and aquatint;
 D. Alexander

16 *Soulagement en Prison; or, Comfort in Prison*, watercolour,
 20 August 1793; The Lewis Walpole Library, Yale University

17 *Who Shall Wear the Breeches?*, 10 September 1793; A. Edmunds

18 *Wearing the Breeches*, 6 March 1794; Whitworth Art Gallery,
 University of Manchester

19 *Opening the Ambassador's Ball in Paris*, published by Newton,
 5 March 1794

20 *The Dance in the Kitchen at Amiens*, 1 March 1794, from
 Laurence Sterne, *A Sentimental Journey*, 1795; Laurence Sterne Trust

21 *A Country Barber's Shop*, 1 March 1794; B. Lemer

22 *Progress of an Irishman*, 8 April 1794; K. Monkman

23 *Progress of a Scotsman*, 22 April 1794; K. Monkman

24 *A White Serjeant; or Special Messenger!*, 16 April 1794; K. Monkman

25 *Undertakers in at the Death!!*, 20 April 1794; K. Monkman

26 *Evangelical Portraits*, 20 June 1794; Laurence Sterne Trust

27 *A Night Mare*, 26 October 1794; A. Edmunds

28 *'Shepherds I have lost my Waist!'*, 12 November 1794;
 British Museum

29 *The Unlucky Discovery*, 21 December 1794; K. Monkman

30 *The Blue Devils!*, 10 February 1795; K. Monkman

31 *Tumbling over a Ghost!*, 6 February 1795; K. Monkman

32 *British Servants ... Against French Servants*, April 1795; K. Monkman

33 *A Magician*, 11 May 1795; K. Monkman

34 *A Will o'th' Wisp or Jack O' Lantern!*, 9 June 1795; K. Monkman

35 *No Body Some Body*, June 1795; A. Edmunds

36 *Enjoying an Old Friend*, 17 July 1795; A. Edmunds

37 *A Clerical Alphabet*, 22 July 1795; B. Lemer

38 *Hungry Rats in a Little House*, 22 September 1795; A. Edmunds

39 *A Bachelor's Litany*, 4 November 1795; B. Lemer

40 *Female Gamblers in the Pillory*, 13 May 1796; A. Edmunds

41 *What a Nice Bit!*, 8 July 1796; British Museum

42 *Contrasted Lovers*, 3 August 1796; K. Monkman

43 *The Four Stages of Matrimony*, 15 August 1796; A. Edmunds

44 *A Flight of Scotchmen/London*, 3 September 1796; K. Monkman

45 *Parsons Drowning Care*, 10 November 1796; A. Edmunds

46 *Billy's Political Plaything*, 21 November 1796; British Museum

47 *A Priest Ridden Village*, 29 November 1796; A. Edmunds

48 *Madamoiselle Parisot*, ?1796; British Museum

49 *A Paper Meal with Spanish Sauce*, published by Newton,
 14 March 1797; A. Edmunds

50 *Mr Follett as the Clown ...*, published by Newton, 3 April 1797;
 A. Edmunds

51 *Self-portrait; holding the print of Mr Follett*, watercolour;
 Wilhelm-Busch-Museum, Hannover

52 *The First Interview or an Envoy from Yarmony*, published by S. W. Fores,
 19 April 1797; K. Monkman

53 *Head – and Brains*, watercolour; British Museum

54 *Head – and Brains*, published by Newton, 5 May 1797; B. Lemer

55 *Drink to me only with thine Eyes*, 8 May 1797; British Museum

56 *Full Moon in Eclipse*, May 1797; A. Edmunds

57 *Cries of London*, May 1797; K. Monkman

58 *Buonaparte Establishing French Quarters in Italy*, published by
 Newton, 9 November 1797; K. Monkman

59 *New Year's Gifts*, ? January 1798; B. Lemer

60 *Consistancy!!– or Rival Clowns*, published by Newton, 8 January 1798;
 B. Lemer

61 *The Celebrated Mr John Cussans in the Character of Jerry Sneak*, published by Newton, 5 April 1797; British Museum

62 *The Male Carriage or New Evening Dilly*, 17 September 1798; A. Edmunds

63 *After Mass*, watercolour, undated; K. Monkman

64 *William Holland and his wife*, detail from *Promenade in the Stateside of Newgate*, 5 October 1793; Henry E. Huntington Library and Art Gallery, San Marino, California

Photographic credits

British Museum
Figures 1, 10, 17, 23, 30–4, 36; plates 1, 11–13, 19, 28, 41, 46, 48, 53–5, 61

Lucinda Douglas-Menzies, London
Plates 2, 4–8, 10, 14, 21, 27, 35–40, 42, 45, 47, 49, 50, 56

Jim Kershaw, York
Figures 2, 6, 7, 12–14, 18, 20–22, 24, 26, 28, 35; plates 9, 15, 17, 20, 22–26, 29–34, 43, 44, 52, 57–60, 62–3

University of Manchester
Figures 19, 25; plate 18

The Print Room, London
Figures 29, 37

Wilhelm-Busch-Museum, Hannover
Plate 51

Yale University, New Haven, Conn.
Plate 16

University of York (David Whiteley)
Figures 3, 4, 8, 9, 11, 15, 27

Henry E. Huntington Library and Art Gallery, San Marino, California
Plate 64

List of abbreviations

BL British Library

BM British Museum. BM followed by a number refers to the entries on individual prints in the *Catalogue of Political and Personal Satires ... in the British Museum* (see Select bibliography, under BM).
BM followed by a date is the registration number of a print or drawing in the Department of Prints and Drawings in the British Museum, London

DNB Dictionary of National Biography

LC Library of Congress, Washington, DC

Foreword

Richard Newton practised as a caricaturist two hundred years ago, at the height of the first great phase of cartoon history in England. A sight of his prints is enough to convince one, that here was an astonishing talent for the art of comic drawing. Inevitably, comparisons arise with the designs of his more famous contemporaries, Gillray and Rowlandson. Newton's drawings lack the intellectual complexity of the one, and the bravura of the other; but their very directness and economy may strike us now as more 'modern' than either. Newton's humour is a strangely innocent kind of bawdy, where busty and over-sexed women defy all the rules of female modesty which supposedly dominated the later Georgian era. Indeed, they bring to mind the tradition of smutty seaside picture-postcards inaugurated by Donald McGill. This affinity with twentieth-century cartoons and comic strips does not lie in subject-matter alone, but in Newton's outrageously exaggerated contours and expressions, and the graphic simplicity of his images. In his work, the art of satirical drawing freed itself altogether from academic inhibitions, from notions of taste, 'correctness' or fidelity to natural appearances. The comic language of Newton's draughtsmanship is inseparable from the humour of his themes.

This sense of kinship with the modern era actually compounds the difficulties of understanding Newton's art in the historical context. To the eyes of the late twentieth-century viewer, it seems self-evidently 'popular'. Yet many of Richard Newton's prints are rare, and he left almost no trace on the historical record. Even the account of eighteenth-century 'humorous designers' in Henry Angelo's *Reminiscences* (1830) makes no mention of him. Possibly this can be explained by his political radicalism, or by his shameless vulgarity. Already the historiography of eighteenth-century caricature leaned towards an emphasis on the work of genteel amateurs, and on a social mildness which distanced itself from the rancour and scandal of public life. Whatever the reasons for it, this absence of literary comment on Richard Newton makes it particularly hard to reconstruct the contemporary audience for his work. The degree to which Georgian satirical prints were understood, purchased and indeed seen outside the metropolitan elite is a vexed question still debated by scholars: in the case of Newton, it is well-nigh impossible, in the present state of knowledge, to provide an answer.

Although Angelo did not refer to Newton's work, he nevertheless affords some insights into the qualities which contemporaries might have admired.

In describing the drawings of the amateur Henry Bunbury, Angelo enthuses over his 'genius' for caricature, his 'fecundity of invention ... the rare felicity with which he could embody whatever his observation or fancy suggested, with that scrambling style, which was entirely his own', but which could not be 'further removed from legitimate art'. The very artlessness and spontaneity of rapid caricature sketches drawn by gentleman-amateurs appealed strongly to eighteenth-century collectors. Newton's art shares these characteristics, and in fact his illustrations to Sterne's *Sentimental Journey* (e.g. figures 20–22, plate 20) are reminiscent of Bunbury's lighthearted satires on the French. Despite the boldness of Newton's affronts to the royal family and politicians, his art is essentially good-humoured fun, which easily runs into slapstick or fantasy. The airborne diaspora of tartan figures in *A Flight of Scotchmen* (plate 44), for example, entirely lacks the venom of anti-Scottish satires from earlier decades of the eighteenth century. Newton's graphic designs play on bold contrasts of shape and character. His drawing stroke is subtly different from the Baroque redundancies of Rowlandson's, and at its best, as in *Wearing the Breeches* (plate 18), has a movement, purity and continuity which might remind one of the Neoclassical designs of the period. The effect of Newton's friezes of figures - and his is essentially a figural art - is enhanced by the reductiveness of his compositions. He rejects the convoluted detail and symbolism found in many eighteenth-century satires. Space is arbitrarily flattened; there is very little tonal modelling, despite the occasional application of aquatint, and the designs rely on gay washes of hand-colouring. Above all, Newton's idiosyncratic manner evokes a strong recognition of his personality as author, and this is perhaps his most remarkable affinity with the cartoonists of our own day.

The virtual absence of contemporary documentation on Richard Newton's life and art may partly explain the silence of later writers. However, Newton's distorted and indecorous imagery would have been obnoxious to most Victorian critics and collectors, and he had little influence on his immediate successors in the field of graphic satire. It is less easy to explain the neglect of Newton's work on the part of twentieth-century historians. Until recently, in fact, the whole field of Georgian caricature has, despite Dorothy George's marvellous catalogue of the British Museum's collections, lacked the critical attention it deserves. In the last few years this situation has changed dramatically, and publication of the first monograph on Newton, two hundred years after his death, is therefore both timely and welcome. Through David Alexander's extensive scholarly research Newton's *oeuvre* has been reconstituted and the surviving evidence about his activities collected together, making it possible for the first time to situate him in the historical context of the 1790s, and in particular to gain a better understanding of his relationship with the publisher William

Holland. Indeed, this exploration of the conditions in a busy, prominent but politically controversial printshop has an interest extending far beyond Newton himself, and brings into focus the work of other coadjutors of Holland such as Byron and Woodward. David Alexander's book will provide an invaluable research tool for the many scholars who now recognise the artistic quality and historical significance of caricature prints, and who seek to move them from the periphery to the centre of eighteenth-century studies.

Diana Donald, Manchester Metropolitan University

Preface and acknowledgements

This book has been many years in the making. I was aware of Newton as a caricaturist who died at only twenty-one, and knew his prints from those described in Dorothy George's catalogue of satires in the British Museum (1938, 1942), from Francis Klingender's *Hogarth and English Caricature* (1944), and from references to him in Draper Hill's pioneering books on James Gillray; however, it was not until I met Kenneth Monkman twenty-five years ago that I got any real idea of the range of his work. I am most grateful to Dr Monkman, who bought his first Newton, the *Sentimental Journey* of 1794 (see plate 20), in 1942; he has given me constant help and encouragement, as has Andrew Edmunds, who has shared his immense knowledge of satires.

Several institutions in the United States had the foresight to buy Newtons. In the 1980s I was able to see those at the Library of Congress and the Lewis Walpole Library, and also, thanks to two Visiting Fellowships, those at the Yale Center for British Art, and the Huntington Library and Art Gallery, San Marino. I am most grateful to the staff of these institutions for their assistance, in particular to those individuals named in the chronological checklist (Appendix). It is in these collections that I found many unpublished Newtons; there are, of course, undoubtedly others to be found.

In 1990 I gave a paper on Newton at a study day in York arranged in conjunction with *Folly and Vice*, the travelling exhibition organised by the South Bank Centre. Roger Malbert, of the Centre, was keen that I should arrange a Newton exhibition, and although no exhibiting institutions responded, his encouragement was much appreciated. Last year, however, I was approached by Professor Diana Donald of Manchester Metropolitan University, author of the principal modern study of the satires of the period, who suggested to the Whitworth Art Gallery that I should select an exhibition of prints by Newton (14 February – 17 May 1998), to be shown in conjunction with a symposium on popular prints in Manchester which she had organised with Dr Cindy McCreery. I am grateful to Professor Donald for this initiative; she has kindly commented on successive drafts of this publication, as has David Morris, Curator of Prints at the Whitworth, who made the arrangements for the exhibition and has been a great help throughout. Particular thanks are owed to Vanessa Graham of Manchester University Press for her readiness to join with the Whitworth in publishing the book, and to the designer, Christopher Lord. Neither this book nor the exhibition would have been possible without the support of the British Museum, and the interest of Antony Griffiths, the Keeper of the Department

of Prints and Drawings, and of three leading collectors, Kenneth Monkman, Benjamin Lemer and Andrew Edmunds, who have generously allowed their prints to be photographed. It has been an enjoyable experience to work with them and with the three photographers who have taken most of the photographs: Lucinda Douglas-Menzies, Jim Kershaw and David Whiteley. The inclusion of colour plates has been made possible by a substantial grant to the Whitworth from the Paul Mellon Centre for Studies in British Art, and we are grateful to Brian Allen for his support. Other people who have helped in different ways include Rosemary Baker, David Bindman, Pascal Dupuy, Richard Godfrey, Craig Hartley, Ralph Hyde, Omek Marks, Robert Patten, John Riely, Frank Stubbings and John Wardroper. More recently I have received some helpful suggestions from Simon Turner, author of an excellent dissertation on Newton's early political prints. Finally, I would like to thank my wife, Helena Moore, who has patiently lived with Newton's presence for longer than she anticipated.

It is inevitable that the first extended essay on Newton should have omissions and oversights. It is difficult to find out much about someone who died at such an early age, and, if there is more than might be expected here about the print publisher William Holland, it is because he was such a key figure in Newton's life. I am aware of raising problems, such as the lettering on Holland's prints, which I have not resolved and of having been led into unfamiliar areas, such as the publication of pornographic pamphlets and 'indecent' prints. I have become conscious of some of the unexplored aspects of satire. The links between visual and literary satire, and the influence of figures like 'Peter Pindar', clearly need much more investigation, and this is one of the reasons why unpublished texts on Holland's prints appear here in full.

Those who already know Newton's work may miss some old favourites here; a number which were illustrated, for example in David Bindman's exhibition catalogue *The Shadow of the Guillotine* (British Museum, 1989), have been left out in favour of unpublished prints, but details of where illustrations of omitted prints can be found are given in the Appendix. Similarly the captions to the colour plates are deliberately longer for prints which are not described in the British Museum *Catalogue of Satires*. I hope that this will make unknown prints available to people with different interests and specialities.

David Alexander, York

The Whitworth Art Gallery and Manchester University Press are grateful to the Paul Mellon Centre for Studies in British Art for their generous grant towards the colour illustrations in this book, and also acknowledge the contribution of The Department of History of Art and Design at Manchester Metropolitan University towards the publication.

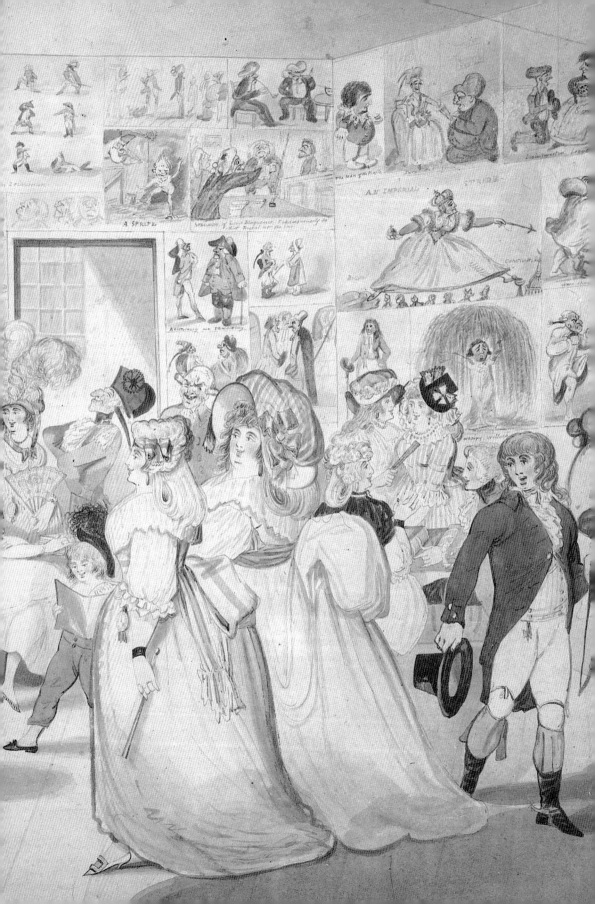

Richard Newton
and English caricature in the 1790s

1 Newton's watercolour of a caricature exhibition

In the autumn of 1794 Richard Newton, a satirical artist of eighteen, made a watercolour of the Oxford Street exhibition room of his employer, the print publisher William Holland (1757–1815) (figure 1). This picture, possibly the only interior view of a shop selling caricatures, shows a display of humorous prints, many etched by Newton himself in the three years he had worked there. Holland was one of the print publishers who, in little more than a decade, had succeeded in establishing the singly issued satire, hand-coloured with transparent watercolour washes, as one of the most important products of the London print trade. He had been fortunate in finding Newton, a fine draughtsman and a rapid worker who was capable of transforming an idea or a rough sketch supplied by Holland or one of his cronies into an amusing and saleable print. For his part, Newton was lucky to have come into contact with Holland, a man of literary tastes who provided many ideas for prints, and who had brought him forward at an age when most youths were obscure apprentices. Newton peopled his picture of the exhibition room with a lively group of people – including fashionable couples, clergymen, officers, widows and some self-confident beauties; the latter may perhaps be ladies of the town who hoped that the shilling admittance charge to the exhibition would be a rewarding investment. Most of those present are preoccupied with observing the others, or being seen themselves, but some are shown enjoying the range of humorous prints; these include such topics as the battle of the sexes, country ghosts, old maids, and the gluttony of the clergy: all stock subjects for literary and pictorial humour. There are four pairs of prints, which suggests that they were aimed at buyers who might display the prints, rather than simply keeping them loose in a portfolio, as if they were drawings, or inserting them into an album. There are also two larger prints, showing the *Progress of an Irishman* and the *Progress of a Scotsman* (see plates 23, 23), which combine xenophobic feelings with some of the same elegance

Note: Further information about prints by Newton which are mentioned in the text but not illustrated will be found in the Appendix: Chronological checklist.

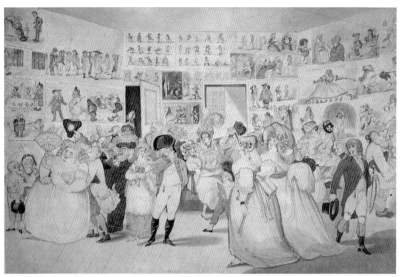

Figure 1

Newton's watercolour of Holland's Exhibition Room (BM 1876–5–10–764)

Ten of the exhibit shown here are prints designed and etched by Newton. On the extreme left the second print is *Babes in The Nursery*, 1 March 1794, below it is the pendant, *Babes in The Wood* (figure 19), and below that *Which way shall I turn me*, 1 July 1794. The large print on the left hand wall is *Promenade in the State Side* (figure 17) and below it to the right is *Fast-Day!* (plate 13). High on the central wall can be seen *Progress of a Scotsman* (plate 23) and *Progress of an Irishman* (plate 22). High on the right hand wall is *Interested Love* (plate 15), and below these to the right are *Who shall wear the Breeches?* (plate 17) and its pendant *Wearing the Breeches* (plate 18). A number of the prints are by F. G. Byron; in the centre Burke is shown on his knees in *Frontispiece to Reflections on the French Revolution*, 2 November 1790 (BM 7675), and on its left is *An Apparition*, after Woodward, 1 May 1790, probably etched by Byron.

that Newton has shown in his portrayal of the younger spectators. In the words of Dorothy George, who just before the Second World War catalogued those of Newton's prints that were then in the British Museum, he had 'two manners, one grotesque and bold, the other realistic, conventional, and rather charming'.[1] Newton was a master of the burlesque, with a command of exaggerated expressions and wonderful movement, with an extraordinarily vigorous and inventive style. If there is a noticeable variation in Newton's manner it may owe something to the way in which he often relied on Holland for the ideas behind his more ambitious prints, notably the narrative *Progresses*; Newton's prints played an important part in the development of this genre.[2]

In fact thirty-seven prints which Newton showed here were by no means a representative selection: he excludes, for understandable reasons, three main categories of print which Holland had published. First, there were those of an indecent nature. Many of his prints are very schoolboyish in their subject matter: exposed breasts, bare bottoms, assaults on private parts and people relieving themselves. Such vulgarity was typical of the period and medium but was particularly prominent in his work. Second, images depicting scandals in high life were also omitted. The third category

comprised political prints attacking the monarch, George III, and his principal minister, William Pitt (1759–1806), which Holland had issued in considerable numbers until he had been sent to prison for a year in 1793 under Pitt's so-called Reign of Terror. This episode was in fact recalled by the largest print on the left-hand wall: a group (figure 16) in which Newton showed Holland and fellow inmates in Newgate prison, from which the publisher had emerged only six months before Newton painted the watercolour of the exhibition room.

In three years Newton had made his mark in London. His satires, if not the most subtle of those being produced, were probably the funniest and most outrageous. It was fitting that he should mark his success by making this celebratory picture. What he could not know was that he was already half-way through his career: in little over four years he would be dead, leaving a corpus of nearly three hundred singly issued prints, plus over eighty in books. For various reasons, which will emerge, he was soon forgotten. The 1998 bicentenary of the death of this remarkable youth is an appropriate moment to look at what he achieved, to set it against the background of his times, and to examine some of the questions which his career raises: for example, the extent of his debts to other artists, and how he was able to emerge as an individual talent at such an early age. Before his career is examined in more detail, however, it is important to say more about the development and role of the satirical print.

2 The development of the satirical print in England

Satirical prints had been produced in England for generations, and freedom of expression was tolerated in a way which surprised foreigners. The prints of William Hogarth (1697–1764) had shown that graphic satire could be used for moral ends, but most satirical prints were simply attempts to take advantage of public interest in current events. There were periods when particular political issues produced a flurry of satires; one of these was in the 1760s when the activities of the opportunist politician John Wilkes (1727–97) attracted great populist support, and some satires were distributed in considerable numbers. It was at this time that, largely due to George Townshend (1724–1807), personal caricature was grafted onto political satire.[3] The satirists were regarded as a venal set, whose services could be bought by administration or opposition, and satirical prints were looked upon with some distaste by the members of polite society, even though these images clearly had a certain role in public life and in attempts to influence opinion. These prints were generally etchings, which could be produced with some speed, often within days of an event. These could often be bought coloured, but some were very heavily engraved and had to be coloured thickly in gouache, rather than washed with watercolour.

At the same time there was another tradition of humorous print: that of the mezzotint 'droll', which generally sold for a shilling plain, two shillings coloured. Drolls were usually non-political, exploiting amusing social situations, such as the pretensions of the City *nouveau riche*, rather than topical events. The market for comic mezzotints, based on plates which often remained in print for decades, was dominated by relatively few firms, such as that of Carington Bowles, whose shopfront is shown in a number of prints.[4] Mezzotints could not readily be coloured with watercolour: because the prints were tonally dark, colouring had to be done with thick gouache paints. Many of these prints were engraved on copper plates measuring fourteen by ten inches and could, if required, be easily fitted into frames of a standard size.

Conventional members of polite society regarded satires rather as they regarded the novel, as tending to be vicious or vulgar; they were certainly not considered as suitable for the drawing-room, or for female scrutiny. On occasion the caricaturists could violate privacy and pillory, or even blackmail, a private individual, perhaps with the encouragement of some personal enemy. In 1780 Fanny Burney (1752–1840) was told that Lady Mary Duncan (1723–1806), a widow in her late fifties, had been obliged to buy up the entire printing of a satire which linked her with the singer

Gasparo Paccherotti (1740–1821), who sung at the private concerts she arranged in Bath.[5] It was due to the success of Burney's *Evelina*, as a work by a gentlewoman describing a young lady's entry into the world, that during the 1780s the novel as a genre ceased to be condemned out of hand: some novels became socially acceptable in a way that only Samuel Richardson's had previously been. In a similar way the work of a gentleman artist, Henry Bunbury (1756–1811), showed that humorous prints could be made suitable for a respectable house. Bunbury, the younger son of a prominent baronet, moved in the highest social circles and later became equerry to Frederick, Duke of York (1763–1827), the soldier son of the King.[6] His prints were published initially by Matthew Darly (d. 1778) and his wife Mary, who had been active in the 1760s as publishers of political prints, many in support of Wilkes. In the 1770s the Darlys abandoned political subjects in favour of social ones and began to produce larger satires: in 1771, when most of their prints were at the traditional price of sixpence or a shilling – double if coloured – they sold Bunbury's *Kitchen of a French Post-house* for four shillings plain or six coloured.[7] The Darlys held exhibitions of humorous social satires many of which, according to them, were designed by ladies and gentlemen. Bunbury's subsequent publisher, James Bretherton (fl.1750–99), issued some very large etchings after Bunbury, a few of which were horizontal three-sheet prints, that is printed from three copper plates. Most of these prints were heavily etched and unsuited to colouring: even in the early 1780s coloured satires were in the minority, but some of Bunbury's decorative sentimental prints were published with hand colouring. The fashion for larger plates was now established and in 1787 another publisher, William Dickinson, issued Bunbury's *Long Minuet as Danced at Bath*, a print without any dialogue on four plates which was seven feet long, and *The Propagation of a Lie*, a three-sheet print on the theme of scandalous rumour.[8] These were social, rather than political satires; some publishers avoided the latter, probably because they were afraid of alienating potential customers by appearing to take up particular political views. On account of the raffish associations of satirical prints, exceptional efforts were made to present Bunbury's prints as not only genteel but also moral: *The Propagation of a Lie* was the subject of puffing paragraphs – which were paid for – in newspapers, to the effect that 'it has the praise of moral tendency ... to promote the interests of candour, to sweeten the charms of elegant conversation, and to discourage scandal, hypocrisy, and falsehood'.[9] Indeed Fanny Burney, at that time a member of Queen Charlotte's household, felt confident enough to show the print to the very serious-minded King, even though many people took it that the rumour which Bunbury had in mind was of the secret marriage of his son George, Prince of Wales (later George IV) to his widowed friend Mrs Maria Fitzherbert

(1756–1837).[10] The marriage was in defiance of the law of the land, both because she was a Roman Catholic and because the King's consent, necessary under the Royal Marriage Act of 1772, had not been obtained.

The social and political background of the 1780s

The King and Queen felt it their duty to set an example by a respectable and domestic way of life, though the way they brought up their eldest son led to the same conflicts between father and son which had marked every generation of the Hanoverian dynasty. The 1780s were years when an extraordinarily active social life was led by sections of the aristocracy and upper gentry, reflected and encouraged by the accomplished but self-indulgent Prince of Wales, with his extravagant expenditure on building, gaming, entertaining and the Turf. What life was like for the *Haut Ton* and its hangers-on can be seen in the racy memoirs of Henry Angelo (1760–1839), the fencing master; and in the lives of such varied figures as Georgiana, Duchess of Devonshire (1757–1806) – the leader of Whig society; Richard Brinsley Sheridan (1751–1816) – dramatist and politician; Richard, seventh Earl of Barrymore (1769–93) – greatest of fashionable spendthrifts; and the fourth Duke of Queensberry ('Old Q') (1724–1810), the most notorious *roué* of the time.[11] How a young man, at a lower social level, could be drawn into London night-life is vividly described in the diary of William Hickey (1749–1830).[12] What united them all in those days prior to the French Revolution was the assumption of their right to pursue a life of pleasure, often with little regard for other people. Most lacked any of the feelings of social conscience displayed by figures such as the intensely religious William Wilberforce (1759–1833). Wilberforce was the moving spirit behind the Proclamation Society, set up in 1787 after the King's Proclamation against Vice, which included vicious prints as one of its targets.[13] The political scene was far from dull, with Pitt, who had become Prime Minister at the age of twenty-four in 1784, opposed by the charismatic Whig leader Charles James Fox (1759–1806). Information about events, social and political, was disseminated to the reading public by an increasingly influential press; satirical artists had a continual stream of news and incident to comment upon and turn into prints, which were bought largely for their capacity to amuse.

It was against this background that two outstanding satirical artists emerged: James Gillray (1756–1815), sometimes described as the first professional political cartoonist, and Thomas Rowlandson (1756–1827), a brilliant draughtsman and convivial figure.[14] Their sophisticated prints became widely known, both to the moneyed classes who could afford to buy them and to those Londoners who merely saw them in the printsellers' shop-windows. At the same time there were many other satirical etchers at work, from the idiosyncratic William Dent (fl.1788–93) to James Sayers

(1748–1823), whose apparently crude but very effective etching needle was deployed entirely in support of Pitt.[15] Sayers was rewarded for this by Pitt, but stands out as one of the few political satirists who held a consistent political attitude; unlike most of the others, he did not regard himself as having a skill to be deployed on behalf of whoever chose to pay for it. He is also interesting because he was the sole artist who refused to adapt to the growing demand for coloured satires. By the early 1790s the price quoted for a satire was generally inclusive of colouring. The etchers worked in a more open style to admit areas of watercolour and, despite the additional cost, many of the print publishers began to use the smoother wove paper which took watercolour in a more satisfactory way; on traditional laid paper the chain lines made by the mesh of the paper mould were often very noticeable.

Although the output of literary and visual satire rose dramatically after Pitt's rise to power in 1784, it was the French Revolution, starting in 1789, and the subsequent war between Britain and France which provided the great opportunity, not only for Gillray, but also for other artists and publishers such as William Holland. The intensity of political debate and the importance of extra-parliamentary opinion further increased, and the satirical print was seen on all sides as a way of influencing it. It was during the time of this debate, in the years 1791–3, that Newton was to come to prominence. Before describing his debut it is important to set out what has been discovered about his background, early years and all-important relationship with William Holland as his publisher.

3 Newton's early years

Newton's childhood

Newton appears to have been born in 1777, and to have been the son of another Richard, who acquired three houses in Brydges Street, near Drury Lane Theatre, in the 1780s and described himself in 1784 as a haberdasher.[16] The street name is now lost and the area where Newton lived has now become part of Catherine Street, which, before the creation of Aldwych, opened into the Strand. This part of London had deteriorated by the 1770s and behind the main street were warrens of crowded courts. Already in 1717 John Gay had warned the visitor:

> O may thy virtue guard thee thro' the roads
> Of Drury's mazy courts and dark abodes!
> The harlot's guileful paths who nightly stand
> Where Catherine Street descends into the Strand.[17]

The Strand was, of course, the main thoroughfare between Westminster and the City; across the road from Catherine Street was Somerset House, home of the Royal Academy, which first held its annual exhibition there in 1781, when Newton would have been four; near to it was the Crown and Anchor, with its large assembly room where various clubs and associations met. The presence of the theatre, which had been remodelled in the 1770s by the Adam brothers for the proprietor, David Garrick (1717–79), and which was taken over by Sheridan in 1776, meant that people from all social classes visited Drury Lane, and the young Newton must have grown up knowing about the leading actors and actresses. He would, for example, have been eight when Dorothy Jordan (1762–1816) made her successful debut as a comic actress there in the winter of 1785/6, and it is possible that as a child he saw her act.

Politics played an important part in the life of Westminster, which had a franchise wider than most constituencies. The young Newton would have been about seven in 1784, when Charles James Fox was re-elected as Member with the help of his fashionable friends such as the Duchess of Devonshire. What schooling Newton received is not known, but there is no evidence that he had the kind of literary grounding which Gillray displayed in his prints.[18] Given that his artistic talent must have been apparent at an early age, it is possible that he had lessons from a drawing master or attended a drawing school; on the other hand his totally individual and zany talent shows no sign of having been subjected to conventional training. An ambitious teacher might have encouraged him to exhibit at the Royal Academy or the Society of Artists, but he did not do this. His father appears

to have been in reasonably affluent circumstances: when he voted in the 1788 Westminster by-election, supporting the Foxite Lord John Townshend, he was described in the polling book as 'Gentleman'.[19] This description was often applied to retired tradesmen, and, unlike the appendage 'Esquire', did not carry any automatic association with the gentry. Although he seems to have been only in his mid-thirties, his rental income was perhaps sufficient for him to have given up business. His capital was possibly increased further if he was compensated when the three houses he leased were demolished in 1791 as part of the rebuilding of the theatre by Sheridan.[20]

Most boys of Newton's background were apprenticed at the age of about fourteen and their initial years were often spent doing menial tasks; when they were proficient their work was passed off as their masters'. Newton would have been fourteen in 1791, when his first signed prints appeared. These were published by the radically minded William Holland, of Oxford Street, who had had a shop in Drury Lane during Newton's boyhood. Holland's personality and career were to be crucial to Newton's development; they call for detailed examination in order to understand the artistic and social milieu in which he established his career as a caricaturist.

4 The rise of William Holland

Holland in Drury Lane

Holland's early years are obscure; it would be tempting to believe he was Irish: he used the pseudonym 'Paddy Whack' and there was also an Irish miniature painter of the same name.[21] He was associated with the publication in 1782 of a 'king-baiting' pamphlet, *The Festival of Wit*. This was a series of anecdotes supposedly told by the King; it is an early example of the genre initiated by William Combe (1741–1823) in the late 1770s.[22] The appointment of Pitt as Prime Minister in 1784 saw the beginning of an important period for verse satire, initiated by the publication of the first of a series of Whig lampoons, *The Rolliad*.[23] Satirical verse was soon to be associated primarily with the name of 'Peter Pindar', the pen-name of an ordained doctor, John Wolcot (1738–1819), who was to make a small fortune from his innumerable doggerel satires. *The Lousiad*, a burlesque of 1786 inspired by the alleged discovery of a louse on the King's dinner plate, saw him emerge as the leading satirist against the King, mocking his stutter, trivial small talk, homely interests and supposed avariciousness: all themes which were taken up by the caricaturists.[24]

Holland was in business as a publisher of prints at 66 Drury Lane by July 1783, when he issued *Apollo and the Muses*, an unsigned satire by Gillray on Dr Samuel Johnson.[25] He apparently shared premises with George Peacock, a publisher of pamphlets specialising in flagellation literature, and the two called their shop a 'Print and Literary Museum'. They advertised publications such as *Female Flagellants*, which cost a guinea, or a guinea and a half with the six plates coloured; the title can be seen on the box marked 'For the Amusement of Military Gentlemen' at the foot of the auctioneer in Gillray's *Sale of English Beauties, in the East Indies*, published by Holland in May 1786.[26]

The 1784 Westminster Election saw a spate of political satires, including a group published by Holland; several of these prints, signed 'WPC', were the work of a young Irishman, William Paulet Carey (1759–1839), who was later to attain some fame as a political and artistic journalist.[27] These plates were presumably etched by Carey himself, but it is likely that Holland had a direct part in their production. On two of the prints there was a very distinctive looped script, and this continued to appear on the prints which Holland published, both for the titles and the dialogue, until the end of the century; it will be referred to here as 'Holland's' writing, though it could be that of an assistant.

Holland's publications give the impression that he was a literary man, a devotee of the novelist Laurence Sterne (1713–68) – the subject of one of

his known poems[28] – and a lover of paradox, bawdy and low life, as well as the friend of writers and journalists. He shared the new delight in demotic language that was reflected in the publication of Francis Grose's *Dictionary of the Vulgar Tongue* in 1785 (Grose 1796). This view of Holland is confirmed by one obituarist who wrote that Holland 'was himself a man of genius and wrote many popular songs and a volume of poetry, besides being the author of the pointed and epigrammatic words which accompanied most of his caricatures'.[29] Many of the prints he published rely on lengthy texts, including songs of his own composition, which are among the longest on any English satires.

Holland and Gillray

After the excitement of the Westminster Election, Holland began to build up a wider printselling business. A print dated 5 April 1785, heading William Cowper's ballad *John Gilpin's Race*, is signed 'IC' and indicates that he was using the services of Isaac Cruikshank (1764–1811), recently arrived from Edinburgh.[30] Cruikshank, however, was to work principally for another newly established publisher of satires, Samuel Fores, who was Holland's main rival and a publisher of Tory-inclined prints; his shop was in Piccadilly, in the heart of the fashionable West End. In March 1786 Holland resumed his association with Gillray and over the next three months he published seven of the latter's political satires, including *Wife and No Wife*, his depiction of the rumoured marriage of the Prince of Wales and Mrs Fitzherbert, which had indeed taken place in December 1785.[31] Holland advertised these prints in the London newspapers; this was usual practice for the larger printsellers and for artists publishing prints after their own works, but it could be expensive for a small publisher.[32] Initially Holland seems to have advertised in the *Morning Chronicle*, an opposition newspaper, in which Fores was also taking space. *Wife and No Wife* was, for example, advertised there in April 1786 at five shillings coloured and three shillings plain.[33] Holland made much of the talent of the artist, referring in one advertisement to his 'transcendent genius' – and to his own shop as a 'museum of genius' – but he did not mention Gillray by name. This may have been at the request of the latter, who was not signing his prints at this stage; he hoped for a career as a serious reproductive engraver, which could be a very remunerative occupation at this time, and did not want his name associated only with caricatures.[34]

Holland moves to Oxford Street

Holland's business obviously prospered and some time after November 1786, when the young Newton would have been about nine, he left Drury Lane, and set up on his own at 50 Oxford Street, on the north side, a few doors to the east of Berners Street.[35] Although the use of hanging shop signs had largely been abandoned by this date Holland had the sign of 'Garrick's

Richard', based no doubt on Hogarth's picture of the famous actor-manager in that role. His shop, presumably a larger one than in Drury Lane, was also in a more prominent position: fashionable customers were more likely to call, to laugh over the latest prints and 'lounge' away time between social engagements. An admittance charge of a shilling kept out the riff-raff. As we will see, his premises became something of a centre for those of advanced views, many associated with journalism and politics, and some of them on the edge of the high-living social circles around the Prince of Wales and his brother, the Duke of York, extravagant young men who sorely tried their royal father. Holland also began to publish pamphlets, several with coloured plates, and songs by Captain Charles Morris (1745–1838) and others. Songs are an important, if largely forgotten, part of the general culture of the time; they were inserted into plays and also sung at dinners, particularly political ones.[36] The first song-book which Holland published was *Edwin's Pills ... all the songs sung by Mr Edwin* (John Edwin, the comic actor (1749–90)) which appeared in early 1788, and had at the end a list of pamphlets and sixty-three prints. Holland may have thought of widening his printselling business, as his most expensive print, priced at ten shillings and sixpence, was not a satire but a mezzotint of *Harley and old Edwards*; this was a scene from *A Man of Feeling*, a sentimental novel by Henry Mackenzie (1745–1831) which influenced many young people, for example Robert Burns. As Mackenzie's literary model was Sterne, the book was probably one of Holland's favourites. The print was engraved by John Pettit, who made other prints for Holland and may possibly have been his assistant.[37] The print was after a picture by George Morland (1763–1804), the best-known painter of rustic genre pictures, a democrat and a convivial companion who may well have known Holland; as it was one of very few literary pictures by Morland it was possibly commissioned by Holland.[38] In addition, Holland was almost certainly among those in Oxford Street who sold 'indecent' prints, which could be a lucrative sideline.[39] In a later pamphlet Holland rebutted the defamatory report being put around to

the female sex, that a number of the prints exhibited, were of that complexion that would suffuse the cheek of modesty with the blushes of aversion, the Proprietor assures the Female World, there is not a Print in the collection of an indelicate nature.

This disclaimer did not, of course, mean that he was not selling them, and there is evidence that he was producing pornographic prints as well as ones which were merely improper.[40] His business, however, was to remain centred on the burgeoning market for satirical prints, generally highly coloured with watercolour washes.

The vogue for long prints

As has been mentioned above the vogue for long prints, of which Newton was to make several examples, established itself in the late 1780s on the basis of Bunbury's designs. In March 1788 Holland produced one with nineteen figures, *The Prince's Bow*, inspired by the graceful bow which the Prince of Wales had given a month earlier at the opening of the trial of Warren Hastings (1732–1818), the lengthy proceedings instigated by Edmund Burke (1729–97), Sheridan and other Whigs to draw attention to the East India Company's misrule in India. *The Prince's Bow* bears an advertisement:

> Holland's Caricature Rooms are now open, presenting a general Exhibition
> of all the distinguished Caricatures that have been published the last Ten
> Years with many original Paintings and Drawings of high celebrity.
> Admittance one Shilling.[41]

The print, which measured just over six feet long, was on three sheets; as it was regarded as the equivalent of three prints Holland was able to sell it for thirteen shillings and sixpence coloured, that is four shillings and sixpence for each sheet. The designer was a gentleman, Frederick George Byron (1764–92) – uncle of the future poet, Lord Byron – who had served as an officer in the Nottinghamshire Militia and was then in his mid-twenties.[42] Sufficient buyers came forward for Holland to produce two other long prints, *English Slavery*, and *Meeting an Old Friend with a New Face*, which both sold for the same price. These differed from most of the long prints in including recognisable figures.[43] According to a six-page 'Catalogue of Books, Pamphlets, and Prints' at the back of *Jordan's Elixir of Life* (a book of the most popular songs sung by Mrs Jordan, which was published by Holland in 1789), 'Those Prints exhibit Portraits of Sixty Public Characters'. It is interesting that the catalogue mentions Byron, as this is the first time Holland names one of his artists. It lists no less than 112 prints, up to June 1788, though not all were necessarily published by Holland himself. He concluded the catalogue with a paragraph which is interesting in identifying the way he was targeting 'collectors':

> Caricature Collectors
> May be now supplied with the greatest variety in London, of political and other
> humorous Prints, bound in Volumes, and ornamented with an engraved Title, and
> a characteristic Vignette; one hundred Prints in a volume, Five Guineas plain, or
> Seven Guineas coloured. A greater Number in a Volume, in proportion. [44]

Although no intact album has been found, at least one of the title pages to which he referred has survived (figure 2).

Holland also published a few prints by Rowlandson, and by his friend Henry Wigstead (*c*.1745–1800), whose *Propagation of a Truth*, 12 January 1789 (BM 7482) was etched, like many of his prints, by Rowlandson. As George pointed out, Wigstead was identified in the *Morning Post* as the designer of one of Holland's political satires and criticised for descending to the level of political caricature. This comment is worth repeating here as it is further evidence of how 'respectable' opinion looked on political satires:

> That the common order of Caricaturists should seize upon temporary events for the exercise of their feeble powers, is to be expected; but that the respectable talents of Wigstead should descend to current topics, and join in the vulgar cry against a retiring Minister, must excite some surprise; and while we admire the abilities obvious in his Propagation of Truth, we cannot but wish they had a higher and a nobler direction.[45]

Meanwhile Holland had published two further prints by Gillray and reissued three earlier ones with his new Oxford Street address. These included *Wife and No Wife*, which acquired a new topicality as a result of the Regency crisis precipitated by the King's illness, and the possibility that the Prince of Wales might be made Regent. A pendant to this, the famous *Morning after Marriage* (BM 7298), another daring print of the Prince of Wales and Mrs Fitzherbert, dated 5 April 1788, was, however, the last satire by Gillray which Holland published. Gillray, who had been paid through the Treasury in 1788 for pro-ministerial satires, then settled into a regular engagement with the publisher Hannah Humphrey; she later showed his prints in the prominent bow window of her shop in St James's Street (figure 3).[46] During the political turmoils of the 1790s he was to produce some of the greatest of political satires, such as his telling depiction of Pitt as a toadstool (figure 4).

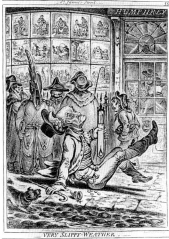

Figure 3

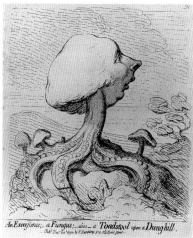

Figure 4

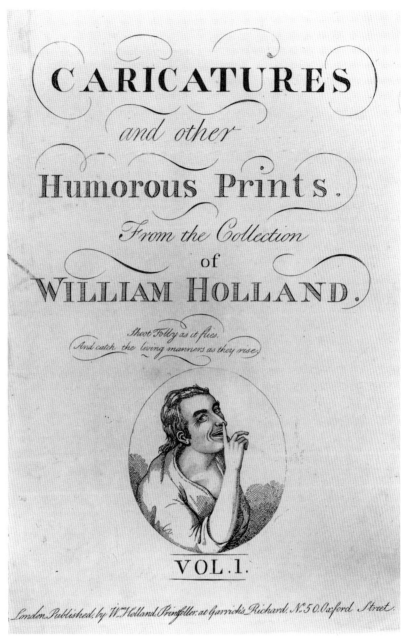

CARICATURES

and other

Humorous Prints.

From the Collection

of

WILLIAM HOLLAND.

Shoot Folly as it flies.
And catch the living manners as they rise.

VOL. 1.

London. Published. by W.ᵐ Holland. Printseller. at Garrick's Richard. N.º 5 0. Oxford Street.

Figure 2

While Holland continued to produce some quite modestly priced satires, his strategy seems to have been to publish a large number of different prints which sold to a limited circle of people at high prices, rather than selling a large number at low prices. He published over thirty prints in the thirteen

months between 18 March 1788 and 29 April 1789 when he brought out *The Grand Procession to St Paul's* (BM 7525), on which no less than fourteen prints are listed. He may soon have been able to build up a group of regular customers, some of whom may have given standing orders for all the prints which he published. One very good customer was Count Starhemberg, who arrived in London as the Austrian envoy in July 1792 and bought a great number of caricatures, several of which are illustrated here. It is possible, of course, that a great personage such as Starhemberg never visited Holland's shop, simply sending a servant to fetch prints on approval. Other continental collections of English satires were built up through agents.[47] Some purchasers, such as the Count, kept them carefully, but other wealthy people treated them as ephemera, perhaps cutting up the longer prints to decorate screens and throwing away others which they did not like or which had become dog-eared.

Byron and Holland's other draughtsmen prior to Newton

Byron was the principal draughtsman acknowledged on Holland's prints in the two and a half years between March 1788 and October 1791, a few months before his death. Some dozen or so prints are signed by him and, largely due to the perspicacity of Andrew Edmunds, a number of others have recently been convincingly attributed to him.[48] Byron made some political prints, notably ones ridiculing Burke, but he also made a number on such topics as ghosts and old maids with their cats, two of the subjects which Newton was later to enjoy drawing. Some of his facial types are similar to the ones which Newton was to make.[49] Byron also learned to etch, though only a few of the prints he designed himself credit him as an etcher, and, as we will see, the full extent to which he etched plates for Holland was not revealed until after his death. By then it was socially acceptable for someone of Byron's secure status to design satires, but it would have been thought inappropriate for him to have been employed as an etcher. The publisher was also soon making use of drawings by other artists, notably another non-professional artist, John Nixon (1750–1818). The latter, an indefatigable sketcher, was a City merchant in the Irish trade; he was popular and presentable and moved in fashionable circles, for example later taking part in the aristocratic theatricals which were so popular at the time.[50] In July 1789 Holland published his *Royal Dipping*, which shows the unfortunate King bathing after the first period of insanity brought on by his undiagnosed porphyria.[51] The print is not typical of Nixon, who usually produced general social satire rather than personal lampoons. His work was well received, and by December 1789 Holland felt confident in asking no less than a guinea for *A Country Dance* (BM 7813), a long print designed by Nixon. It has been suggested that Newton's first published print is a slight etching, Kind Phyllis – Cruel Chloe, signed 'RN sculpt 1788' 'JN[ixon] Delt', and dated 20 February 1788, but it seems that 'RN' is in fact Nixon's younger brother Richard.[52]

Holland as designer

Although some of Holland's prints at this time have the name of a designer, the majority are unsigned. It is probable that Holland himself conceived a number of these. As we have seen, the lettering on many prints can be ascribed to him, even on prints known to have been designed by others. Why he did not sign prints as the designer is unclear, but it may be partly because the authorship of many of the prints was not simply explained; in many cases they may have been the result of verbal suggestions from others. We can imagine his print shop as a meeting place for a group of lively individuals with political, theatrical and literary interests, eager to give him ideas for new prints. Some of these were fairly unscrupulous adventurers, familiar, for example, with the blackmailing practices used by newspapers, but whether Holland was tempted into producing political prints in order to have the prints bought up by their victims is not known.[53] It is clear that the rapidly expanding nature of his business obliged him to use outside printmakers, and there are a few plates on which professional engravers, for example Pettit, are acknowledged. He may also have used the unacknowledged services of Isaac Cruikshank, who was soon working principally for Fores and may have been reluctant to sign work undertaken for his rival.

Holland and Woodward

It was in spring 1790 that Holland began to use designs by George Murgatroyd Woodward (c.1760–1809); he was a poor draughtsman but he was to be an important source of social satires for Holland and an influence on Newton. Unlike Holland's other artists he did not etch his own drawings, leaving this to the publishers to organise. Over the following year or so Holland was to issue at least a dozen singly issued prints after Woodward, in addition to three sets, a total of some sixty prints. Woodward was the son of a Derbyshire squire, but apparently ran through what money he received from his family.[54] He may have appeared to his contemporaries to have gone down in the world and he worked primarily to make money, which was promptly spent in taverns. Unlike Byron and Nixon, who may well have been paid for their efforts but were gentlemen not dependent upon the publishers for their livelihood, Woodward was not given the appendage 'Esq'(uire) on his prints. Although Holland did not remain Woodward's principal publisher for very long, his link with Holland came at an important time for the young Newton. Woodward was an undoubted influence on the boy, who took over some of his characteristic expressions, notably the firmly downward-set mouths of older men, as well as producing many prints, notably those of ghosts, which are based on his style (e.g. figure 13). Woodward was a prolific designer and George suggested that after the turn of the century his prestige was higher than that of Rowlandson.[55]

5 Newton's first years with Holland

The nature of Newton's employment

Newton had probably joined Holland's enterprise by 1791, when he would have been in his fourteenth year. Although the usual age for being apprenticed was fourteen, some boys and girls were bound at an earlier age. At the end of his apprenticeship a youth of twenty-one could become a freeman of his master's livery company or a freeman of his town, and in many constituencies this carried the right to vote in elections. Although no evidence has been found which proves that Newton was formally apprenticed to Holland, this does not rule out the possibility that he was. If Newton's father had got to know Holland when he was established in Drury Lane it is quite possible that there was an informal agreement without an indenture.[56] If, as is likely, Holland was not a member of a livery company there was not much advantage, beyond ensuring some security of occupation and maintenance, in binding the boy to him. Such considerations may not have mattered to his father, who, as we have seen, probably had capital behind him. As an apprentice Newton would not, in theory, have been able to earn money on his own. It is possible that, as Newton was so obviously capable of earning his own living, he was, despite his extreme youth, either treated as a superior pupil or was a paid employee from the start of his time with Holland; as we will see, he does not seem to have lived as a member of Holland's household, as would have been usual for an apprentice. By 1791 it was clear that the life of an artist was one which could lead to advancement in the world, and even if the milieu of the satirical print was looked upon with some disdain by many in polite society, it could be the starting point for a rewarding life as an independent draughtsman.

Newton and Woodward

It seems that Newton began his working career by etching rough sketches or verbal suggestions put forward by Holland and his associates, above all Woodward, with whom he was working very closely in the early 1790s. It is difficult to be entirely confident about George's attribution of certain early prints to Newton. One at least described by her as '[Newton]', i.e. unsigned but definitely by Newton, may well have been etched by him, but is now known to be after Woodward.[57] It is important to look at the precise way in which Newton signs the prints on which he was allowed to put his name. A high proportion of satires were collaborative ventures. When Newton puts 'Newton fecit' or 'Drawn by Richard Newton' it does not necessarily mean that the design was his idea; it may mean that he was working from the instructions of Holland, or one of the many customers who made suggestions for prints; after all even Gillray, with the most fertile

imagination of any satirist, freely took ideas from others. It is only when Newton names himself as the designer of a print that we can be sure that it is fully his work, and even then the dialogue on the print may have been composed and etched on to it by Holland.

The advantage of identifying the artist

It is undoubtedly true that the humorous etchers of the time stamped their identity on any print they produced, irrespective of who had thought up the idea behind it. A print etched by Rowlandson, for example, after Wigstead, who was a poor draughtsman, is still recognisably a 'Rowlandson'. The problem with Newton's early style is that it can be so like that of Woodward or Byron. Publishers such as Holland could treat authorship in a casual way, because what was important was whether the print amused the public, not who precisely was responsible for it. On the other hand the print publishers found from the 1770s that humorous images would sell on the name of the designer. This was shown initially by the success of prints after Bunbury, which were collected as a category, often being kept in albums in libraries.[58] Holland had no doubt hoped to build up this kind of reputation for Byron, and later for Woodward and Newton. Newton's name appears on only about five prints in 1791, the earliest being *A Sketch from Highlife*, 27 May 1791, one of many prints published by Holland which mocked the King and Queen. His name does not appear on *September in London – All our Friends out of Town !!!*, although this is known to be by him; it is a delightful glamorisation of low life, which shows a group of ladies of the town outside a pawnbroker's (plate 1). The watercolour has survived; it was probably kept initially as a guide for the colourists, though it is clear from Holland's advertisements that he also sold humorous drawings, and we know from Rowlandson's practices that artists might make several versions of a popular drawing for sale.

Holland the Radical

Holland was among many in England – most of whom later changed their views and forgot their early enthusiasm – who welcomed the French Revolution, and hailed the destruction of the Bastille in July 1789 as the beginning of a new era. He was not slow to recognise the opportunities which events in France might offer for his business. On 14 August 1789 he published a satire, probably by Byron, showing the fall of the Bastille and the triumph of the Enlightenment philosophers. It has both a French and an English title, *La Chute du Despotism*; *The Downfall of Despotism*, and was probably aimed partly at the French market.[59] The dialogue is in 'Holland's' script. By exporting the print he would have been able to secure French prints in return, and in early 1790 he was advertising on prints that

In Holland's Caricature Exhibition Rooms may be seen the largest
Collection in Europe of Political and other Humorous Prints with
those Published in Paris on the French Revolution.

He did not immediately produce many prints, other than *A Grand
Cavalcade of French Cuckolds*, commenting on events in France.[60] This is
perhaps understandable, given the speed at which events were moving and
the demand for realistic rather than satiric depictions of what was going on:
English satiric reaction to the Revolution, led by Gillray, was to be marked
by the division of English opinion about the great event. The print on
which reference to French prints probably first occurs, *Puritanical
Amusements Revived!*, 27 February 1790, was provoked by the sermon of
Joseph Priestley (1733–1804) to the Revolution Society, in which he spoke
of orthodoxy and hierarchy being blown up 'perhaps as suddenly, as
unexpectedly, as completely, as the overthrow of the late arbitrary
government in France'. Holland had great fun with this, imagining the
return of puritan restrictions and signing both *Puritanical Amusements* and a
companion plate, *The Battle of the Angels*, 2 March 1790, 'Designed by Oliver
Cromwell. Etch'd by William Holland'. However this should not be taken to
mean that Holland actually made the print, which bears Byron's stamp.[61]
The most influential reaction to the events in France was of course Edmund
Burke's *Reflections* published in December 1790, countered by Thomas
Paine's *Rights of Man* in February 1791. At the end of 1790 Holland
published a series of prints ridiculing Edmund Burke as 'Don Dismallo',
and Newton included two of these, which must be by Byron, in his picture
of Holland's exhibition.[62]

Holland's business expands

The years 1790 and 1791, when Newton was learning his trade under
Holland, were ones of remarkable activity for the publisher. It is difficult to
gain a complete idea of Holland's business since examples do not seem to
have survived of some prints known through advertisements. In 1790
Holland published some forty plates, plus three sets after Woodward, a total
of some sixty plates. In 1791, when he began to focus on English reactions
to the Revolution, he published at least sixty-five plates plus one set, the
Lilliputian World (BM 7874–9), a total of some seventy-one prints. One of the
most interesting, in which Holland shows his sympathy for Paine's ideas, is
Contrasted Opinions of Paine's Pamphlet, 26 May 1791, which has been
attributed to Byron.[63] Holland was quick to react to the news of the
attempted flight of the French royal family on 20–21 June, and although the
English public observed their plight with some sympathy Holland saw its
comic possibilities. *An Escape a la Francois!*, attributed to Newton, has the
publication date 1 July 1791, and *Long Faces*, or the first meeting of the
French Assembly after the King's escape, is dated 7 July.

Holland's 1791 catalogue

In the autumn of 1791 Holland issued another catalogue, consisting of four pages at the end of a songbook: *Wit and Mirth; or, Tom D'Urfey's Pills to Purge Melancholy*. This 'Catalogue of books, pamphlets, and Prints, to be had at Holland's Museum of Genius', has a whole page devoted to the subscription for a large print of the meeting of the French Federation, after a drawing made on the spot by Byron; a page listing thirteen books and pamphlets, several of which had coloured plates; and just over a page given to singly issued prints.[64] By 15 September 1791, the date of the most recently published print, *Crops and Bandelures in St James's Street*, attributed to Newton, Holland had published some two hundred singly issued prints over seven years. However, the catalogue listed only thirty-one, plus two sets containing twenty-seven prints. Although Holland listed a number of political prints, such as those of Burke, he did not include any of those ridiculing the royal family. This suggests that Holland was initially somewhat circumspect in the way he distributed such prints; they had his name on them as publisher, so that potential buyers knew where the print could be obtained, but he did not actively promote them.

The prints he listed in his catalogue ranged in price from a guinea for three-sheet prints such as Nixon's *Country Dance* down to two shillings, by then the usual price for a coloured print of around fourteen by ten inches. The names of Byron, Nixon and Woodward as designers were given, but, although the titles of the Gillray prints issued by Holland in the mid-1780s were listed, his name was still withheld. Nor is Newton mentioned; this is more understandable given the short time which he had been with Holland. What is both surprising and puzzling, however, is that shortly after this catalogue of Holland's appeared, the young etcher published a print himself.

1791: Newton as publisher

On 30 November 1791 an unsigned print, *A Visit to the R---l Cole Pit* (BM 7924), was published by 'Richd Newton Gt Portland St'. This shows the King and Queen as miserly hoarders, taking possession of the dowry of the newly arrived Duchess of York. Newton's name is not on the print as the designer; the lettering is in Byron's hand, and the head of the King is very similar to the one which he etched in his *English Slavery* (figure 9). It is possible that Byron passed the plate to Newton to publish before going for the sake of his health to Bristol Hotwells, where he died in early 1792.[65] Why he should have done this is a puzzle.

Great Portland Street, a very genteel residential street, was also the address from which Newton subsequently issued some other prints; notable among these was *The Duchess of York's Foot* of January 1792, on which a street

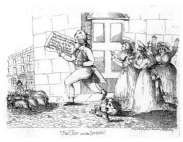

The Tar and the Jordan!

Figure 5

number, probably '50', is given.[66] This print was one of several inspired by the revelation that the Duchess's foot was only five and a half inches long. Soon afterwards Gillray adapted the design by inserting the Duke's feet between those of his Duchess to produce *Fashionable Contrasts*, one of his most memorable images.[67] There is another satire published by Newton, *The Tar and the Jordan* (figure 5), one of several prints following disclosure of the liaison of the actress Dorothy Jordan and one of the King's younger sons, the Duke of Clarence, who was a naval officer (known when William IV as 'The Sailor King'). This undated print has Newton's address as 'Old Bailey'; George dated it circa November 1791, perhaps simply because that is the date of one of Gillray's most effective prints, *Lubber's Hold, alias The Crack'd Jordan* (BM 7909). Newton's rather awkwardly composed print may well be earlier than this, since he used the Great Portland address until December 1792.

If one assumes that 'R. Newton' the publisher is the fourteen-year-old and not his father, it is remarkable that he was able to publish prints on his own account from his own address. It shows a degree of personal, economic and artistic independence unusual for one so young. It could be seen as strengthening the idea that Newton was an employee of Holland rather than an apprentice, and was given leave by Holland to publish on these occasions. Perhaps Holland was apprehensive about publishing certain prints, for example ones ridiculing the King's sons, who, as we will see, were customers of his business, and preferred Newton to bring them out himself. It is possible that he was using an 'accommodation' address while he lived with Holland; equally he could have been living with his parents, if they had moved following the demolition of their houses in 1791. On the other hand it is quite likely that he was living by himself, with all the increased freedom that allowed. Lodgings were not expensive and he may have been relatively well off, with payments from Holland as well as the sale of his own prints through the printshops, supplemented by direct sales to Holland's customers, and possibly an allowance from his father. Free of the constraints imposed on apprentices, and with money in his pocket, Newton may have got to know London and all its entertainments – from the Pantheon in Oxford Street to Ranelagh and Vauxhall Gardens – much better than his peers; their only escape from their masters' houses during six days of the week was to the riotous taverns where apprentices would meet; Newton's *Row at a Cock and Hen Club*, 1 March 1798, shows the kind of gathering which, as George points out, the radical tailor Francis Place knew about when he was an apprentice.[68]

1792: Newton's royal satires

Figure 6

Newton was little known in 1791; this was to change during the following year, when there are some twenty prints signed by him, and about forty more which can be given to him with some confidence. He also signed a plate illustrating a pamphlet issued by Holland: *The Battle between Doctor Farmer and Peter Musgrave, the Cambridge Taylor, in Hudibrastic Verse ... embellished with an etching of the battle by a celebrated caricaturist*; this was a poem making fun of the exchanges between Richard Farmer (1735–97), Master of Emmanuel College, and Musgrave at a meeting in Cambridge held in support of a new Proclamation by the King. Farmer made an unguarded remark to the effect that what Musgrave had said was 'irrelevant to the subject before us, as a red cod-piece would be on a black pair of breeches'. Newton's etching, for which the original drawing survives (figure 6), shows the tailor lunging at the clergyman's groin with his scissors, exclaiming 'D--n me I knew I was right there's nothing in em' (figure 7).[69]

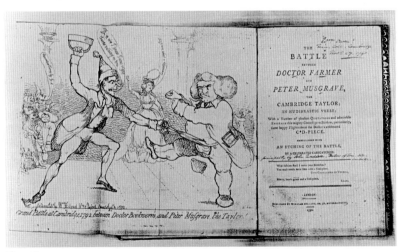

Figure 7

It is interesting that the publisher makes no mention here, or apparently elsewhere, of Newton's youth. Although boys had to grow up faster then, often starting work as children or joining the army or navy at a very tender age – Byron had become a cornet in the militia at fourteen – artistic precocity could have its publicity value, as had been attested by the well known example of Thomas Lawrence (1769–1830), who had been promoted as a prodigy from the age of ten. It is possible that Holland may

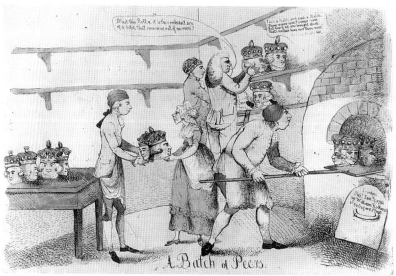

Figure 8

have felt that to stress Newton's youth would have been counter-productive, and undermine his potential standing as a caricaturist.

It was no doubt the death of Byron in the winter of 1791/2 that led Holland to bring the youthful Newton forward. Under Holland's direction he began to produce more plates which ridiculed the King, and often the Queen with him. One of the first prints which Holland issued in 1792, and which has its title *A Batch of Peers* in 'Holland's' distinctive hand, may be etched by Newton after a drawing by Byron; this shows the King and Queen, assisted by Pitt, taking the heads of newly baked peers out of an oven (figure 8). Again, the head of the King in this print is very similar to that in Byron's *English Slavery* (figure 9).

The first group of prints mocking the royal family were inspired by the discovery of a pair of burning breeches in the ceiling of a privy in

Figure 9

Parliament. This gave Newton the cue for some absurd prints of the King and Queen, including *The Combustible Breeches*, 11 May 1792 (plate 4) and *A Blow-up at Breakfast!* (figure 10). The first of Newton's more serious prints is *A Proclamation in Lilliput* (plate 5), provoked by the King's new Proclamation against 'tumultuous meetings and seditious writings' of 21 May 1792; the print is in fact dated the

next day. This was quickly followed by *A Bugaboo!!*, 2 June 1792 (plate 7), so striking because of its bold scale. *Content and Discontent* (plate 8), and *The Windsor Milkman*, showing the King carrying pails of milk, also appeared in June, and a pendant of the Queen, *Dainty Nice Sprats*, in July. *Louis dethron'd*, – which included a vicious depiction of the Queen as an avaricious crone – and *The Libertine reclaim'd* came out in August. In these the influence of Gillray, who had begun to show the King in distorted profile in 1791, is apparent. Newton adapted Gillray's depictions of the King and Queen, seen in such prints as *Temperance enjoying a Frugal Meal*, 28 July

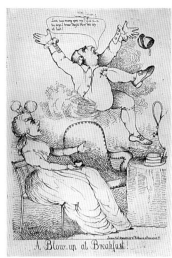

Figure 10

1792. Newton made the King's profile more fish-like, with bulging eyes, just as Gillray had done in his profile of George in *The Hopes of the Party*, 19 July 1791 (figure 11). Bulging or goggle eyes soon became one of Newton's favourite devices, and are seen in many of his prints. Holland published over a dozen prints by Newton ridiculing the King and Pitt during the course of the year, culminating in November in what has been described as probably his most radical print, *Liberty and Equality* (plate 10); this includes a provocatively levelling depiction of the king walking hand in hand with a plebeian holding a copy of Paine's *Rights of Man*.[70] Political prints were by no means all, however, that Newton produced in 1792, which was by far the most productive year of his whole career.

Newton's larger prints of 1792

One of Newton's most powerful plates of 1792 is *A Forcible Appeal for the Abolition of the Slave Trade*, 2 April 1792 (plate 3), signed simply 'Etch'd by R. Newton' and perhaps after an idea by someone else. At this time Newton also began to satirise the behaviour of the aristocracy: *Tasting a Norfolk Dumpling* (plate 6) appears to be an amusing, if rather ambiguous, commentary on two of the leading society figures, the rather uncouth Duke of Norfolk, who had radical leanings, and the hard-headed Duchess of Gordon. He now began to produce bigger plates for Holland. His first was *A Party of the Sans Culotte Army marching to the Frontiers*, 1 October 1792, a

Figure 11

31

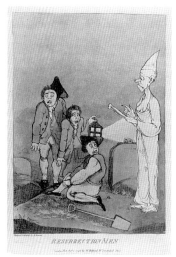

Figure 12

wonderfully zany composition which makes fun of the ragged, but unexpectedly successful Citizens' Army of France.

Newton's principal contribution was the narrative print on a large rectangular plate rather than frieze designs. The first print of this kind which Holland seems to have published was Woodward's *Clerical Exercise*, dated 8 December 1791, which shows the progress of an undergraduate through the ranks of the clergy to a bishopric; this was one of the few plates signed by Byron as an etcher, and was the last to appear in his lifetime.[71] Newton's first large print of this type appears to be *Wonderful News from Seringapatam*, 18 May 1792, an unsigned print selling for three shillings and sixpence; one of Holland's later catalogues reveals that this has 'Mr Merry's excellent lines under each figure'; Mr Merry must be the improvident Robert Merry (1755–98), leader of the pretentious 'Della Crusca' poets, active journalist and enthusiastic supporter of the French Revolution, who went to Paris several times during the 1790s.[72] A few weeks later, on 4 June 1792, Holland's rival Fores published Nixon's clever *The Progress of Passion*; here the artist imagines the disappointment which the Chancellor, Edward, Lord Thurlow (1731–1806), felt at his dismissal being vented on his family and passed down through his household until his cat takes it out on a rat.[73] This print is important as one of the first to revive the Hogarthian title of 'Progress', giving a lead to Gillray and Newton.

The addition of aquatint

One refinement which was introduced into Holland's plates on a more regular basis in 1792 was the addition of aquatint to the plates. Aquatint was a form of tonal etching discovered in the 1770s; it could increase the visual impact of etchings, providing a ready-made foundation for the addition of colouring. On 1 October 1792 Holland published a group of two-shilling prints of ghosts etched by Newton after Woodward, to which was added one of Newton's own composition, *Resurrection Men* (figure 12), which shows grave-robbing, a favourite topic for storytelling. The shortage of corpses for teaching anatomy did indeed lead to grave-robbing, with Laurence Sterne's corpse being the most famous one to suffer this fate. Ghosts, devils and other supernatural figures were favourite subjects in country areas.[74] Woodward, who probably acquired the habit of drawing them in his

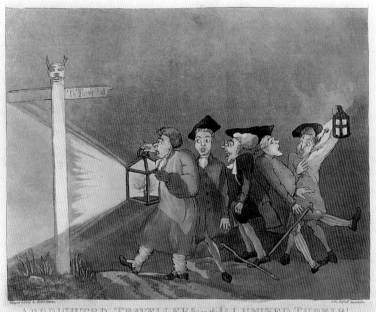

Figure 13

Derbyshire youth, passed on his enthusiasm to his young colleague. Newton made two larger plates, the first to be signed 'Design'd & Etch'd by R. Newton': *Affrighted Travellers* (figure 13), which shows country folk frightened by a turnip on a signpost, and a drunken scene, *One Too Many* (plate 9), which was published as a pendant to *The Haunted Cellar* after Woodward. Woodward was also the designer of *A Doctor in Purgatory!* (figure 14), based on the lines in the *Dispensary*, by Samuel Garth (1661–1719), which describe a doctor who has just died surrounded by his former patients. These prints had aquatint added by John Hassell (d. 1825). All these aquatints are lettered in a neat italic hand – much more professional than that of 'Holland' or of Newton himself, which is seen on a number of later plates; if this is Hassell's own hand he worked quite regularly for Holland at this time.[75]

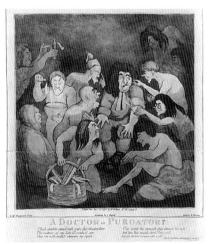

Figure 14

6 Newton during Holland's imprisonment, 1793–4

Holland's arrest

After a year of great activity as an oppositional publisher, Holland was suddenly brought to heel by the government. He had produced a number of humorous or scurrilous pamphlets since 1788 but he had not issued any political tracts. He clearly did not heed the warning inherent in the Proclamation; one small sign was that he listed several of the satires hostile to the King in the 'Catalogue' appended to the *Grand Battle in Cambridge*.[76] More significantly, at the end of 1792 he published *Paine's Address to the Republic of France; September 25, 1792*, a sixpenny pamphlet, on which he announced that he was also selling Paine's *Letter to Dundas* and *Letter to the Addressers*; he also issued another political pamphlet, *Pathetic Particulars of a Poor Boy sentenced to Suffer Seven Years Imprisonment in Gloucester Jail*. It had been clear for some time that the authorities wanted to move against radical publishers – the King's Proclamation had been a clear warning – and they were encouraged by loyalist groups and the newspapers in the pay of the government.[77] It suggests that Holland held radical convictions in that he had gone ahead with selling these works, despite the obvious dangers. On the other hand he does not seem to have belonged to any radical organisations, and it may be that he was egged on by his associates.[78] Holland was named as a Jacobin by *The Times*, which was delighted when he was indicted – apparently much to his surprise – by a Grand Jury for selling Paine's *Letter to the Addressers*; he was arrested on 17 December 1792. It may be on account of Holland's arrest that in December Newton's *A Real San Culotte!!* (plate 11) was published by the young artist, again from Great Portland Street, rather than by Holland. This print is rather ambiguous in its treatment of the dreaded sans-culotte figure and it is not ostensibly a radical print.

Although some of Holland's prints showed his sympathy for radical ideas, and others ridiculed the King in a way which offended many people, it would have been difficult for the authorities to have convinced a jury that any of his prints were seditious: it was different with political pamphlets. Holland and James Ridgway (fl. 1782–1817), a bookseller and publisher for the radical Friends of the People, arrested at the same time for selling *The Rights of Man*, were both imprisoned until they found bail, for which they had been ordered to give forty-eight hours' notice.[79] The arrest attracted attention at the time, and a pamphlet published soon afterwards by Ridgway commented that they had

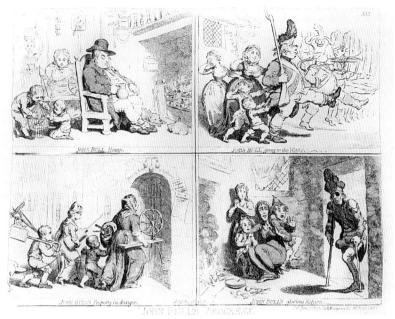

Figure 15

been dragged from their families and their business, been imprisoned even
with felons, during eight and forty hours, in positive avowed refusal of all
bail, under the absolute order of a bench warrant; ... have ... been punished
first, with a promise of being heard afterwards.[80]

Holland resumed his publishing, and in the New Year he brought out a
couple of prints by Newton which initiated two new themes in the young
artist's work. The first, under the title of *Venus Surrounded by Cupids*, 12
January 1793, was a print of a young lady of the town brought in by the
watch. This was the first of a series of prints illustrating conflicts between
the sexes, with the title in professional-looking capitals and similar in scale
to *A White Serjeant* (plate 24).

The second new direction was the appearance on 11 February 1793 of
the first of Newton's 'Progresses': *The Progress of a Player* (plate 12), which
shows the unsuccessful attempt of a young man to go on the stage. It was
Nixon, as we have seen, who first revived the title of 'Progress', but
Newton's use of the 'Progress' format may have been prompted by Gillray's
chilling prediction of what war would mean for the ordinary family: *John
Bull's Progress* (figure 15), published on 3 January, shortly before France
declared war on Britain. On 23 February 1793, however, any plans that
Newton and his employer might have had for new prints were thrown into
confusion by Holland's conviction for selling Paine's pamphlet. He was

fined £100, sentenced to be imprisoned for a year and ordered 'to find sureties for his good behaviour' on his release, to the tune of £200 put up by himself and £200 by two others.[81] This was not the end of his troubles: on 10 May 1793 he was brought back to King's Bench and a second action was brought against him for publishing the pamphlet on the boy imprisoned in Gloucester gaol, which appears to have also carried the provocative title of *Gloucester Bastille!!!*.[82]

Holland in prison

Holland was sent to Newgate. Imprisonment did not, as one might expect, bring his business to an immediate halt. Newton may have gone to live above Holland's shop, as in February 1793 he published *A Serious thought of a Plain Englishman* under his own name, but from 50 Oxford Street. A few prints came out in Holland's name during the early months of his sentence. These included two prints designed and etched by Newton. *Fast-Day!*, 19 April 1793 (plate 13), was a robust attack on clerical gluttony published to coincide with the day of fasting decreed by the King; it was the first of his many prints which made fun of the clergy. The second was the outrageous *Making a Freemason!* (plate 14). In July 1793 there were a couple of humorous prints related to events in France, *The Assassination of Marat* and *The Funeral Procession of Marat*, in which Newton had great fun depicting sans-culottes. The title on *Fast-Day!* appears to be in 'Holland's' hand; it is possible that plates were taken into Newgate for him to look at by his wife or by Newton, who between them must have been running the business.

Visitors had access to prisoners 'on the State side', that is those who were not felons, and Newton produced at least four portrait groups showing Holland with visitors and prison acquaintances; he then made large etchings from some of them, the largest plates he had yet made. The first was *A Peep into the State Side of Newgate*, 12 July 1793 (figure 16), in which

Figure 16

36

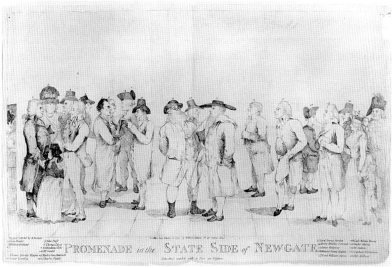

Figure 17

Newton showed nine men: from left to right are Ridgway; Lord George Gordon, whose anti-Catholicism had led to the riots named after him in 1780, but who had become an object of curiosity after his conversion to Judaism; his secretary Dr Robert Watson; Holland; the publisher Henry Delahay Symons (fl. 1784–1808), serving four years for selling pamphlets by Paine; Thomas Townley Macan, serving three years for attempting to blow up King's Bench prison; Thomas Lloys, a lawyer confined for a libel; John Frost (1750–1842), a veteran reformer arrested in February 1793 on a charge of sedition; and Daniel Isaac Eaton (?1751–1814), a radical publisher and a member of the London Corresponding Society, the most plebeian and extreme of the reforming societies. Eaton, like Watson, was a visitor: indeed the authorities failed in a total of eight attempts to convict the publisher of libel or sedition.

This plate was followed by the larger *Soulagement en Prison; or, Comfort in Prison*, 20 August 1793, which sold for ten shillings and sixpence; Newton's original watercolour for this survives (plate 16). These show Holland together with the eight others shown in *A Peep*, together with six others, notably the journalists Charles Pigott and Daniel Holt and the lawyer Joseph Gerrald (for more information on these see the caption to plate 16).

The largest of the groups was *Promenade in the State Side of Newgate*, 5 October 1793 (figure 17); this was set at a lower price, seven and sixpence, which may mean that the *Soulagement* had not sold as well as had been hoped. It shows a larger and more self-conscious group of nineteen adults; eight are prisoners, and all but one, Lord William Murray (shown with his wife and child on the right), are included in the earlier print. The visitors

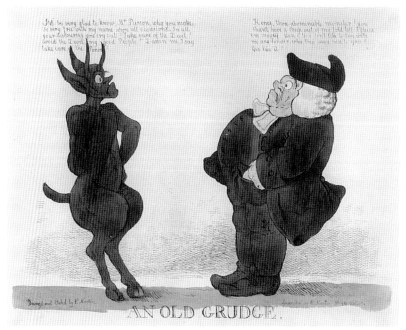

Figure 18

include the indefatigable 'Peter Pindar', shown on the left, next to Holland, peeping in on the group; the veteran radical John Horne Tooke (1736–1812) – later to be imprisoned in the Tower of London; Count Alvise Zenobia – a Venetian who was ordered to leave England in 1794; and, on the extreme right, a Captain Wilbraham, who must have objected to being included in such company as in a later state of the print he was replaced by Daniel Holt. In the centre is the bearded and be-spectacled figure of Martin van Butchell (1735–1814), an 'anatomist' and expert self-publicist. The group also includes Holland's wife and daughter. There is a certain poignancy in this, since Mrs Holland died on 10 August, before the print appeared; according to one report, 'the sufferings of her husband ... agitated a mind of uncommon sensibility till her feelings preyed upon her life'.[83] In October there was an outbreak of gaol fever in Newgate and two of those in the group, Lord George and Thomas Townley Macan, shown here facing Holland, died.[84] Another watercolour, *Recreation in Newgate*, which does not seem to have been engraved, is recorded.[85] In these works Newton showed his considerable skill as a portrait draughtsman and it is possible that they led to commissions for other portraits at that time.

It was probably because of Mrs Holland's death that, apart from two humorous prints etched by Newton in September and one in November, Holland's business does not seem to have issued any further plates until March 1794. What Newton was doing during this interval is uncertain, and

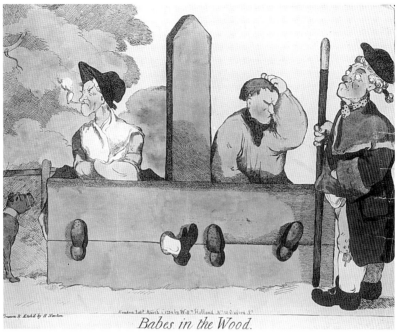

Babes in the Wood.

Figure 19

it has been suggested by Michel Jouve that he was himself imprisoned.[86] There is no reason to believe that this was the case; it does seem, however, that as a visitor Newton caught gaol fever; a letter in the *Oracle* on 5th November, a few days after Gordon's death, from John Frost, the radical lawyer shown in Newton's print, stated that Holland's 'Apprentice was removed with a fever upon him'.[87] This is presumably a reference to Newton, whom Frost may have mistaken for an apprentice because of his youth. How long Newton was ill is unknown, but on the face of it he was not very active at this time; there are only a few prints which he brought out himself while Holland was in prison. On 5 March 1794 he published *Opening the Ambassador's Ball in Paris* (plate 19), which shows a dandified Fox dancing with a cheerful but formidable revolutionary woman; this was issued from a new address, 26 Wallbrook, which was near the Mansion House in the City, and a considerable walk from Oxford Street. Newton was to use this address for another print in July, *A Peep into Brest with a Navel Review*, 1 July 1794, a saucy print of a man ogling two barebreasted beauties, with its pun on the naval blockade of Brest. He published another, *A Dance round the Poles*, on 5 August. Unlike his usual work for Holland, the first two are designs which require no text. Newton does not seem to have published further political prints from this address for nearly a year, though there is one undated print of a parson and a devil, *An Old Grudge* (figure 18). The dialogue is apparently in 'Holland's' hand and with his

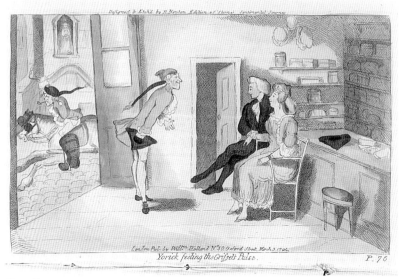

Designed & Etch'd by R. Newton Edition of Sterne's Sentimental Journey

London Pub. by Will:m Holland N.o 50. Oxford Street. March 3 1794.
Yorick feeling the Grifset's Pulse.

P. 76

Figure 20

characteristic cleverness, which would seem to confirm that Newton published with Holland's cooperation:

> Devil: I'd be very glad to know Mr Parson, why you make so very free with my name upon all occasions – In all your discourses you cry out "Take care of the Devil! Avoid the Devil my good People". Damn me, I say take care of the Parson.
> Parson: Hence thou abominable monster! you shan't have a sheep out of my fold till I fleece 'em myself then if they dont like to live with me any longer, why, they may run to you if they like it!

Newton was, as we will see, to be particularly productive on Holland's behalf over the next two and three-quarter years: between spring 1794 and Christmas 1796, he etched over one hundred singly-issued plates (including several three-sheet prints) for Holland, of which only twenty-three, or less than a quarter, are in the British Museum *Catalogue*. Even before Holland came out of prison, Newton must to a large extent have been occupied with commissions from him: in early March 1794 his publisher issued three humorous prints by Newton, including the large *Country Barber's Shop* (plate 21); *Babes in the Wood*, a town-boy's view of country justice (figure 19), and an edition of Sterne's *Sentimental Journey* with plates by Newton.

As has already been mentioned, Holland was a devotee of Sterne. In the late 1780s he had advertised an edition of Sterne's *Tristram Shandy*, 'with 10 fine Mezzotinto Prints', of which no example has been traced.[88] It is possible

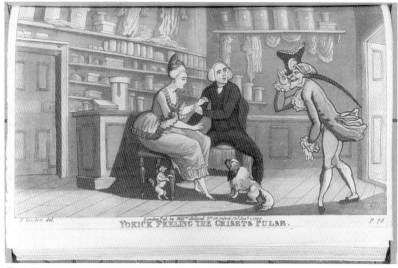

Figure 21

that these may have been related to a set of illustrations which Nixon exhibited at the Royal Academy in 1786.[89] He may have had the idea of an illustrated *Sentimental Journey* while in prison; his edition was published with twelve plates, 'Design'd & Etch'd' by Newton and dated 3 March 1794, which were hand-coloured (figure 20, plate 20). In 1797 he brought out a new edition, with the same illustrations re-engraved with added aquatint, and some of the plates changed (figures 21–22).

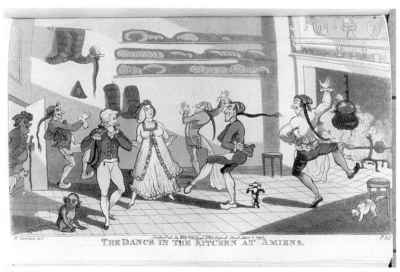

Figure 22

7 The mainstay of Holland's business, 1794–6

Newton's 'Progresses'

Holland was soon very active as a publisher once again, though he seems to have stopped publishing pamphlets completely, and he was careful over political satires: most of Newton's prints for him were henceforth concerned with humorous but harmless topics such as the battle of the sexes, ghosts, old women, the clergy, foreigners and fashion. In April 1794 Holland brought out five prints by Newton, including the *Progress of an Irishman* (plate 22), and *Progress of a Scotsman* (plate 23), which both sold for five shillings, and *A White Serjeant* (plate 24), one of the large format prints with many figures showing scenes of conflict between the sexes. In June appeared the splendid *Evangelical Portraits* (plate 26), another five-shilling print which shows nine clerics having their portraits painted, with the dialogues in Holland's writing. Further 'Progresses' appeared: *A Lesson for Spendthrifts*, 1 August 1794, and The Life of Man. As Ann Friedman pointed out, the style of these 'Progresses', particularly the last, is sympathetic to those who are depicted. Newton, she observed, had an appreciation of the pathos of life.[90] There is none of the absurd exaggeration and sheer funniness, sometimes verging on viciousness, seen in some of the smaller satires.

Newton's watercolour of an exhibition

It was at this point that Newton made his watercolour of an exhibition of humorous prints (figure 1); the most recent print on show appears to be Newton's *Which Way Shall I Turn Me*, showing a parson torn between a woman and a roasting pig, the print of which was published in July 1794. As was emphasised in the opening discussion, the thirty-seven exhibits which are visible are nearly all of the social rather than political subjects published by Holland; as well as the ten by Newton there are a number by Byron or after Woodward which were not etched by Newton, who has positioned some of these on the edge of the arrangement.[91] Eight of those by Newton himself are illustrated here (figures 17, 19; plates 13, 15, 17, 18, 22, 23). One point which was not discussed earlier is that there is in the foreground a smartly dressed youth in riding dress who is generally, but not necessarily correctly, considered to be Newton himself. The drawing is clearly of Holland's exhibition; the prints are certainly all ones which he published, but if the young man is Newton it is unlikely that he would have excluded Holland himself.

Diana Donald has pointed out that the work appears to parody earlier prints showing the exhibitions of the Royal Academy, notably a semi-humorous mezzotint after a drawing by Charles Brandoin.[92] Newton was

never to exhibit, as an ambitious young artist was expected to do, in public exhibitions, but whether this watercolour was a conscious statement drawing attention to a form of 'alternative art' it is difficult to judge; nor is it possible to know whether Newton had intended to engrave the drawing.

Holland's broadsheet catalogue

Holland's full return to business was underscored by the publication, in the autumn of 1794, of a letterpress broadsheet listing his publications, which has recently come to light.[93] This is a most important document, both because it shows what prints he considered it safe to publicise, and because it gives some information which is not to be found on the prints themselves nor in press advertisements for them.

There are 117 prints listed, ranging from a shilling, the price of two old plates by Rowlandson and six by J. P. de Loutherbourg, to a guinea for coloured three-sheet prints, of which four are listed. Twelve prints are named as being after Byron (who is also revealed as the etcher of many of the prints after Woodward), ten after Woodward (plus three sets, a total of thirty-one prints), three after Nixon, and seven after Rowlandson. There are only four by Gillray, and it is possible that he may have recovered his copper plates. Some of the political prints, for example those of the 1784 Westminster Election listed in 1791, were no doubt dropped from the catalogue because they were no longer topical, but the omission of the political prints of the early 1790s, such as those ridiculing the King, must be explained on prudential grounds. One of the most interesting aspects from our point of view is, of course, that in contrast to the 1791 catalogue, which did not mention Newton, he is now given equal prominence with Byron, Nixon and Woodward. There are no less that twenty-four prints listed as being by him; he is known to have been the etcher of six others, to which his name is not attached on this list. One of the guinea prints is by Newton: *A Dance in the Temple of Hymen*, which shows a number of humorous weddings, and which is dated 25 October 1794; this is the most recently dated print listed in the catalogue. Some of Newton's larger prints, such as *The Life of Man*, are not included, and it is clear that the list is a rather haphazard compilation, rather than a comprehensive catalogue of Holland's best stock.

Holland claimed on the broadsheet to have

the largest Collection of old and scarce Caricatures in this Kingdom, which, with those of modern Date, may be arranged in Volumes, so as to form an interesting Display of Wit and Genius, like those he has had the Honour to make up for their Royal Highnesses the Prince of Wales and Duke of York.

He closed the list with a further offer: 'Compleat Collections of the Works of Hogarth, Rowlandson, Bunbury, Byron, Woodward, Newton and Nixon, made up into Volumes, in a few Days after the Order is given'. The prints bought by the Prince of Wales are now in the Library of Congress; it would be interesting to know if he bought Newton's prints in a separate album.[94]

The reference to the exhibition which Holland had held since 1788 was dropped from his prints after August 1795, however it recurred on an isolated print by Newton, *Black Eyed Lovers* in November 1795, suggesting that Holland's exhibition did continue, even if he was advertising it less.

Holland's print *'Destruction'*

After Holland's release from prison his business in satirical prints was to depend almost entirely upon Newton. During 1794 he does not seem to have issued any political prints of the kind which were based on his own ideas, apart from one interesting plate, *Destruction/A Wicked Attorney's Coat of Arms*, 1 December 1794 (figure 23), which is signed 'Design'd by W. Holland'. This burlesque coat-of-arms, flanked with a menacing attorney and gaoler, is a denunciation of wicked attorneys. It reflects the bitterness Holland felt at the effect on his family of his imprisonment, though Newton failed to live up to the spirit of the text in the scenes he drew, which are theatrical rather than moving. These show an attorney visiting a man's family, the man bidding farewell, another man attended by the devil tempting the wife, and finally the husband dying in gaol attended by his children.

> It is not Mr Holland's intention to publish this print to cast a general stigma on a Profession highly respectable & of which his best friend is a most Worthy member. No this true Picture of one of the heaviest calamities of human life, is inscribed to the Inhuman Attornies of Great Britain and Ireland.

Newton etched a few prints based on drawings by other draughtsmen: *National Characteristics* was after Woodward, 6 May 1795; a lively three-sheet print, *Advertisements Illustrated*, June 1794, costing ten shillings and sixpence, and the amusing *Midnight Revels*, 10 June 1795, showing a couple disturbed by cats at night, were both after Nixon. Given Holland's new caution about political prints, the few which he published about events in France could not be construed as having any political message. The only one advertised in the 1794 broadsheet, apart from two humorous scenes in France after Byron, was Newton's *Funeral of Marat*, 25 July 1793, a burlesque which cost two shillings and sixpence. In June 1795 Holland published a printed broadside of the letters of Camille Desmoulins (who had been guillotined in April 1794) to his wife; the letterpress sheet had as a headpiece a romantic print of a wistful young man looking out of his cell, for which Newton's vigorous watercolour has survived.[95]

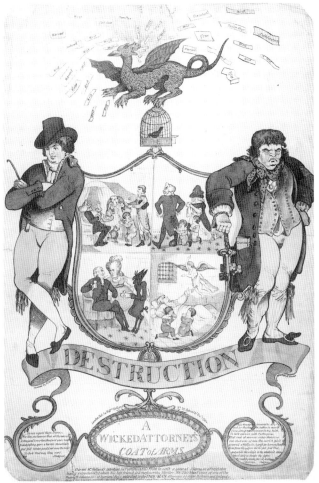

Figure 23

Social satires of 1795–6

Most of the prints which Newton made for Holland between March 1794 and the end of 1796 were relatively simple ones, often with only a couple of figures. Most presumably sold for a couple of shillings, the price, for example, of *A Curtain Lecture*, 29 May 1794 (figure 24), and *On a Journey to a Courtship in Wales*, 16 June 1795 (figure 25), in which Newton has a dig at the Welsh interest in 'pedigree'. The prints included some risqué ones, such as *Too Much of one Thing …* , September 1795 (figure 26). Peter Wagner has written that Newton here

> laughingly hints at the limits of male sexual stamina. The women [in this and the print of Parisot (plate 48)] are attractively painted; but the erotic tension thus created dissolves in laughter and is not developed towards sexual stimulation.[96]

Other prints, such as *Female Gamblers*, 13 May 1796 (plate 40), were inspired by society scandals. This shows two of the society ladies who ran illegal gaming sessions, and it is instructive to compare Newton's depiction with Gillray's (figure 27): Newton makes them into attractive figures.

However there are a number of more ambitious prints: some single compositions with a number of figures, such as *A Scots Concert*, 4 February 1796, which has added aquatint; some larger plates with different groups, such as *Samples of Sweethearts and Wives*, 23 July 1795, signed 'Drawn and etch'd by R.d Newton'. It is doubtful whether Newton became capable of conceiving these large prints without help from others, at least for the dialogue; Holland himself was still full of ideas. Among the prints known to be based on the suggestions of Holland and others is *A Clerical Alphabet*, 22 July 1795 (plate 37); it is signed 'Drawn and Etch'd' by Newton, and has dialogue in 'Holland's' lettering, but carries a 'Note – The idea of this Print originated with Mr W---n, who wrote the 1, 2, 3, 4, 6, 7 and the last two lines – All the rest were written by Mr Holland'. This could perhaps be Robert Wathen, the associate of Lord Barrymore.[97] Other large prints with the dialogue in 'Holland's' hand include *The Princess's Curtsey*, April 1795, with its mixture of grotesque Woodwardian old women and pretty Newtonian girls, and *The Progress of a Lawyer*, 10 July 1795 (figure 28), the last of his 'Progresses'.[98] *A Bachelor's Litany* , 4 November 1795 (plate 39), illustrating an amusing song about the horrors of life with different kinds of wife, is lettered 'Invented and written by Willm Holland'. One must also mention *Dances of Death*, 12 July 1796, an elaborate three-sheet print, which is signed 'Drawn and etched by Richard Newton' and also carries a note, 'the Writing and some of the Ideas by William Holland'. This is one of Newton's liveliest efforts, with the skeletal figure of Death confronting a range of people in thirty groups.

Prints after Newton

In June 1795 Holland published one print, *Warming the Legs*, which shows, as it were, Newton's graduation to a different class of artist. This was probably the first print after a drawing by Newton which was not etched by

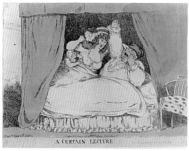

A CURTAIN LECTURE

Figure 24

Figure 25

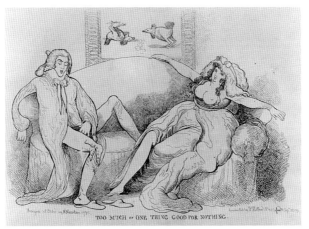

Figure 26

the artist himself. It is signed 'Engraved by Townley', that is Charles Townley, an engraver and artist, who is jokingly referred to on *Evangelical Portraits* (plate 26).[99] The following month a print of *Wild Boars Fighting* signed 'R.Newton delin' appeared in *The Sporting Magazine* with a note in the text that this was the work of 'that ingenious young artist, Newton'.[100] These were straightforward illustrations. The sale of drawings for engraving gave promise of the way forward for the young artist, though either from choice or necessity, Newton was to remain principally a humorous artist.

Newton's return to political satire, 1795–6

Newton's intensive work for Holland, producing an average of one print a week in 1794–6, no doubt explains why he does not seem to have published any prints himself for a year after issuing *A Dance around the Poles* in August 1794. In June 1795, still using the address of 26 Wallbrook, he adapted an earlier design, *A Will o'th' Wisp* (figure 29), to show Fox as an outrageous *Political Will O' the Wisp*, a blast issuing from his posterior. Holland can hardly have objected to this, any more than *Buy my Pretty Guinea Pigs*, 1 July 1795, as dangerous images to publish. The latter, which represents Fox carrying a tray of guinea-pigs on his head, refers to the guinea tax for the use of hair powder; Newton brought it out on 1 July 1795, but it is lettered in a hand that looks like 'Holland's'. Perhaps Newton was chafing to set up on his own, free of Holland's understandable caution. One of the few political prints which Holland published in 1795, *Spectacles for Republicans*, 24 November 1795, shows the extent to which Holland had now ceased to supply prints of a radical nature. This is virtually a royalist print, an exception, George points out, to the prevailing attacks on dearth and oppression.[101] Holland may have been paid to publish it; the print is signed 'Rd Newton fecit', i.e. he simply etched it, and there is no clue to its

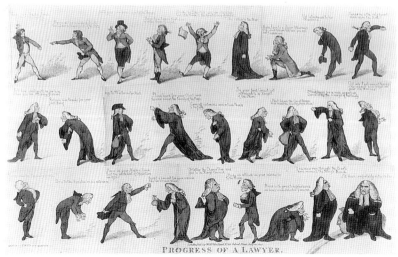

Figure 28 (for caption see p. 138)

authorship. Support for radical ideas among the wealthier classes had of course largely gone by this time, so that there would have been little sale for radical prints. Newton was able to resume political prints to a limited extent in 1796, when he produced a few depicting Pitt for Holland, notably *Billy's Political Plaything* (plate 46), in which he gives Pitt one of the cruellest expressions on any of his prints. Holland published a few others concerned with Pitt's efforts to raise money to conduct the war, such as *William the Conqueror's Triumphal Return!!!*, December 1796. However, Pitt's policies aroused widespread reaction from caricaturists and such comments were not necessarily considered radical.

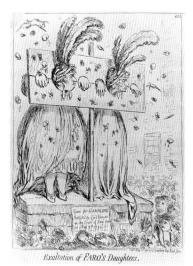

Exaltation of FARO'S Daughters.

Figure 27

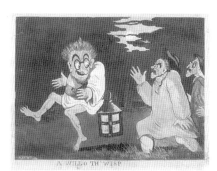

Figure 29

8 Newton as an independent publisher, 1797–8

Newton's 'Original Print Shop'

In early 1797 Newton was able to set up on his own in Brydges Street, in what he variously called his 'Original Print Shop' or 'Warehouse' or his 'Caricature Shop'. The elder Newton had died on 24 August 1796.[102] Newton may then have been able to release himself from his apprenticeship, if there had indeed been any arrangement made between his father and Holland, and he may have inherited some capital. His last print made for Holland as an employee seems to be one of a singer on stage, *The Opera-House Bantum*, dated 23 December 1796. Newton was making more

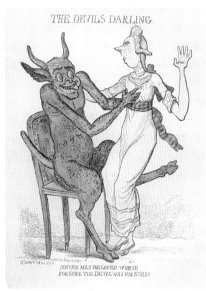

Figure 30

prints of stage personalities: the charms of the young French dancer Mlle Parisot obviously made a great impression on him, and he etched two attractive prints of her in 1796 (plate 48). In January and February he seems to have been inactive. One can only speculate whether he was working as a portraitist or whether he was ill, and perhaps in the country for his health; how much, if at all, did he ever go outside London? It was not until early March that he began to publish his own prints. He then produced them with an almost frenzied speed: in March alone he produced eight prints, including ones attacking Pitt's financial policies (plate 49). Pitt, generally thought of as a sexually cold figure, is shown in

female dress in *The Devil's Darling* of 5 May 1797 (figure 30). Pitt, who is often shown with his Secretary of State, the Scotsman Henry Dundas (1742–1811), became Newton's particular target in 1797, just as the King had been five years earlier. They are both shown extracting money from John Bull in *The*

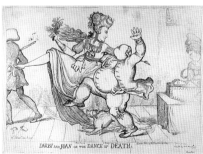

Figure 32

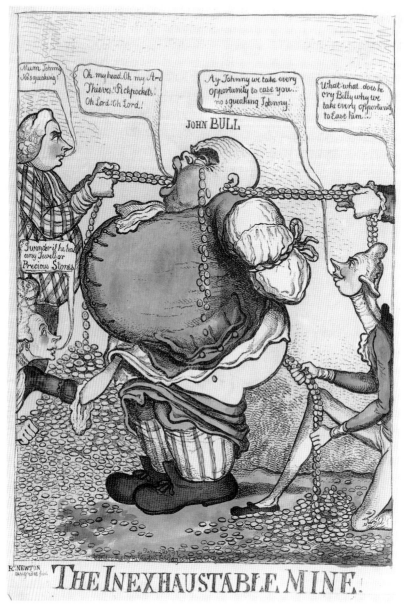

Figure 31

Inexhaustable Mine of 22 June 1797 (figure 31), in which the Queen is shown reaching in an unseemly way under John Bull's shirt.

Newton also made a few prints commenting on the activities of the *Ton* which were attracting publicity from other satirists, such as Lord Derby's long courtship of the actress Elizabeth Farren (?1759–1829), whom he was

50

able to marry after his wife died on 14 March 1797. Gillray was first off the mark with an elaborate print of Farren entitled *Contemplations upon a Coronet* (BM 9074, 25 March 1797); Newton followed a fortnight later with his animated *Darby and Joan* (figure 32).

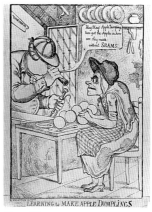

Figure 33

In total Newton published some thirty-five prints over the year between March 1797 and March 1798, as well as making at least a dozen for other publishers. In addition to designing and etching the print, he would have had to get them coloured and to publicise them, all the time running his shop. Despite this he also began to sell more humorous drawings, and several were engraved and published as 'drolls' by Laurie and Whittle in 1796–8. Five satires by Newton were also published by Holland's old rival S. W. Fores; these include one of the arrival of the corpulent Duke of Württemberg to marry the Princess Royal (plate 52) and *Over Weight*, 14 March 1797, which ridicules Lady Buckinghamshire, one of the ladies who had become notorious for their gaming parties. Two are signed as 'design'd' and three as drawn by Newton; these could either have been commissions from Fores, or plates bought from Newton on completion. It does not seem that he had fallen out with Holland, as the latter published at least six plates by his former assistant in May and June 1797, including another three-sheet print, *Cries of London*, May 1797, with twelve figures of public personalities (plate 57), and two of the most splendid of his non-political satires: *Drink to me only with thine Eyes* (plate 55) and *Parsons Drowning Care* (plate 45). From July 1797, however, nearly all Newton's plates were published by himself, which suggests that his business was going well.

The nature of Newton's business

How do the prints Newton published himself compare with his earlier prints? The first point to be made is that, with Holland's cautious influence removed, Newton was able to make political prints more freely. He resumed his personal pillorying of George III, for example in *Head – and Brains*, 5 May 1797 (plate 54), and *Learning to Make Apple Dumplings* (figure 33), 27 November 1797, which is closely based on lines by Peter Pindar about the King watching an old woman at work. He acknowledged his wider debt to Pindar, whom as we have seen he had included in an earlier print as a visitor to Newgate (figure 17), by dedicating one print, *An Atlas!*, 18 January 1798, to him as 'that Prince of Satirists'. The most arresting of these political prints is *Treason!!!* of 19 March 1798 (figure 34), with its offensive treatment of the King. He made further attacks on Pitt and

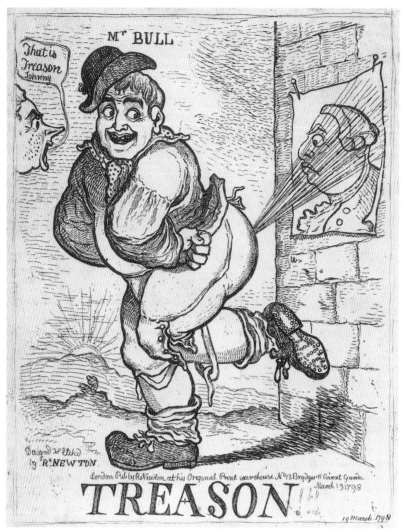

Figure 34

Dundas, such as *The Birth of Billy Bugaboo!*, 13 August 1797. He also
commented on wider issues, such as the increased taxes made necessary by
the war with France, further raised after Pitt's Budget in November 1797
when the Assessed Taxes were tripled. At the begining of 1798 Newton was
able to turn the invasion scare to advantage in *They are Coming or Deliver your
Money*, 16 January 1798. He made more political prints in one year than he
had been able to make in the previous three, following Holland's release
from prison. He was, incidentally, one of the first caricaturists to depict
Napoleon, with such prints as *Buonaparte Establishing French Quarters in Italy*,
9 November 1797 (plate 58), in which he could not resist the temptation to
interpret 'quarters' as 'backside'. Few of the prints of Buonaparte seem to

have been sold; their extreme rarity is shown by the way in which A. M. Broadley, who wrote a study of Napoleonic caricature, was unaware of them.[103] In addition, as *Treason* in particular shows, Newton brought out a number of prints which verge on the obscene; another example is *The Taylor's Revenge on the Parson*, 15 October 1797, with a tailor attacking a parson's groin with his scissors, which is reminiscent of his *Grand Battle at Cambridge* (figure 7). Newton did not

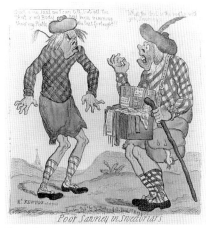

Figure 35

attempt to produce large plates on his own, either as long strips or as the compartmented 'Progress' type. One has to conclude that this kind of composition was beyond his capacities without the help of Holland. The last of these long prints may be *New Year's Gifts* (plate 59). However, he grew more confident with his facial depictions, and some of his faces, for example those in *Poor Sawney in Sweetbriars*, May 1797, which shows Sawney suffering from the 'runs' talking to a fellow-Scots pedlar (figure 35), are distorted in a remarkable way; similarly there is nothing in earlier caricature like the goggle eyes seen in many of his later prints (e.g. plate 55). Finally he made more studies of single figures, notably of stage personalities. He was, as we have seen with his studies of Mlle Parisot, capable of producing very attractive portrait studies. His shop, as he pointed out on one print, was 'opposite the Pit Door, Drury Lane Playhouse' and several of his prints depicted actors. *Consistancy or Rival Clowns!!* (plate 60), which is remarkable for its large scale, is an excellent example . One of his last prints was a study of the eccentric *John Cussans as Jerry Sneak* (plate 61), which in the mildness of its caricature is similar in some ways to the full-length caricatures which Robert Dighton (1715?–1814) had begun to make in 1794.[104]

Holland as a portrait painter

We know that Newton was not content merely to go on as a satirical etcher and publisher: he wanted also to establish himself as a portrait painter or miniaturist. So little of this work has survived that he is not included in any reference books as a portraitist. Some time after the end of February 1798 he wrote an advertisement on the back of an unsold copy of one of his satires to put in his shop window (figure 36):

> R.Newton/ takes warranted/ strong likeneses[s]/ for half a guinea/in miniature on ivory/ [f]or a locket or framing/ Specimens, to be/seen within. [105]

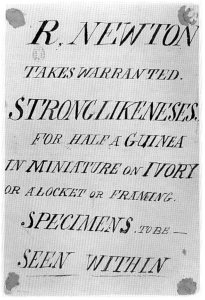

R. NEWTON

TAKES WARRANTED.

STRONG LIKENESES.

FOR HALF A GUINEA

IN MINIATURE ON IVORY

OR A LOCKET OR FRAMING.

SPECIMENS TO BE —

SEEN WITHIN

Figure 36

How far did he get with this ambition? Putting a sign in his window would not seem to be the most obvious way to attract the best custom. As we have seen, he did not exhibit at the Academy, which would have been a better shop window.

Was Newton ever tempted to try and follow the conventional route to recognition, or did he perhaps despise the toadying to patrons and senior artists which was inevitably involved? We can only guess what he felt about the Academy; on the other hand it seems that contempt for the silhouette artist A. Charles, who implied fraudently in his advertisements that he was associated with the Academy, was behind his satire of *Mr C--- the Puffing Painter ... a Royal Academean by his own appointment*, 8 August 1797. Newton's self-portrait (plate 51) must date from this time, as it shows him holding the print of *Mr Follett the Clown* being watched by the King, which he published in April 1797 (plate 50). He could hardly have expected to be welcome at the Academy without giving up his disrespectful depictions of the Academy's founder and protector.

Newton was not able to pursue this activity for very long. He probably fell ill in the spring of 1798, as the last print he published himself, that of Cussans, was on 5 April 1798. A few other plates were published during the course of the year by Holland, possibly because Newton was not in a position to sell them himself, and he died on 8 December of that year.[106] One of the last designs, *The Male Carriage*, 17 September 1798 (plate 62), which has an outrageous text in 'Holland's' hand, shows no falling-off in Newton's powers. Holland later published an illustrated edition of Fielding's *Tom Jones* with twenty plates by Newton dated 1 January 1799, and a few posthumous prints which may be after Newton's drawings. The notices of his death, in which he is described as 'caricaturist and miniature-painter', are very short; he may have had no family prepared to pay for the insertion of obituaries. Such notices as have been found do not include the cause of his death. It is tempting, in view of the frenetic nature of his production, to wonder whether he suffered from tuberculosis, but this is no more than conjecture.

9 Newton's posthumous reputation

On his death Newton's shop was taken over by members of the Hixon family of plate printers and engravers. William Hixon was living in Brydges Street by 1788, where he was to die in 1802.[107] His son Robert (1766–1813 or after) was at 13 Brydges Street by 1794, when he published a fan from this address. It is possible that the Hixons were tenants of Newton's father. Perhaps they printed Newton's plates for him. One watercolour, *After Mass* (plate 63), is on the back of a proof of a sporting print which may be one discarded by the Hixons. Robert's brothers William and John published satires from the house in 1800. Whether they acquired Newton's own plates is unclear, but if they did reissue them, it was not in a very effective way. Some of Newton's images were published by Thomas Tegg, who began to publish inexpensive satires in 1803, and employed Rowlandson to etch at least six of Newton's drawings, including *Launching a Frigate*, 1809 (figure 37). Holland went on selling the plates by Newton in his possession, and the prints continued to be bought by collectors. What happened to Newton's plates after Holland's death in 1816 has not been discovered, but they may well have been considered worthless and could have been sold as scrap copper. Newton had not been as well known during his lifetime as Gillray, Woodward and Rowlandson, largely because his prints, like those of Byron, seem to have had such a restricted circulation. Certainly Newton did not continue to be known in the way that Gillray did; Gillray's plates were reissued in large volumes after his death, with the more risqué prints excluded and separately published. The value of Gillray's prints as historical documents was understood, and various commentaries were published to explain the plates.[108] In contrast, few of Newton's prints seemed to have lasting political interest, though one of the best holdings, that of the Bibliothèque Nationale in Paris, was made by a collector primarily interested in the French Revolution.[109] Newton's plates were hardly considered in Thomas Wright's widely-read *Caricature History of the Georges*.[110] Furthermore, the bawdy nature of many of the prints meant that his work met with hostility in Victorian times: in his *Dictionary of Artists* published in 1878, Samuel Redgrave dismissed him as giving 'promise of ability, but his works were chiefly convivial and licentious'. Indeed, some of the first books in which Newton's work was reproduced were those on erotic art written by Eduard Fuchs.[111] Some of his prints were illustrated by Paston in 1905, but it was an exhibition in London and an associated book by Francis Klingender in 1944 which first drew public attention to the enormous comic vitality of Newton's work.[112] The British Museum almost doubled its collection of Newton's prints when it acquired a large holding of satires from Dr Klingender in 1948, too late to have been included in Dorothy George's classic catalogues of the Museum's collection.

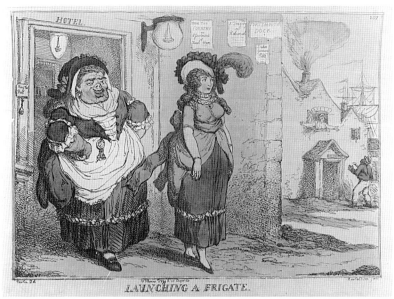

Figure 37

The selection of Newton's prints here can only show about a quarter of the three hundred prints he produced. It is an astonishing output for one so young. The bicentenary of his death in 1798 is a fitting time to enable a wider public to enjoy the work of a fascinating artist who has been described by Draper Hill, the authority on Gillray and himself a distinguished professional cartoonist, as 'an extraordinarily original and "modern" humorist'.[113] There is much that is memorable and striking in his prints: the liveliness of his figures, so often pictured in movement, his wonderfully exaggerated expressions, his delight in the contrasts between youth and age and the battle of the sexes, and above all, the ability to make us laugh despite the passage of two centuries.

Notes

1 D. M. George, *Catalogue of Political and Personal Satires ... in the British Museum* (London, Trustees of the British Museum), vol. vii., 1942, p. xliv. The fifty-eight prints by or attributed to Newton which were in the British Museum by the late 1930s were catalogued by George in vol. vi, 1938 (George 1938), covering 1784–92 (BM 6361-8283), and vol. vii, 1942 (George 1942), covering 1793–1800 (BM 8284-9692). Many of the prints which she catalogued are illustrated in her *Hogarth to Cruikshank: Social Change in Graphic Satire* (London, Allen Lane, 1967).

2 David Kunzle, *History of the Comic Strip, Vol. 1, The Early Comic Strip* (Berkeley and London, University of California Press, 1973) contains valuable discussions of six of Newton's narrative prints; he did not know about *The Progress of a Lawyer* (figure 28), and *The Progress of An Author* (no copy located).

3 D. Donald, ' "Calumny and Caricatura": Eighteenth-century Political Prints and the Case of George Townshend', *Art History*, 6: 1(1983), 44–66.

4 For example BM 3758, June 1774, ill. D. Donald, ' "Characters and Caricature": The satirical view ', in N. Penny (ed.) *Reynolds*, exhibition catalogue (London, Royal Academy, 1986), p. 366. There are many other views of print-shop windows, which were a feature of the London street scene.

5 Joyce Hemlow, *The History of Fanny Burney* (Oxford, Clarendon Press, 1958), p. 126. Lady Mary, daughter of the seventh Earl of Thanet, had been widowed in 1774.

6 For Bunbury see *Henry William Bunbury*, exhibition catalogue by John Riely (Sudbury, Gainsborough's House Society, 1983).

7 BM 4764, ill. Richard Godfrey, *English Caricature 1620 to the Present*, exhibition catalogue (London, Victoria and Albert Museum, 1984), plate 68.

8 *The Long Minuet*, June 1787 (BM 7729) and *The Propagation of a Lie*, 29 Dec. 1787 (BM 7230), are both ill. Kunzle (1973: 360–1).

9 *World*, 1 Feb. 1788, p. 3 c .3.

10 Kunzle (1973: 455, note to 12–7).

11 See Henry Angelo, *Reminiscences* [1830], Lord H. de Walden (ed.) (London, 1904). The social background and the mixture of literary and visual satire which it provoked is amusingly covered in John Wardroper, *Kings, Lords and Wicked Libellers: Satire and Protest 1760–1837* (London, John Murray, 1973).

12 *Memoirs of William Hickey*, A. Spencer (ed.) (London, Hurst & Blackett, 4 vols , 1913–25); there is a single-volume selection, Peter Quennell (ed.) (London, Hutchinson, 1960).

13 Donald Thomas, *A Long Time Burning: The History of Literary Censorship in England* (London, Routledge, 1969), p. 113.

14 For Gillray see the works by Draper Hill listed in the Select Bibliography; for Rowlandson see John Hayes, *The Art of Thomas Rowlandson*, exhibition catalogue (Art Services International, Alexandria, Va., 1990), with bibliography; for his prints see Joseph Grego, *Rowlandson the Caricaturist*, 2 vols (London, 1880).

15 For Sayers see *DNB* and discussions of his work in Nicholas K. Robinson, *Edmund Burke: A Life in Caricature* (New Haven and London, Yale University Press, 1996), and in D. Donald, *The Age of Caricature: Satirical Prints in the Reign of George III* (New Haven and London, Yale University Press, 1996), pp. 62–6.

16 Newton's birth date is inferred from press reports stating that he was only twenty-one at his death; details of his birth have not been found, but – assuming he was not baptised at birth – he could be Richard, son of Richard, baptised in St Paul's Covent Garden on 19 May 1779. 'Richard Newton Brydges Street Haberdasher' voted for Fox in 1784 (*Westminster Poll Book*, 1784, Guildhall Library, MS 6484). It was David Arkell who noticed that on a site map of Drury Lane Theatre in 1778 reproduced in the *Survey of London*, 35 (London, 1970), plate 7, his name is on two properties at the corner of Brydges and Russell Streets; Mr Arkell further deduced from the Westminster rate books that he did not take over the properties until Lady Day (25 March) 1781, and that he acquired a third house by 1789 (information conveyed by Simon Turner).

17 John Gay, *Trivia*, quoted M. D. George, *London Life in the Eighteenth Century* (London, Kegan Paul, 1925; reissued, Harmondsworth, Penguin, 1965), p. 93. For an account of life in the area see E. J. Burford, *Wits, Wenchers and Wantons: London's Low Life: Covent Garden in the Eighteenth Century* (London, Hale, 1986).

18 Jonathan Bate, 'Shakespearian Allusion in English Caricature in the Age of Gillray', *Journal of the Warburg and Courtauld Institutes*, 49 (1976).

19 *Poll Book for St Paul Covent Garden*, p. 46, 31 July 1788 (Greater London Record Office WR/PP 1788/4; microfilm X71/103).

20 That Newton's houses were demolished was discovered by David Arkell.

21 For example *The Newmarket Humane Society*, published by Holland, Sept. 1788 (BM 1948-2-14-984) is inscribed 'Design'd by Paddy Whack'. For William Langford Holland, last heard of in Kilkenny in 1787, see W. G. Strickland, *A Dictionary of Irish Artists* (Shannon, Irish University Press [1913], 1968), i, pp. 497–8.

22 For Combe see Harlan Hamilton, *Doctor Syntax* (Cambridge, Mass, MIT Press, 1989); Combe began his *R[oya]l Register* in January 1778.

23 For a discussion of the *Rolliad* see O. Elton, *A Survey of English Literature 1780–1830* (London, Arnold, 1933), i, pp. 31–3.

24 For Wolcot see Grzegorz Sinko, *John Wolcot and His School* (Warsaw, Prace Wrocławskiego Towarzystwa Nankowego, A, 79, 1962); T. Girtin, *Doctor with Two Aunts* (London, Hutchinson, 1959), is a lively but unreferenced biography.

25 This satire, BM 6328, ill. George (1967: figure 121), may well not be the first which Holland published, but others such as *The Rival Queens of Covent Garden and Drury Lane*, BM 6126; George (1967: figure 99), which George assigned to ?Oct. – Nov. 1782, are undated. *The Festival of Wit* was published in 1782 by 'M. A. Holland', whose relationship to William Holland is uncertain. Holland continued to sell the work, which was subsequently re-published by 'M. Smith'. See my article on William Holland as a publisher of pamphlets, *Book Collector*, forthcoming.

26 Holland and Peacock advertised their 'Print and Literary Museum' in about 1786 (undated press cutting, Victoria and Albert Museum, PP 17 G, vol. I, p. 300). *Female Flagellants*, published first in 1777, and six other similar publications were reprinted without plates as *The Library Illustrative of Social Progress* (London, J. C. Hotten, 1872) (BL: P.C 31.e.18). *The Sale of English Beauties* (BM 7014) is discussed by Peter Wagner, *Eros Revived: Erotica of the Enlightenment in England and America* (London, [Secker & Warburg, 1988], Paladin, 1990) pp. 1–2, figure 1: Wagner did not appreciate that Holland was involved in the sale of these works.

27 For Carey see *DNB*.

28 Holland wrote a poem in pencil on Sterne's London tombstone which later appeared in a periodical; I am grateful to Kenneth Monkman for telling me this.

29 Holland's death, aged 58, is mentioned in the *New Monthly Magazine*, 4 (Aug. 1815); the obituary from which this quotation is taken appeared first in the *Monthly Magazine*, 40 (1 Sept. 1815), 180, and was reprinted verbatim in the *Gentleman's Magazine*, 85 (Oct. 1815), 380, quoted George (1959: 175, as '1816').

30 BM 6888; for Cruikshank see Edward B. Krumbhaar, *Isaac Cruikshank: A Catalogue Raisonné with a Sketch of his Life and Work* (Philadelphia, 1966); there is information on Isaac in the masterly biography of his son: Robert L. Patten, *George Cruikshank's Life, Times, and Art*, vol. i; 1792–1835 (London, Lutterworth Press, 1992).

31 BM 6932; D. Hill, *Fashionable Contrasts* (London, Phaidon, 1966), plate 54.

32 Advertising in the London newspapers was the usual practice for the larger printsellers and for artists publishing prints after their own works, but it could be expensive for a small publisher. Advertisements generally cost between four and six shillings for eighteen lines, plus three shillings tax: see L. Werkmeister, *A Newspaper History of England 1792–1793* (Lincoln, University of Nebraska Press, 1867), p. 20.

33 *Morning Chronicle*, April 1786.

34 D. Hill, *The Satirical Etchings of James Gillray* (New York, Dover; London, Constable), 1976, p. xx, notes that although he signed stipple engravings from 1781 he did not sign satires until 1789, and then not on on regular basis until 1792, 'when he had all but abandoned his "serious" aspirations'.

35 An advertisement in the *Morning Chronicle*, 30 Nov. 1786, shows that Holland was still in Drury Lane. The rate books reveal that Holland took over 50 Oxford Street in early 1788, paying his first rates on 1 May 1788; the rent was raised from £52 p.a. under the previous tenant, Elizabeth Richie, to £100, and reduced to £94 in 1789 (*Rate Books*, Westminster City Archives). The elevation of 50 Oxford Street, a four-storied building with a central door between two shop windows is shown on *John Tallis's London Street Views 1838–40*, Peter Jackson (ed.) (London, London Topographical Society, 1968), p. 105.

36 For a song-sheet published by Holland and with a headpiece by Newton showing Morris amid the rooftops of London, see *Country and Town*, 17 Oct. 1796. For Morris see Richard Dexter, *Captain Charles Morris* (Cleveland, Rowfant Club, 1923).

37 There were so few prints signed by Pettit that it is likely that he was an employee; most of those which he did sign were for Holland.

38 *Harley and Old Edwards, with the School Mistress and Grand-children at the Grave of Young Edwards*, 1 May 1787; there is an impression in the BM. Holland published two other mezzotints after Morland, both engraved by William Ward: *Tom Jones's First Interview with Molly Seagrim*, 1 Nov. 1786, which sold for three shillings, and *Sportsman's Hall*, 1 Dec. 1788.

39 An article in one newspaper declared that 'the venders of indecent representations ... are passed by unnoticed, and left to accumulate fortunes ... Surely if the venal justice of the peace finds it convenient to look over these enormities, the clergymen of the district are in duty bound to exert themselves ... we recommend to their notice, Lombard-street in Fleet Street, and Oxford Street' (*Argus*, 1 Dec. 1789, p. 3, c. 3.).

40 Holland's disclaimer appears in *Jordan's Elixir of Life* (Holland, 1789), p. 8; that he was involved in the trade in pornographic prints is suggested by lettering in 'Holland's' hand on *Old Drybones drenching a Flame* (BM 1977-U-471). The name of 'Alderman Drybones' appears on one of the satirical price lists supposedly compiled by Charlotte Hayes included in *Nocturnal Revels*, 1779, quoted by Fernando Henriques, *Prostitution in Europe and the New World (Prostitution and Society*, vol. II), (London, McGibbon & Kee, 1963), p. 147.

41 BM 7439; Kunzle (1973: no. 12–8, ill. pp. 362–3).

42 Byron, younger son of Admiral the Hon. John Byron and uncle Lord Byron, the poet (the son of his elder brother), began to design satires in 1785.

43 *English Slavery*, April 1788 (BM 7301); *Meeting an old Friend* ..., ill. Donald (1996: 96).

44 Quoted George (1938: xi, fn).

45 *Morning Post*, 23 Jan. 1789, quoted by George, and by Donald (1996: 208, fn. 78). There are other prints signed 'HW' which may have been based on Wigstead's ideas, but unfortunately George confusingly attributes some prints to 'H.W.', which are more likely to be by Byron or after Holland himself.

46 Mrs Humphrey was in Bond Street, moving to St. James's Street in 1797. Gillray received £20 in 1788, 'Charles Stuart's Account with the Treasury', see A. Aspinall, *Politics and the Press, c.1780–1850* (London, Home & Van Thal, 1949), p. 421.

47 Many of the satires at the Yale Centre for British Art came from a German princely collection.

48 The extent of Byron's *oeuvre* was first suggested by Philippe Bordes in an article 'De la satire sociale à la charge contre Burke: La Cour d'Auberge à Calais (1790) de F. G. Byron', *La Revue du Louvre et des Musées de France*, 4 (1992), 57–64; in this he acknowledges his debt to Edmunds. Six of the satires and a drawing attributed to Byron are illustrated in Robinson (1996: plates 147–51, 164, 165, 167).

49 Some of the faces in the French scenes drawn by Byron on his trip in 1790 and published as large aquatints by Holland in 1802 are very similar to ones by Newton.

50 For Nixon see Frank S. Brown, *A Georgian Comedy of Manners: Humorous Watercolours ... by John Nixon,* exhibition catalogue (Bath, Holborne Museum, 1994).

51 BM 7544, ill. George (1967: figure 127); 'Holland's' looped script is noticeable.

52 There is a copy of this in the Library of Congress attributed to Newton (and another in the British Museum, 1948-2-14-363); I am grateful to Simon Turner for pointing out that there exists an impression of the print with a contemporary inscription identifying Nixon's brother Richard as the designer.

53 For the blackmailing practices of the press see Werkmeister (1967: *passim*).

54 Entry on Woodward in *DNB* by F. M. O'Donoghue.

55 George (1942: xlv).

56 Most apprenticeships were recorded when Stamp Duty was paid on the indentures; the ledgers in the Public Record Office do not record Newton's apprenticeship, nor any other apprentices taken on by Holland. Stamp duty on indentures was occasionally evaded and some apprenticeships were organised without them, so the records are not complete. For the conditions of apprenticeship see George (1925).

57 The unsigned *Prelude to Crim Con and the Finale!*, 6 June 1792 (BM 8385), was attributed to Newton by George but is listed as 'by Woodward' in Holland's 1794 catalogue.

58 Although several albums of prints after Bunbury have been dispersed in recent years a number still remain in country houses; some were assembled by purchasers as the prints were issued, and others made up by dealers. No albums of Newton's prints have been discovered; unlike albums of Bunbury's, they would not have been suitable for 'family viewing' and few may have been put together.

59 The print was attributed by George to [?H.W.]; it is discussed in D. Bindman, *The Shadow of the Guillotine*, exhibition catalogue (British Museum, London, 1989), no. 51, ill. p. 89.

60 BM 1989-9-30.

61 I am grateful to Andrew Edmunds for pointing out to me that this print (BM 1948 2 14 971) and its pendant (BM 7632) are more likely to be by Byron than Holland.

62 See Robinson (1996), plates 150, 151; *Frontispiece to Reflections* ... (BM 7675) is in the centre, and part of *The knight of the Woful Countenance* (BM 7679) is on the extreme right of Newton's drawing of Holland's exhibition (figure 1).

63 An impression of this print, which shows the reaction of six prominent people to Paine's pamphlet, was illustrated in Bindman (1989: 108) as 'Anon'; the print is attributed to Byron in Robinson (1996) and the figure of Burke shown as plate 167.

64 I am grateful to Kenneth Monkman for showing me the copy of this work in his possession. The print of the *French Federation*, advertised for the enormous price of two guineas plain and five coloured, does not seem to have come out; the drawing is in the Musée Carnavalet.

65 Byron's death was recorded in the *Gentleman's Magazine*, 62 (Feb. 1792), 184: 'At Bristol Hotwells, whither he went for the recoevery of his health', but the exact date was not given.

66 At this time 50 Great Portland Street was occupied by John Wilson (*Rate Books*, Westminster City Archives).

67 The print, entitled *Fashionable Contrasts*, 24 Jan. 1792 (BM 8058) gave D. Hill the title for a book showing a selection of Gillray's prints: Hill (1966).

68 Entry by George under BM 9308.

69 For the encounter between Farmer and Musgrave see Arthur Sherbo, *Richard Farmer* (Newark, University of Delaware Press, 1992), 50–4. The authorship of the poem is ascribed on the title page of the copy shown here to the classical scholar John Tweddell (1769-99), who disliked Farmer.

70 For a fuller discussion of Newton's political prints of 1792 see the account in S. Turner (1996), 'English Graphic Satire in the 1790s: The Case of Richard Newton', MA dissertation (History of Art Dept., University College, London, 1996), pp. 2–15. The extent to which these have been overlooked is shown by the omission of any mention of Newton in Vincent Carretta, *George III and the Satirists from Hogarth to Byron* (Athens, Ga., University of Georgia Press, 1989); he reproduces the unsigned *Louis Dethron'd* as figure 127.

71 BM 8031; Kunzle (1973: no. 12-9, ill. p. 363).

72 BM 8090; Kunzle (1973: no. 12-11, ill. p. 365); for Merry see *DNB*, Werkmeister (1967), *passim*, and Marcus Wood, *Radical Satire and Print Culture, 1790–1822* (Oxford, Clarendon Press, 1994).

73 BM 8104; Kunzle (1973: no. 12-10, ill. p. 364).

74 When John Wolcot discovered the artistic talent of the fifteen-year-old Cornishman John Opie, then employed as a sawyer, one of the pictures which Opie had painted was, according to Wolcot, 'a portrait of the devil sketched out in strict conformity to vulgar tradition being provided with a monstrous pair of horns, two goggle eyes and a long tail', quoted T. Girtin, *Doctor With Two Aunts* (London, Hutchinson, 1959), p. 66.

75 For Hassell, who became known as an author and topographical artist, see *DNB*.

76 For example, *The Combustible Breeches* (plate 4).

77 Donald (1996: 147).

78 Holland does not seem to have been a member of the London Corresponding Society and is not mentioned in M. Thale (ed.), *Selections from the Papers of the London Corresponding Society 1792–1799* (Cambridge, Cambridge University Press, 1983).

79 Werkmeister (1967: 152). For further details about Ridgway and some of the other radicals see Joseph O. Baylen and Norbert J. Gossman, *Biographical Dictionary of Modern British Radicals, vol i, 1770–1830* (Hassocks, Sussex, Harvester Press and Atlantic Highlands, NJ, Humanities Press, 1979).

80 'Justitia', *Justice to a Judge* (London, J. Ridgway, 1793), 13–14; this is printed in Gregory Claeys (ed.), *Political Writings of the 1790s*, iv (London, Wm Pickering, 1995), 1–11, where the author is identified as William Cecil Hughes (1767–1852).

81 *St James's Chronicle*, 23–25 Feb. 1793, p. 4, c. 4; C. H. Timperley, *A Dictionary of Printers and Printing* (London, 1839), ii, 777.

82 Werkmeister (1967: 279). According to J. Wardroper, *Kings, Lords and Wicked Libellers* (London, John Murray, 1973), p. 159, the charge stated that this pamphlet was illustrated with 'a scandalous infamous libellous and defamatory etching' showing a youth in fetters and a jailer with a whip. This is presumably by Newton. Turner has further examined the indictment in the Public Record Office, which reveals that the pamphlet, of which no copy has been traced, had been published in October 1792; see Turner (1996: Appendix C). It seems likely that this charge was dismissed since Holland's publishing activity resumed at the end of his initial year's sentence.

83 *Gentleman's Magazine*, 63 (1793), 773.

84 Werkmeister (1967:435–6).

85 This watercolour, which apparently shows Holland playing the game of fives, is reproduced in Percy Colson, *The Strange History of Lord George Gordon* (London, 1937), 160, when it was in the collection of Cecil Roth. Among the figures included are those of Ridgway and Gordon, pictured in identical stances to those in the *Promenade*. I am grateful to Simon Turner for drawing this to my attention.

86 Michel Jouve, *L'Age d'or de la caricature anglaise* (Paris, Presses de la fondation nationale des sciences politiques, 1983), p. 32.

87 Werkmeister (1967: 439).

88 Listed in *Edwin's Pills* (Holland: 1788), 'Catalogue' [p.1]; no price is given and the publication is not listed in *Jordan's Elixir*, 1789, so it is possible that the set may not have appeared.

89 D. McKitterick, 'Tristram Shandy in the Royal Academy: A Group of Drawings by John Nixon', *The Shandean*, 4 (1992), 85–110.

90 Ann Marti Friedman, 'Aspects of English Caricature of the 1790s', MA Report (Courtauld Institute, University of London, 1974)

91 For a fuller discussion, see my paper 'Newton's Watercolour of Holland's Exhibition Room', conference on 'The Print in Eighteenth-century Britain', The Whitworth Art Gallery, The University of Manchester, March 1998.

92 D. Donald ' "Characters and Caricatures" ', in N. Penny (ed.), *Reynolds*, exhibition catalogue (London, Royal Academy, 1986), p. 371; see also the discussion of the watercolour in Donald (1996: 8–9, where it is ill. in colour).

93 A copy of this document, discovered by John Wardroper in the Engestrom Collection, Kungl. Biblioteket (Royal Library), Stockholm, is reproduced in Turner (1996: between 13 and 14); see further discussion by S. Turner, *Print Quarterly*, forthcoming.

94 The royal collection of nearly 10,000 English caricatures, mostly bought by George, Prince of Wales, was, with the exception of prints by Hogarth and Rowlandson, sold to the Library of Congress in 1920; see Godfrey (1984); Godfrey drew mainly on the collection for his 1984 exhibition. There is a list of some 2,000 prints in the Library of Congress which are not in the BM Catalogue of Satires (see Checklist); the fact that prints are not in the Catalogue does not of course mean that they have not subsequently been acquired by the BM.

95 The drawing is now in the British Museum; see Bindman (1989, no. 151a, ill. in colour between 48 and 49); the print based on it is Bindman (1989, no. 151b).

96 Wagner (1990: 289).

97 Captain Robert Wathen was a wit and a keen amateur actor, appearing in Lord Barrymore's theatricals; see Sybil Rosenfeld, *Temples of Thespis* (London, Society for Theatre Research, 1978).

98 D. Hill, 'The Princess's Curtsey by Richard Newton', *Eighteenth Century Life*, vii, no. 3 (May 1982), 48–53.

99 For Townley, who was of a higher social status than most engravers and was related to the great connoisseur of the same name, see *DNB* and *Dictionary of British and Irish Travellers in Italy 1701–1800*, compiled by J. Ingamells from the Brinsley Ford Archive (London and New Haven, Yale University Press, 1997), p. 948.

100 The plate engraved by Cook and signed 'R.Newton delin' is in the *Sporting Magazine*, 6 (July 1795), 217; another print, *Dexterity of the Hottentot*, is signed 'Newton delin' 'Scott sculpt', 7 (Oct. 1795), 47. I owe my knowledge of these prints and their provenance to Kenneth Monkman.

101 See the entry for BM 8695.

102 Richard Newton, aged 44, died on 24 August 1796 and was buried on 25 (*Registers of St Paul's Covent Garden*: v, Burials 1752–1853, *Harleian Society*, xxxvii (1909), 183).

103 A. M. Broadley, *Napoleon in Caricature 1795–1821* (London and New York, 2 vols., 1911); this has an alphabetical list of nearly 1,000 English satires, including over 100 published by Holland.

104 H. M. Hake, 'Dighton Caricatures', *Print Collector's Quarterly*, 13 (April 1926) 137–55.

105 This is on the verso of an impression of *"Sola" Virtus Invicta*, 26 February 1798 in the British Museum (1868-6-8-6703)

106 Newton's death on the morning of Saturday 8 December aged 21 was briefly recorded in various newspapers, e.g. *Oracle*, 14 Dec. 1798, p. 3 c. 3; and in the *Gentleman's Magazine* (Dec. 1798), 1089, quoted by Donald (1996: 205, fn. 7). Newton was buried on 14 December, *Registers of St Paul's Covent Garden* (1909).

107 'William Hixon, Brydges St Printer' voted for Townshend, in 1788, *Poll Book for St Paul Covent Garden*, 1788, p. 14. He is recorded as paying Poor Rate from Bridges St from 1789/90 to 91/2 (*St Paul Covent Garden*, Poor Rate Books, microfilm in Westminster Public Library, Local Studies).

108 e.g. Thomas Wright and R. H. Evans, *Historical ... Account of the Caricatures of James Gillray* (London, 1851).

109 The collector was Mons. Latterade, fl. *c.* 1840–60; these are stamped 'Lat', Lugt 1713: see Frits Lugt, *Les Marques de Collections* (Amsterdam, Vereenigde Drukkerijen, 1921), 309–10.

110 Thomas Wright, *Caricature History of the Georges* ([1868], new edn London, Chatto & Windus, 1904). Wright based his account of the 1790s primarily on Gillray; he mentions a few satires by Newton, e.g. *Making Apple Dumplings*, Nov. 1797, quoting at length (pp. 464–5) the passage from Peter Pindar on which it is based, but does not mention the artist's name.

111 Fuchs was a prolific writer on erotic art; the bibliography of his publications is confusing and as they are not readily available no attempt is made to list them here; Wagner (1990) reproduced a number of Fuchs's plates and lists his principal works, pp. xiii–xiv.

112 F. D. Klingender (ed.), *Hogarth and English Caricature* (London, Pilot Press, 1944), which followed from an exhibition in London in 1943.

113 Hill 1976, p. xxx, n. 44.

Colour plates

1

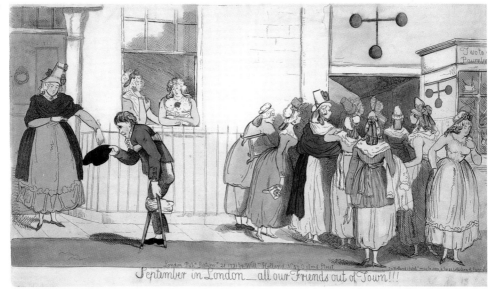

September in London — all our Friends out of Town!!!

2

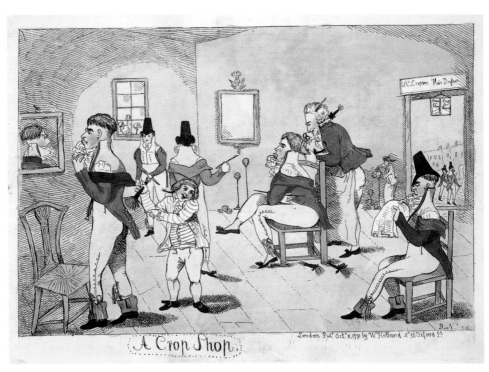

A Crop Shop.

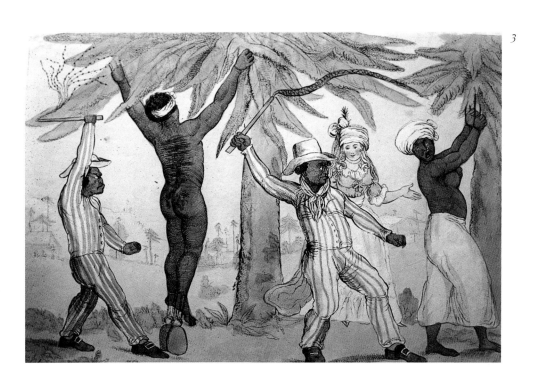

4

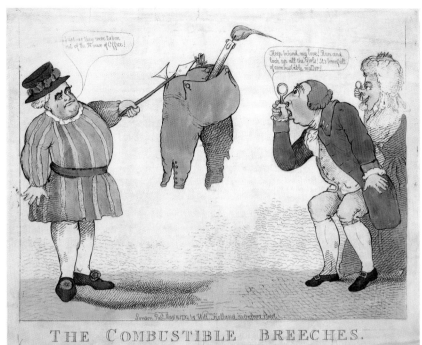

THE COMBUSTIBLE BREECHES.

5

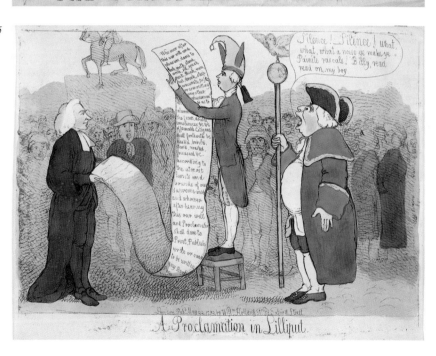

A Proclamation in Lilliput.

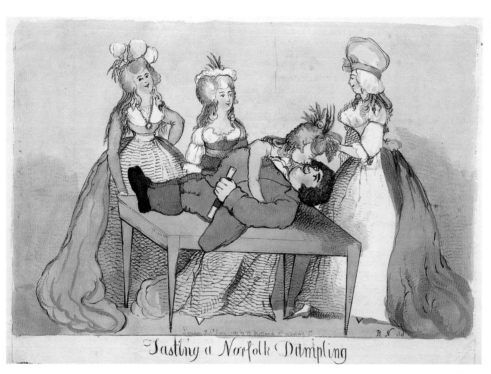

Tasting a Norfolk Dumpling

A BUGABOO !!!

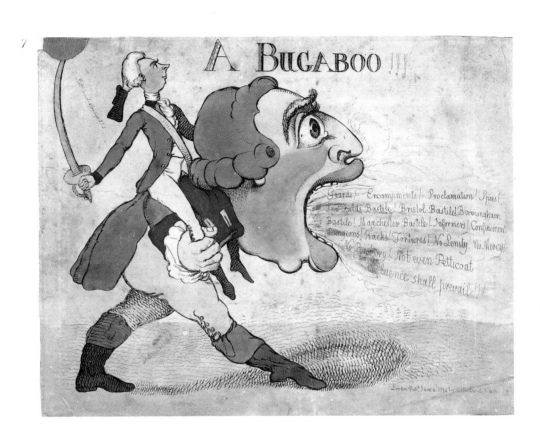

Guards! Encampments! Proclamation! Spies!
Iso' Fields Bastile! Bristol Bastile! Birmingham
Bastile! Manchester Bastile! Informers! Confinement
Dungeons! Racks! Tortures! No Lenity! No Mercy!
No Oratory! Not even Petticoat
Inence shall prevail!!!

London Pub.d June 2 1792 by S.W. Fores N.3 Piccadilly

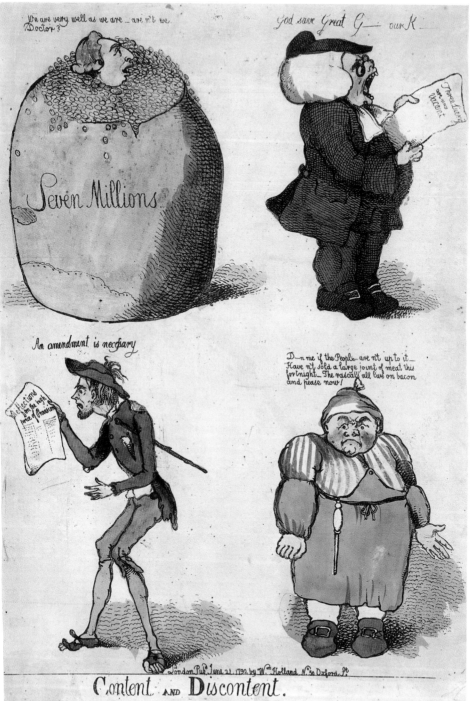

Content AND Discontent.

9

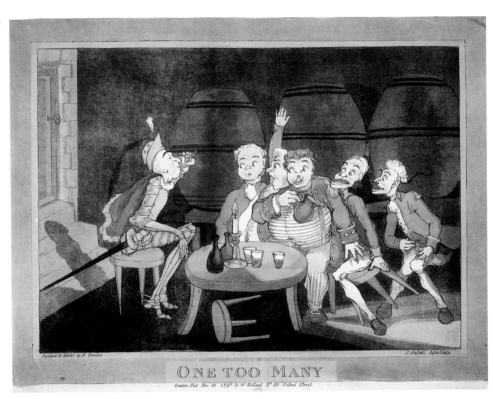

ONE TOO MANY

Designed & Etched by R. Newton

J. Hassell Aquatinta

London Pub. Nov 10 1795 by W. Holland N° 50 Oxford Street

LIBERTY & EQUALITY

London Pub. by W. Holland No 50 Oxford St. Nov 10 1792

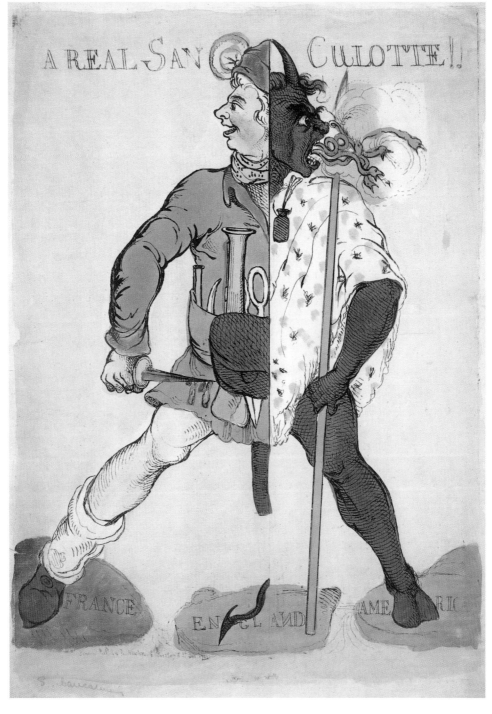

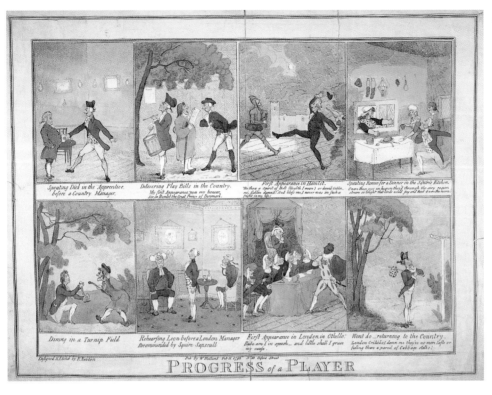

Speuting Dick in the Apprentice, before a Country Manager.

Delivering Play Bills in the Country. My first Appearance upon my honour, Sir, in Hamlet the Great Prince of Denmark.

First Appearance in Hamlet. "Be thou a Spirit of Hell (Health I mean) or damn'd Goblin, no, Goblin damn'd" God bless me, I never was in such a fright in my life:

Spouting Romeo for a Dinner in the Squire's Kitchen. O were there one in anger they'd through the very region stream so bright that birds would sing and took it were the morn.

Dining in a Turnip Field

Rehearsing Leon before a London Manager Recommended by Squire Sapscull.

First Appearance in London in Othello. Rude am I in speech... and little shall I grace my cause.

Went do...returning to the Country. London Critics set down me they're no more taste or feeling than a parcel of Cabbage stalks:

Design'd & Etch'd by E.Newton Pub. by W.Holland Feb 11 1795 N.50 Oxford Street

PROGRESS of a PLAYER

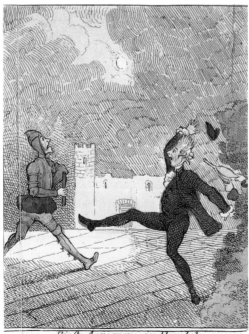

First Appearance in Hamlet.

"Be thou a Spirit of Hell (Health I mean) or damn'd Goblin, no, Goblin damn'd." God bless me, I never was in such a fright in my life:

— detail

13

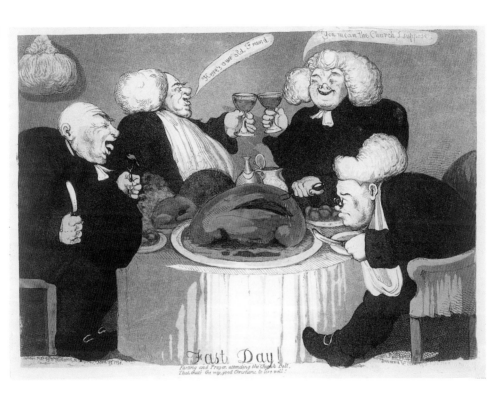

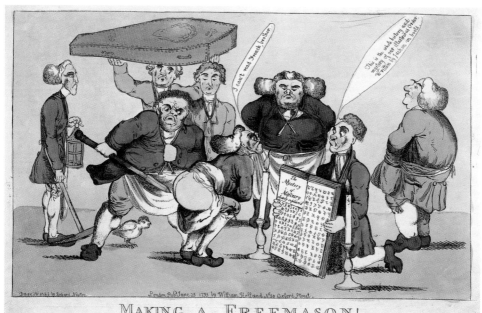

MAKING A FREEMASON!

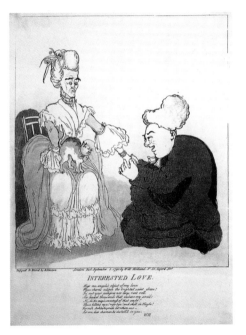

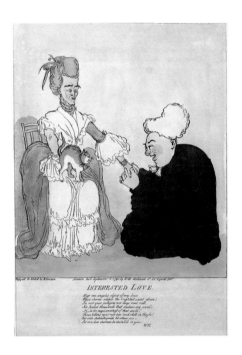

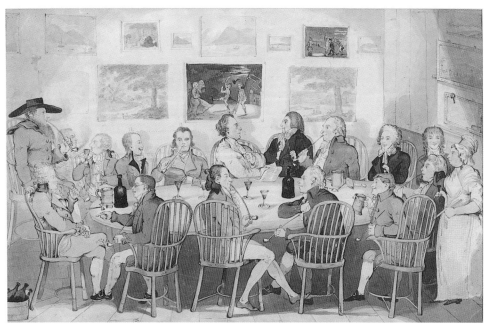

*Charles
Pigott
(7)*

*Daniel
Holt
(10)*

*William
Williams
(14)*

*Joseph
Gerrald
(15)*

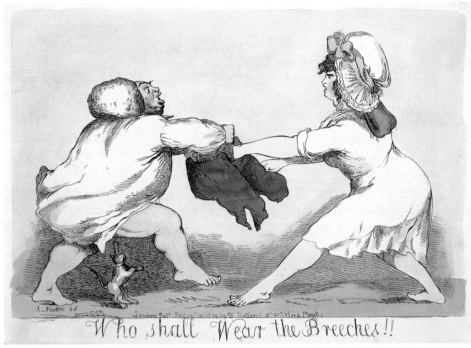

Who shall Wear the Breeches!!

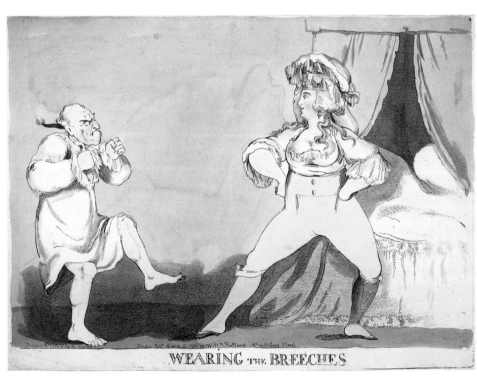

WEARING THE BREECHES

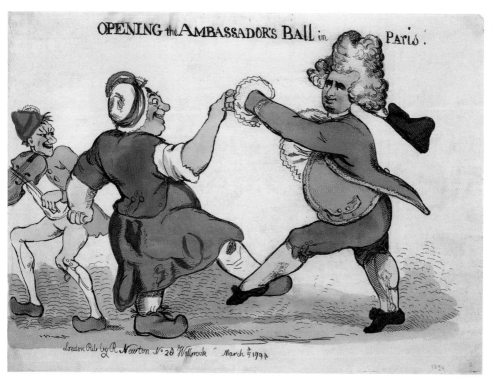

OPENING the AMBASSADOR'S BALL in Paris!

London Pub by R. Newton No 2ᵈ Wallrook March 5 1794

20

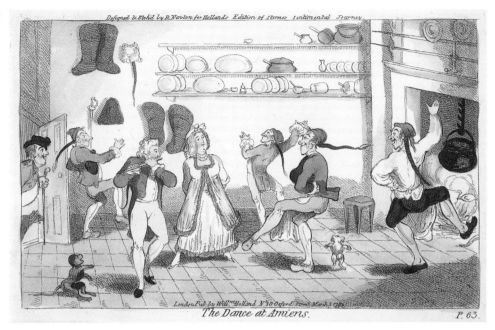

Designed & Etch'd by R. Newton for Holland's Edition of Sterne' Sentimental Journey

London Pub. by Will.^m Holland, N° 50 Oxford Street March 3 1795

The Dance at Amiens.

P. 63.

21

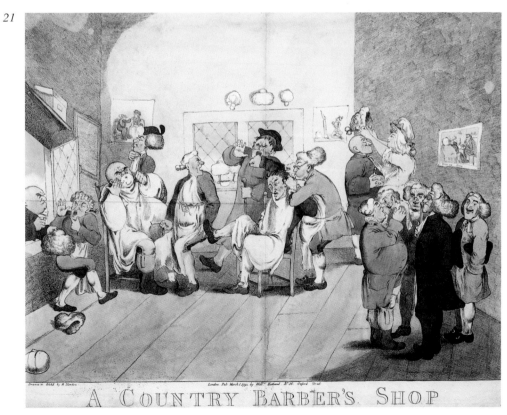

Drawn & Etch'd by R. Newton

London Pub March 1 1795 by Will.^m Holland N° 50. Oxford Street

A COUNTRY BARBER'S SHOP

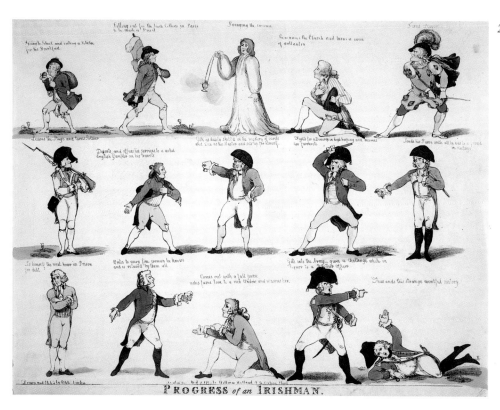

PROGRESS of an IRISHMAN.

23

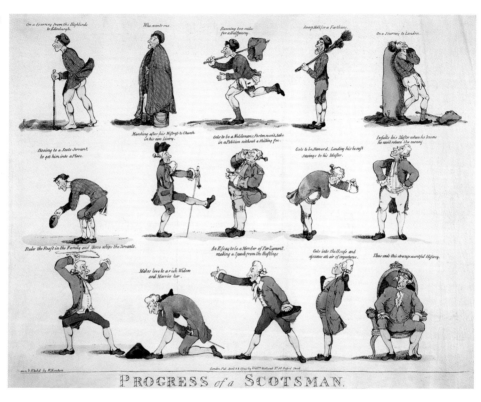

PROGRESS *of a* SCOTSMAN.

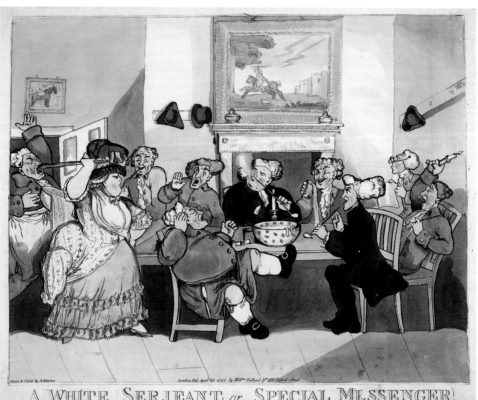

A WHITE SERJEANT; or SPECIAL MESSENGER!

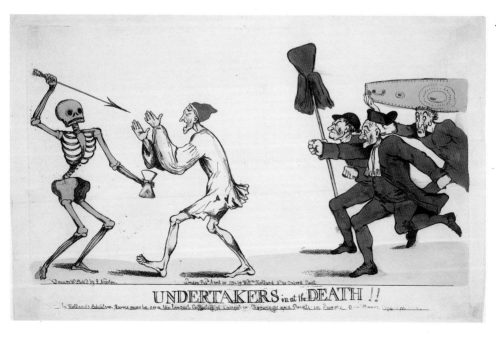

UNDERTAKERS in at the DEATH !!

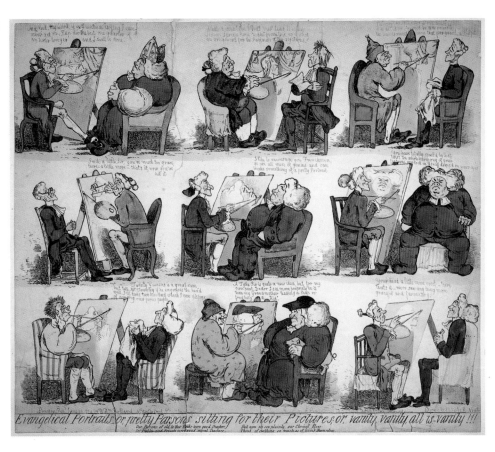

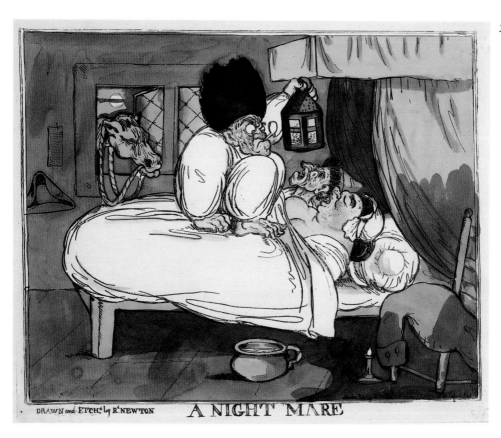

DRAWN and ETCH⁴ by R⁴ NEWTON A NIGHT MARE

28

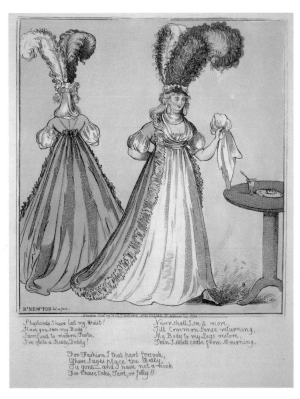

RⁿNEWTON del^t a fecit.

Shepherds I have lost my Waist!
Have you seen my Body?
Sacrify'ced to modern Taste,
I'm quite a Hoddy Doddy!

Never shall I see it more,
Till Common Sense returning,
My Body to my Legs restore,
Than I shall cease from Mourning.

For Fashion I that part forsook,
Where Sages place the Belly,
Tis gone—and I have not a Nook
For Cheese Cake, Tart, or Jelly!!

29

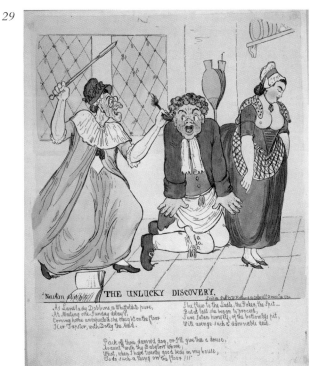

Newton pinx^t et fecit. THE UNLUCKY DISCOVERY,

As Landlady Dobbins a Whitfieldite pure,
At Meeting one Sunday delay'd,
Coming home unexpected, she caught on the floor
Her Tapster, with Dolly the Maid.

She flew to the Ladle, the Poker, the Spit—
But at last she began to perceive,
Sure Satan himself, of the bottomless pit,
Will avenge such a damnable deed.

Pack off thou damn'd dog, or I'll give thee a douse,
Avaunt with thy Bawdon Whore,
What, when I have twenty good beds in my house,
To do such a thing on the floor!!!"

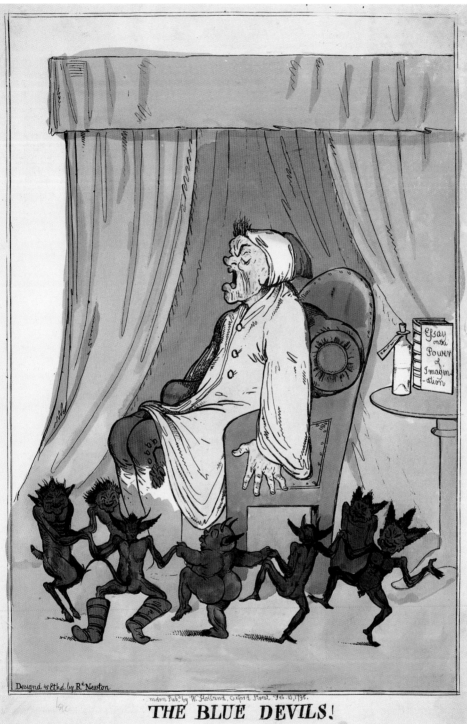

Designd & Eth'd by R'. Newton

London Pub'd by W. Holland, Oxford Street Feb. 15, 1795.

THE BLUE DEVILS!

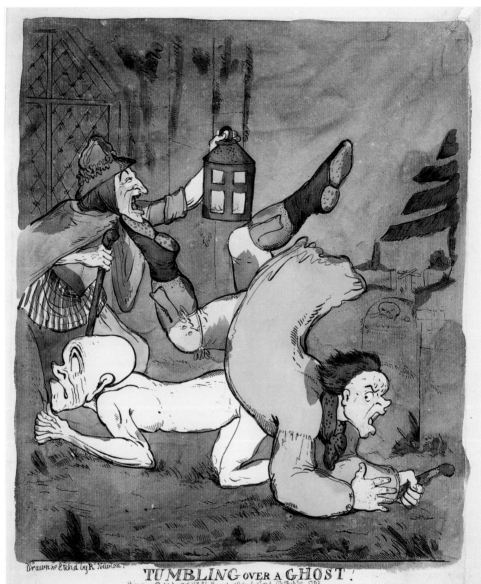

Drawn & Etch'd by R. Newton.

TUMBLING OVER A GHOST!

London. Pub'd by W. Holland, N.º 50 Oxford S.t Feb.º 6 1793

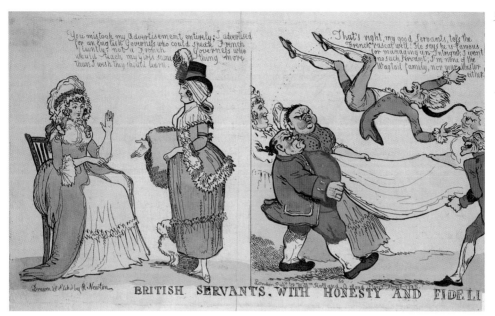

BRITISH SERVANTS, WITH HONESTY AND FIDELI

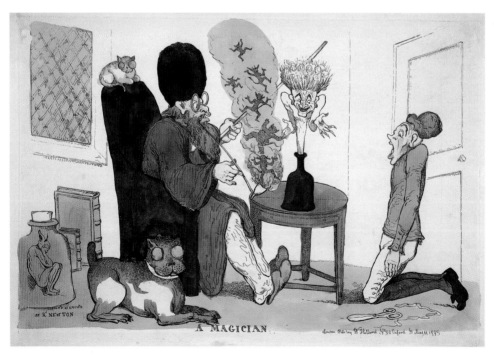

A MAGICIAN.

32b

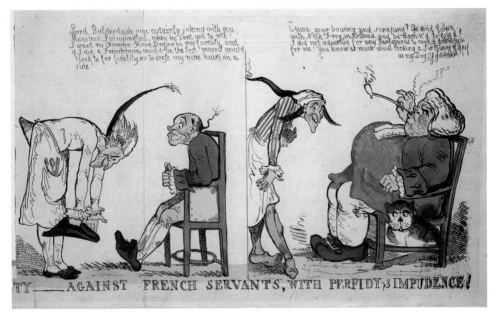

Lord, Baddledash was certainly joking with you,
Monsieur Swingingtail, when he sent you to me.
I want no Foreign-Hair-Dresser in my family, and
if I did, a Frenchman would be the last man I would
look to for fidelity or to dress my nine hairs on a
side!

Curse your bowing and scraping! Go and shave
with Nick Frog in Holland, and be damn'd to you!
I did not advertise for any Parlezvous to cook a dinner
for me! You know as much about cooking a Sir-loin of Beef
as my Dog Jowler!!!

TY——AGAINST FRENCH SERVANTS, WITH PERFIDY & IMPUDENCE!

34

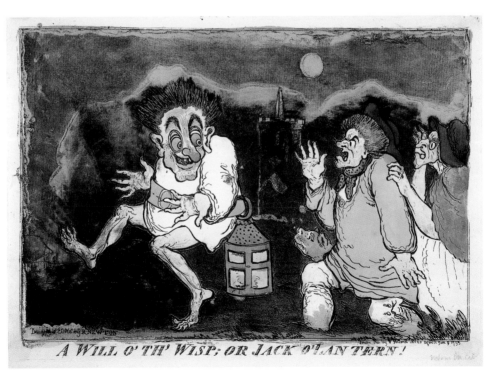

A WILL O' TH' WISP; OR JACK O' LANTERN!

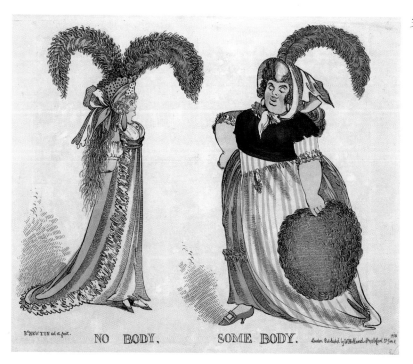

Rn NEWTON del et fecit. NO BODY. SOME BODY. London Published by W Holland N°50 Oxford St Jan. 6

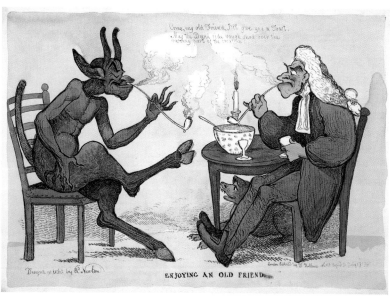

Come, my old Friend, I'll give you a Toast.
May the Devil ride rough shod over the
worser part of the nation

Drawn & etcht by R. Newton ENJOYING AN OLD FRIEND. London Publish'd by W. Holland N°50 Oxford St July 17 96

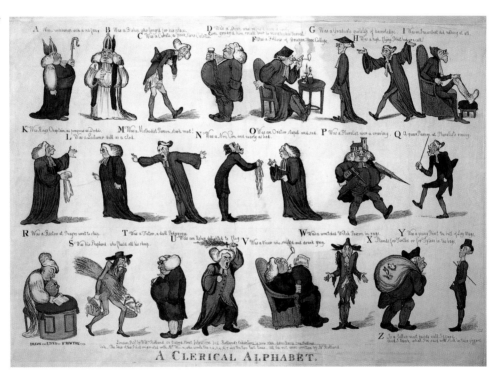

A CLERICAL ALPHABET.

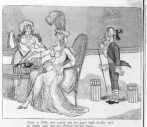

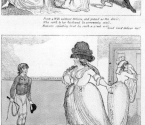

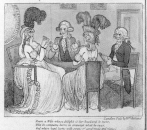

A BACHELOR'S

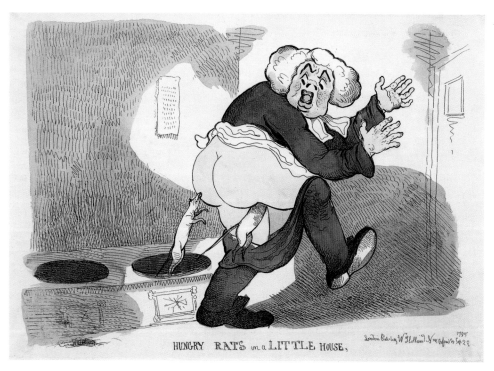

HUNGRY RATS in a LITTLE HOUSE,

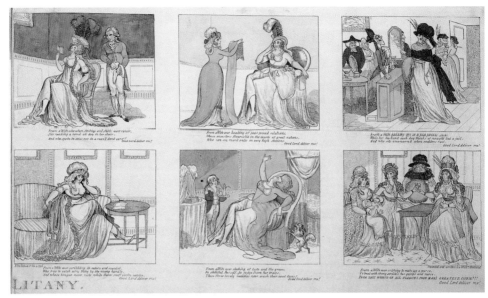

LI'TANY.

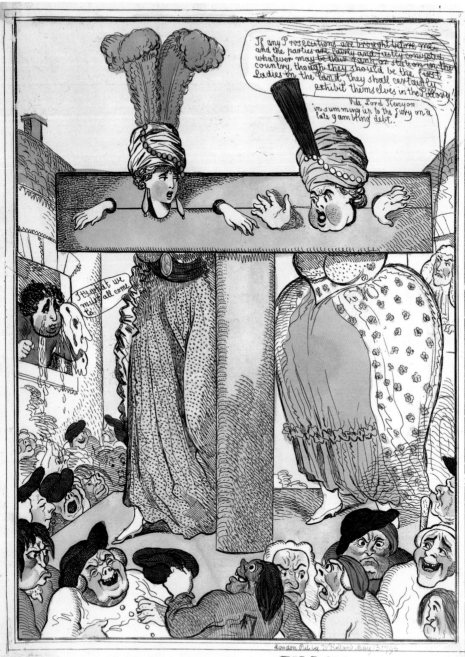

FEMALE GAMBLERS IN THE PILLORY.

41

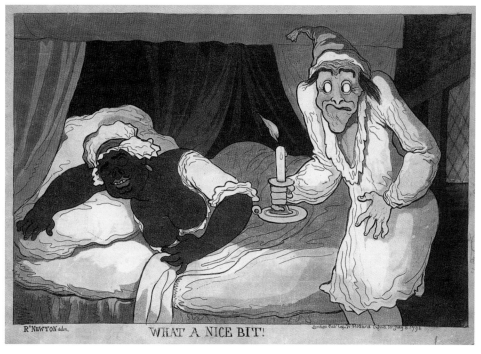

R.º NEWTON delin. London Pub. by W. Holland Oxford St July 8 1796

WHAT A NICE BIT!

42

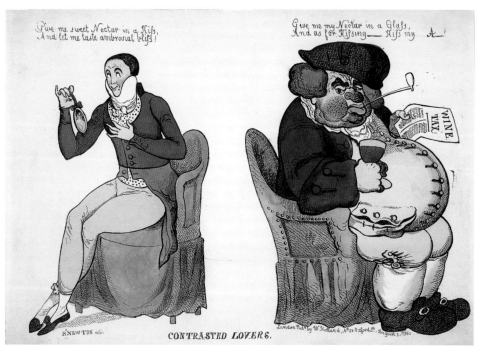

Give me sweet Nectar in a Kiss,
And let me taste ambrosial bliss!

Give me my Nectar in a Glass,
And as for Kissing — Kiss my A—!

WINE VAULT

H. NEWTON delin. London Pub. by W. Holland, N.º 61 Oxford St. August 3 1796.

CONTRASTED LOVERS.

THE FOUR STAGES OF MATRIMONY!

SMICK — SMACK.

HITHER AND THITHER

DRAWN AND ETCH'D BY R.ᵗ NEWTON.

THWICK — THWACK.

London, Pub. Aug.ᵗ 15. 1796. by Will.ᵐ Holland N.º 50 Oxford St.ᵗ

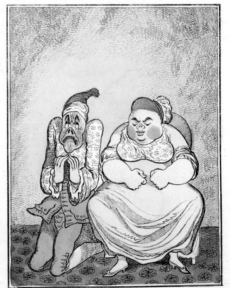

MAY THE DEVIL TAKE THEM, THAT BROUGHT
YOU AND ME TOGETHER!

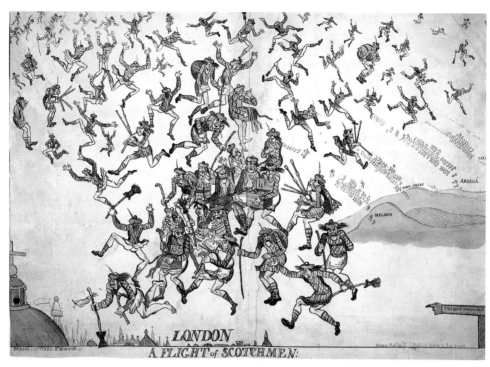

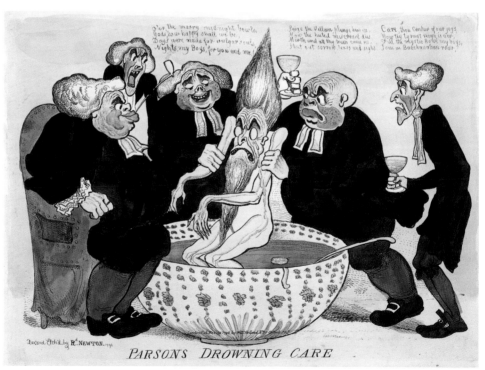

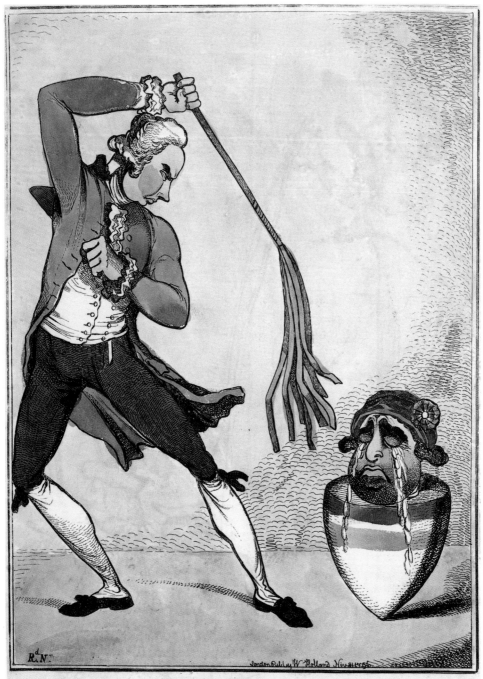

BILLY'S POLITICAL PLAYTHING.

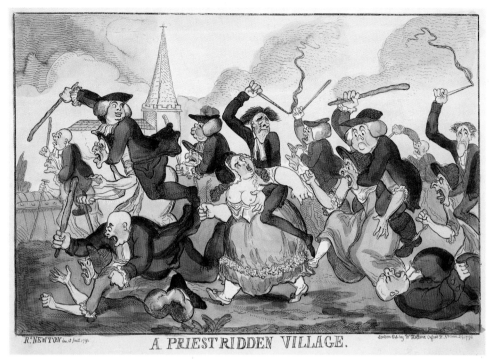

A PRIEST RIDDEN VILLAGE.

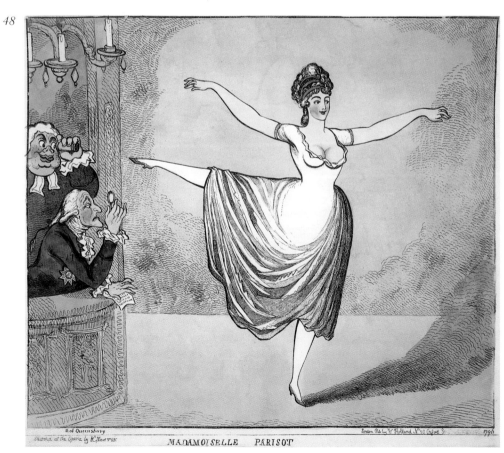

MADAMOISELLE PARISOT

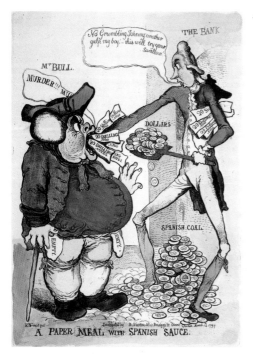

A PAPER MEAL WITH SPANISH SAUCE.

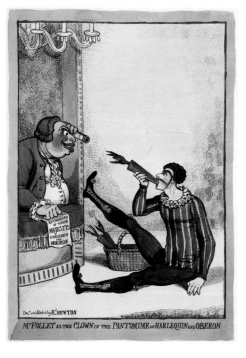

Mr FOLLET AS THE CLOWN IN THE PANTOMIME OF HARLEQUIN AND OBERON

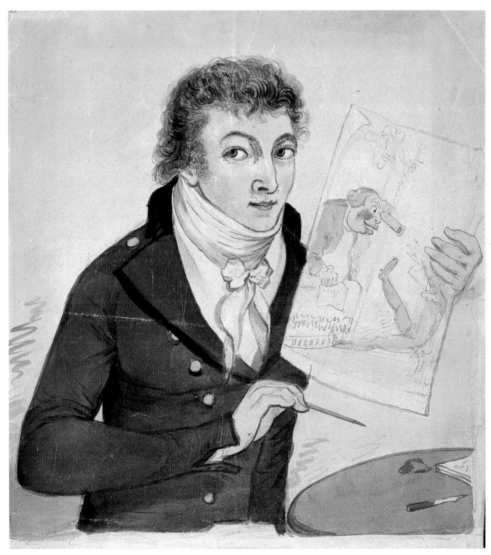

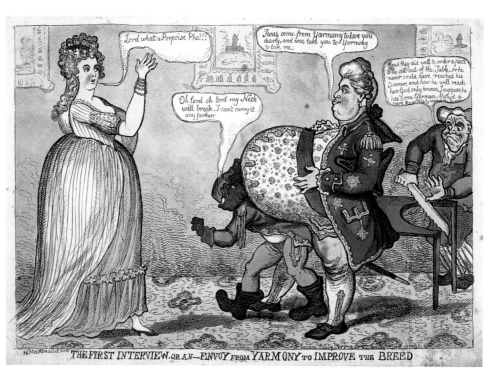

53

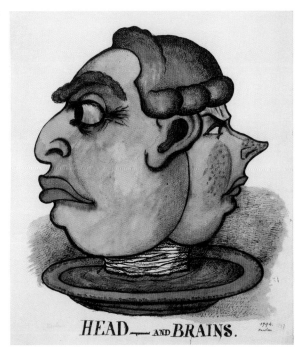

HEAD —— AND BRAINS.

54

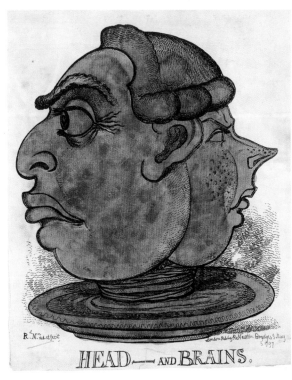

HEAD —— AND BRAINS.

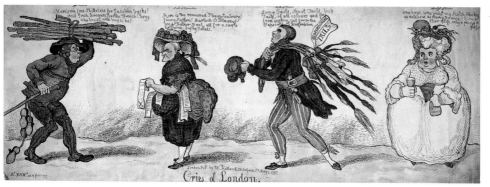

Cries of London.

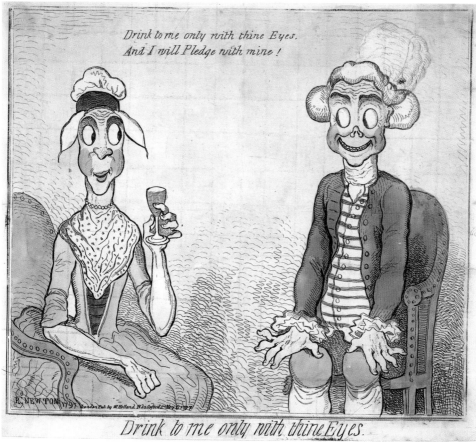

Drink to me only with thine Eyes.
And I will Pledge with mine!

Drink to me only with thine Eyes.

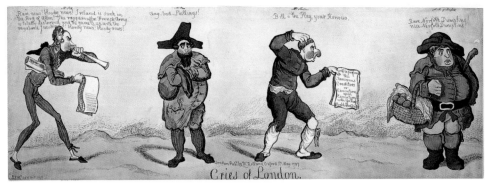

Cries of London.

DESIGND & ETCHD.
BY.
R. NEWTON.

THE FULL MOON IN ECLIPSE.

London Published by W Holland Oxford St. 1797

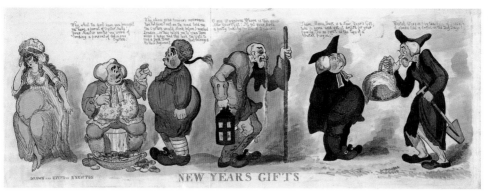

NEW YEARS GIFTS

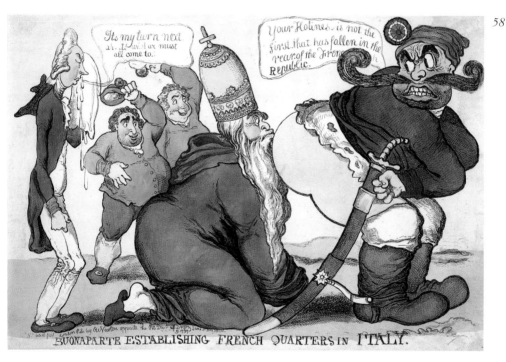

BUONAPARTE ESTABLISHING FRENCH QUARTERS IN ITALY.

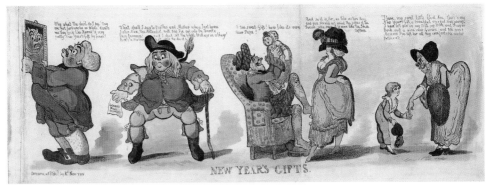

NEW YEAR'S GIFTS.

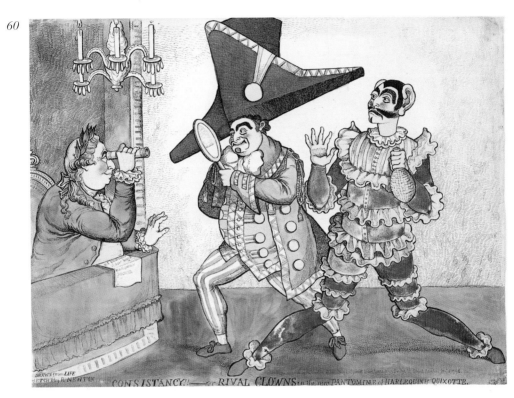

CONSISTANCY!!——or RIVAL CLOWNS in the new PANTOMIME of HARLEQUIN & QUIXOTTE.

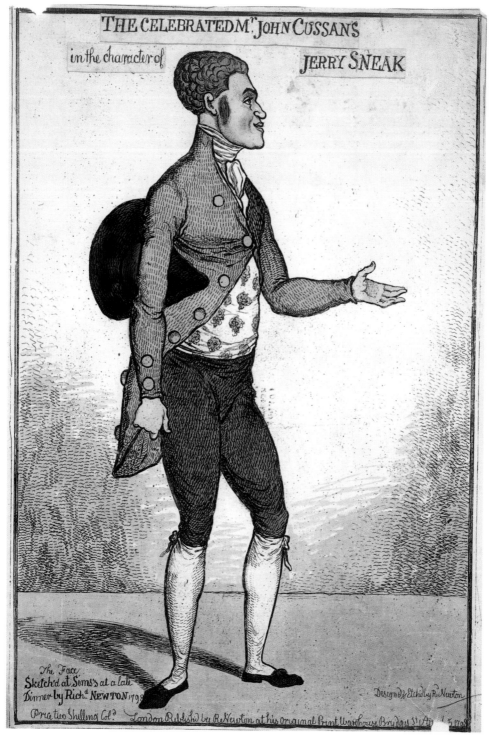

THE CELEBRATED M.ʳ JOHN CUSSANS

in the character of JERRY SNEAK

The Face
Sketch'd at Sims's at a late
Dinner by Richᵈ NEWTON 1798

Designd & Etchd by R. Newton

Price two Shilling Colᵈ London Publishd by R Newton at his original Print Warehouse Bry day 5.ᵗ Ap.ˡ 5 1798

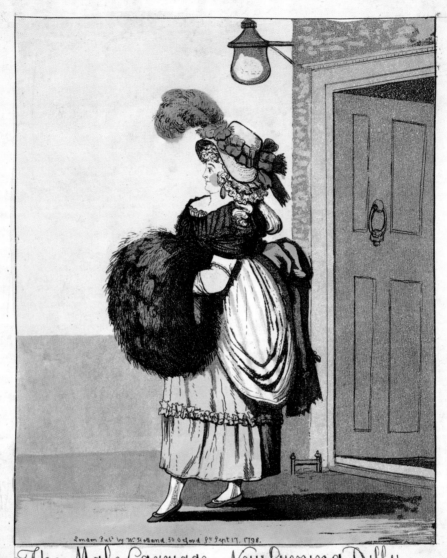

London Pub^d by W^m Holland, 50 Oxford S^t Sept 17, 1798.

The Male Carriage or New Evening Dilly.

Sets out from Soho at 8 O clock every evening; stops at Drury Lane and Covent Garden
to take in, or if desired, will receive in the Yard of S^t George, and go easy over the Stones, and
for the accommodation of the Public will also take up and let down in any part of the Town __
Inside Passengers to pay £1.1.0 allow'd to carry two Stone — The Carriage fresh painted, lined with crimson
velvet; fine hair seat, of remarkable pleasant pace, well guarded and kept in good order. The Axle Tree
warranted from taking fire let the motion be ever so quick, The standing rule to pay before entrance
None permitted to get up behind. Performed by Devere, Hams and C^o

Captions to the colour plates

Note: works are etchings, hand-coloured, unless otherwise stated. Dimensions are those of the plate mark, height before width, given in millimetres; those given in brackets are of the subject, i.e. the image.

1 *September in London – all our Friends out of Town!!!*
Unsigned; published by W. Holland, 21 September 1791
Lit: Holland's 1794 catalogue, 'a crowd of Courtesans at a Pawnbrokers, by Newton. 3 s[hillings]'
c. 272 x 475 (250 x 475)
British Museum 1948-2-14-375
This early unsigned print, related to a watercolour now in the Huntington Library, San Marino, shows the fourteen-year-old boy's delight in the pretty women to be seen on the streets of London; there were many ladies of the town living in his home area of Drury Lane. The print implies that, as the gentry who patronised the ladies were either in the country or in resorts such as Bath, they were having to pawn their possessions. The principal prostitutes of the area were listed in a notorious publication, *Harris's List of Covent Garden Ladies*; one printseller, James Aitken, was imprisoned for selling this in 1795. Newton made a print with that title dated 24 May 1794, which shows one of his typically cloddish males trying to choose between three delectable young ladies.

The women had to keep up the appearance of being cheerful and well turned-out; a few might graduate into 'high keeping' for a few years but the reality of life for most of them was, of course, grim. Newton was a boy, conveying his delight in what he saw, not a Hogarth, drawing a moral from what could happen to a prostitute, as in *The Harlot's Progress*.

2 *A Crop Shop*
'RN Del' in subject; published by W. Holland, 8 October 1791
248 x 355 (215 x 330)
Andrew Edmunds, London
The barber's shop, a popular meeting place in the days when many men were shaved there, was an obvious subject for social satire. A large print of *A Barber's Shop* engraved in 1785 from a drawing by the gentleman artist Henry Bunbury in the possession of Sir Joshua Reynolds, President of the Royal Academy, became well known (BM 6882). The print here, which is one of the first to be signed by the fourteen-year-old, shows the new fashion for cropped hair associated with the French revolutionary style (see also plate 16). The barber himself appears to sport a simple toupée with side curls. The abandonment of wigs was accelerated after Pitt's government put a tax on hair powder in 1795; those who chose to pay the tax were called 'guinea-pigs' and Newton made a caricature referring to this, dated 1 July 1795. Cropped hair continued to be associated with advanced ideas and in 1795 the *Times* reported that 'A club has been formed called the Crop Club, every member of which is obliged to have his head cropped ... for the purpose of evading the tax on powdered heads ... the new crop is called the Bedford Level' (after the radical Duke), quoted Cunnington (1964: 247).

The young men are all wearing long breeches and the round hats originally designed as a riding hat; they have very high collars. Newton is probably caricaturing the way they wear their short frock-coats around their shoulders. The two in the foreground wear jockey boots, derived from a long-established type of riding boot with a turned down top of lighter leather.

Newton returned to the subject in 1794 (plate 22).

3 *A Forcible Appeal for the Abolition of the Slave Trade*
'R Newn' in sub; 'Etch'd by R.Newton', published by W. Holland, 2 April 1792
(*c.* 380 x 510)
Andrew Edmunds, from the Stahremberg Collection
The campaign against the slave trade was gathering momentum during Newton's early years, and a number of satires against slavery had been issued, e.g. Gillray's *Barbarities in the West Indias* 23 April 1791 (BM 7848). On 23 April 1792 a motion for gradual abolition was carried, though Wilberforce's Bill for its abolition was narrowly defeated when it was introduced into the House of Commons in March 1796. The writings of Thomas Clarkson and others had drawn attention to the cruelties of many plantation owners in the West Indies. At the very time that this print appeared, Robert Burns's friend Agnes McLehose was being forced by her husband to watch the flogging of slaves under his control in Jamaica. The pretty woman in this print is showing no revulsion at the sight before her, and although this print may be read as anti-slavery propaganda, it is possible that Holland was also aiming it at buyers who had a penchant for flagellation prints. Some of the publications he had been associated with in the 1780s, such as *An Exhibition of Female Flagellants* and *Fashionable Lectures Composed and Delivered with Birch Discipline*, were illustrated with prints.

A later print attributed to Newton, *Justice and Humanity at Home*, 10 May 1792, showed a British sailor being flogged, with the figure of Wilberforce saying 'I and my tribe must look abroad for acts of cruelty and oppression – This is so near home it is beneath our notice'.

4 *The Combustible Breeches*
Published W. Holland, 11 May 1792
425 x 520 (425 x 490)
Benjamin Lemer
On 9 May 1792 the House of Commons nearly caught fire: a pair of smouldering breeches were found under the ceiling of a closet. In this absurd and offensive depiction of the royal couple the Warder is presenting the breeches 'Just as they were taken out of the House of Office', i.e. the privy, while the King exclaims to the Queen 'Keep behind my love! Run and lock up all the girls! Its brimful of combustible matter!'

This print, costing two shillings and sixpence, was one of the few anti-royal prints in a catalogue at the back of *The Battle between Doctor Farmer* ..., a pamphlet issued by Holland in August 1792 (see figure 7).

5 *A Proclamation in Lilliput*
Unsigned; published by W. Holland, 22 May 1792.
Lit: Turner (1996: 3–5).
350 x 462 (310 x 445)
Benjamin Lemer
This print, with its derisive title, was prompted by the Royal Proclamation of 1792, which included a specific reference to the need to suppress 'all loose and licentious Prints, Books and Publications, dispersing Poison to the Minds of the Young and Unwary, and to punish the Publishers and venders thereof'. William Pitt, wearing a jester's cap, is shown reading the absurdly long scroll; the inscription – no doubt written by Holland – parodies the Proclamation:

Who ever after this our will and pleasure, dares to look, walk, stand, write, sit, speak, act, think, run, eat, drink, sleep, evacuate, piss or committing any other misdemeanour so as to alrm the fears, doubts, conscience, & of peaceable Citizens shall forthwith be bash'd, broil'd, stew'd, roasted, fricaseed & according to the utmost limits and bounds of our supreme wisdom and whoever hearing this our will and Proclamation shall dare to Print, Publish, write or cause to be written any book ...

The scroll is supported by Thurlow, the Lord Chancellor, and the King is shown as a beadle, exclaiming with his characteristic stutter 'Silence! – Silence! What! what a noise ye make ye Paineite rascals! Billy, read read on my boy!'

In his satirical response to the Proclamation, *Vices Overlook'd in the New Proclamation*, 24 May 1792 (BM 8095), Gillray drew attention to the failings of the King and Queen and three of their sons.

6 *Tasting a Norfolk Dumpling*
'R N' in sub.; published by W. Holland, 1 June 1792
Lit: Klingender (1944: plate 86)
252 x 352 (232 x 352)
Andrew Edmunds, from the Starhemberg Collection
This is one of the first prints by Newton depicting the aristocratic goings-on which filled the columns of newspapers such as the *World* and *Morning Post*. Klingender describes it as showing the Duchess of Gordon trying to capture the Duke of Norfolk for one of her daughters; this is an unlikely interpretation, as the Duke was married, though his wife was insane and he lived with a Miss Gibbon, a relation of the historian, who bore him children. The massively built Charles, eleventh Duke of Norfolk (1746–1815), head of the leading Catholic family, had conformed to the Church of England in 1780 in order to enter the House of Commons, and was a loyal follower of Fox. He was notorious for his capacity for drink and his aversion to soap and water, and the print may be an ironic comment on the undesirability of getting too close to him. Jane, Duchess of Gordon (*c*.1749–1812), wife of the fourth Duke, was a powerful figure in London society, ambitious for her daughters and forthright in her manner: when asked by the Prince of Wales to wear his feathers and a cap with his motto *Ich Dien* during the Regency crisis of 1788-9 she told him she would sooner be hanged.

7 *A Bugaboo!!!*
Unsigned; published by W.Holland, 2 June 1792
Lit: BM 8102 as [N]; Wardroper (1973: plate 27); Bindman (1989: 116); Turner (1996: 6–7).
(345 x 450)
Benjamin Lemer
In this striking print, a further riposte to the Proclamation of 21 May 1792, Pitt is shown riding on the shoulders of the King, out of whose mouth comes a stream of unconnected words (see the entry in the BM *Catalogue*). Their implication was that prisons would be built in the most radical cities to suppress the reform movement. The measures which the administration took to repress the possible spread of revolutionary ideas were condemned by radical opinion as a 'reign of terror'; Paine and his publisher J. S. Jordan were soon indicted for sedition, and Paine fled to France. However the initial failure of the authorities to move against other publishers, including Holland, seems to have encouraged a false sense of security among them.

In his contemporary dictionary of slang, Francis Grose defined a bugaboo as 'a scare-baby', that is, an imaginary object of terror used to frighten children. Although it is difficult to appreciate in reproduction, this print is on an exceptionally large scale: the King's head is about 175 mm, or seven inches, high. There is a preliminary drawing for it in the Wilhelm-Busch-Museum, Hannover.

8 *Content and Discontent*
Published by W. Holland, 21 June 1792
Lit: Turner (1996: 13).
445 x 305 (425 x 305)
Benjamin Lemer

This is another daring print. The King's head is sticking out of a bag of gold coin marked 'Seven Millions', while next to him is a clergyman; below an emaciated man reads 'Reflections on the high price of Provisions', while a fat butcher complains of his failure in two weeks to sell a 'large joint' to the people who 'now all live on bacon and pease'.

9 *One Too Many*
'Design'd & Etch'd by R. Newton' 'J. Hassell Aquatinta', published W. Holland, 10 November 1792
Lit: BM 8209; Klingender (1944: plate 92)
(305 x 429)
Kenneth Monkman
This hilarious commentary on the effect of too much drink, with the revellers joined by a knight in armour, is one of the earlist prints in which Newton shows his capacity for distorting faces and his use of goggle eyes. It was published as a pendant to a print entitled *The Haunted Cellar*, which shows a group frightened by an owl in a cellar, and was priced at four shillings in Holland's 1794 catalogue.

10 *Liberty and Equality*
Unsigned; published W. Holland, 20 November 1792
Lit: Turner (1996: 11–12)
420 x 340
Benjamin Lemer
This has been described as probably the most radical of the prints which Newton made in 1792, since the greatest in the land are shown fraternising with the meanest. The Queen is shown drinking with a market-woman in St Giles, one of the poorest parts of London; the King walks arm-in-arm with a plebeian waving a copy of Paine's *Rights of Man* and sporting a revolutionary cockade. The Lord Chamberlain, Lord Salisbury, is shown on a donkey; finally a vicar is sharing his dinner with a thin curate. This print came out on the same day as Holland published a song sheet, with a headpiece by Newton, of the French revolutionary song, *La Marseillaise*.

11 *A Real San Culotte!!*
Published by R. Newton, Great Portland St, December 1792
355 x 250
British Museum 1948-2-14-350, from the Klingender Collection.
Newton had published at least two prints from this address by the time he issued this one. It is remarkable that a fifteen-year-old should have published prints on his own account, but it may be explained by an increased anxiety on Holland's part about the publication of political prints. Indeed it was in the month in which this print appeared, December 1792, that Holland was arrested for selling pamphlets by Thomas Paine. The print, with a sans-culotte who is cheerful rather than fearsome, is ambiguous in its meaning. It may represent an ironic comment on fears of Revolution. On the other hand, it is possible that it was intended to be an anti-French print, for which Newton was paid, and which he did without conviction.

12 *Progress of a Player*
'Designed & Etch'd by R Newton', published by W. Holland, 11 February 1793
Lit: Kunzle (1973: no. 12-12, ill. p. 365)
Outer line around sub. 440 x 580 (380 x 530)
British Museum 1948-2-14-339
In the early 1790s a number of graphic artists used the 'Progress' formula familiar from the work of William Hogarth, whose *Rake's Progress* was published in 1735. The first artist to revive the idea was, according to Kunzle, John Nixon, whose *Progress of*

Passion was published by Fores in 1792; his example was soon followed by Gillray, with *John Bull's Progress* (figure 15), his powerful indictment of war, and then by Newton, with this print and four others (see Index of titles and Appendix). This plate shows the vicissitudes of an aspirant actor. Although the theatre was a long-established subject for satire, Newton probably knew more than most people about it, because he was brought up near Drury Lane Theatre. To graduate from a country touring company to the London stage, as some leading figures such as Dorothy Jordan had managed to do, was the dream which encouraged young men and women to take to the boards. However, Newton's account of his idiotic hero's progress – for example his fright as Hamlet at the Ghost – is too absurd to be taken seriously. This plate has dialogue which was no doubt composed by William Holland, though the lettering is probably in the hand of Hassell:

Top far left:	Spouting Dick in the Apprentice/ before a Country Manager
Top second:	Delivering Play Bills in the Country. My first 'pon my honour / Sir, in Hamlet the Great prince of Denmark.
Top third:	First Appearance in Hamlet 'Be thou a Spirit of Hell (Health I mean) or damn'd goblin/ no Goblin damn'd! God bless me, I never was in such a/ fright in my life!'
Top far right:	Spouting Romeo for a Dinner in the Squire's Kitchen O were those eyes in heaven they'd through the airy region/ stream so bright that birds would sing and think it were the morn.
Bottom far left:	Dining in a Turnip Field
Bottom second:	Rehearsing Leon before a London Manager/ Recommended by Squire Sapscull
Bottom third:	First Appearance in London in Othello Rude am I in speech – and little shall I grace/ my cause
Far right:	Wont do --- returning to the Country London Criticks! damn me they've no more taste or feeling than a parcel of Cabbage stalks

There are drawings in the Royal Collection, Windsor, for two of the scenes.
In Holland's 1794 catalogue this was listed at six shillings as companion to *Progress of an Author*, a print which has not been traced.

13 *Fast-Day!*
'Design'd & Etched by R. Newton', published by W. Holland, 19 April 1793
Lit: BM 8323; George (1967: figure 70)
Etching and aquatint; 248 x 352 (228 x 337)
British Museum 1896-11-18-102
George III declared that a National Fast should be observed on 19 April. At this time Holland was in Newgate Prison, following his conviction in March 1793, and his business in Oxford Street was presumably carried on by his wife and by Newton. The title on this print is in the same hand seen on Holland's prints since about 1784, so unless the plate had been taken into Newgate for his inspection it suggests than he had another assistant who lettered the prints. Although Newton had mocked the clergy before (plate 10), this is his first print solely devoted to the topic. Clerical greed had long been a favourite topic for caricature, and Newton was frequently to return to the theme.

14 *Making A Freemason!*
'Design'd & Etch'd by Richard Newton', published by W. Holland, 25 June 1793
Lit: BM 8386
270 x 422 (245 x 397)
Andrew Edmunds, from the Starhemberg Collection
Organisations to promote mutual assistance linked to conviviality spread rapidly in late eighteenth-century Britain, and were probably one of the reasons why revolutionary ideas did not flourish very widely. The rituals of the Masonic order, which had taken on a new lease of life in Britain following the establishment of a Grand Lodge in London in 1779, were a subject of particular curiosity. Newton has used the topic as an excuse to indulge his schoolboy humour. The faces of several of the men, with the firm downward set of their mouths, owe a lot to Woodward's models. Newton did not include prints of this kind when he later made a large watercolour of Holland's exhibition room (figure 1); a significant proportion of the prints issued by Holland, whether attacks on royalty, mildly obscene or erotic prints, were not advertised and probably circulated with some degree of caution, in order not to put off buyers of humorous prints.

15 *Interested Love*
'Design'd & Etch'd by R. Newton', published by W. Holland, 3 September 1793
335 x 248 (268 x 230)
Etching, with hand colouring: Kenneth Monkman
Etching and aquatint, uncoloured: David Alexander
Two examples of this print are shown, to give an idea of the effect of adding aquatint to an etching; the first is an etching coloured with watercolour; the second has aquatint added to the etching but is uncoloured. The print, with its splendid figure of an old maid and her cat, appeared as a pendant to an earlier plate after G. M. Woodward, *Disinterested Love*, published by Holland on 1 November 1790; it is conceivable that the earlier plate may have been one of the first etched by Newton, but it is more likely to be the work of F. G. Byron. Both can be seen in the top right-hand corner of Newton's watercolour of Holland's exhibition room (figure 1). The aquatint was probably added by Hassell, who probably also engraved the lettering. Holland has here, exceptionally, acknowledged his authorship, and the verse is signed 'W. H.'[olland]:

> Hear me, angelic object of my love
> Whose charms eclipse the brightest saint above!
> Tis not your pedigree nor large rent roll,
> Nor funded thousands that enslave my soul;
> No 'tis the magic sweetness of that smile!
> Those killing eyes! ripe lips! and skill in Hoyle!
> For rich Archbishopricks let others sue –
> Let me, dear charmer, be install'd in you.

'Hoyle' is a reference to Edmond Hoyle, whose 'Laws' governed the game of whist.

16 *Soulagement en Prison, or, Comfort in Prison*
Lit: BM 8339 (this entry is based on a photograph of the print: 'Drawn from Life, and etched by Richard Newton', published by W. Holland, 20 August 1793); Bindman (1989: no. 193, ill. p. 191); Thale (1983) and Werkmeister (1967) for additional biographical information. Watercolour in the Lewis Walpole Library, Farmington, Conn.
This and the companion groups drawn in Newgate Prison (figures 16, 17) are fascinating historical documents, since they show several of the leading writers and

publishers – Paine excepted – whom the authorities believed were fomenting revolution in Britain. Holland (2), seated on the extreme left, is shown with fellow-prisoners and a few visitors. The standing man on the left (1) is Lord George Gordon (1751–93), in prison for a libel on Queen Marie Antoinette and the only one not in prison for political offences. Those in the previous group, *A Peep into the State Side* (figure 16; see above p. 36) are Lloyd (3); Macan (4); Ridgway (5); Symonds (6); Eaton (11); Frost (12) and Watson (14), who was sentenced to two years for possessing a seditious libel in November 1794 (Thale 1983: 235). The additional prisoners are Charles Pigott (7); Daniel Holt (10); William Williams (14) and Joseph Gerrald (15).

Charles Pigott (d. 24 June 1794) was a prolific writer who wrote some of the most popular of radical pamphlets. These included *The Jockey Club*, which drew attention to the dissolute behaviour of the King's sons, and was published by Symonds in 1792; *The Female Jockey Club*, which did the same for notorious females such as the Countess of Buckinghamshire (see plate 40); and the amusing *Political Dictionary*, published by Eaton in 1795. Pigott was a member of the London Corresponding Society (L.C.S.).

Daniel Holt (1766–99), printer and bookseller of Newark, who started a radical newspaper, the *Newark Herald* in 1791. In 1793 he was charged with selling two of Paine's pamphlets and sentenced at Nottingham Assizes in July 1793 to a total of four years' imprisonment. His Newark press continued to publish during his confinement, but his health was broken and he died soon after his release.

William Williams (fl. 1789–1820) is presumably the printer of the *Morning Post*, who in July 1792 was charged with a libel on the King and sentenced to a year in King's Bench Prison (Werkmeister 1967: 97–8).

Joseph Gerrald (1760–96), a lawyer, joined the L.C.S. and went as one of its two delegates to the British Convention of the Delegates of the Friends of the People, held in the winter of 1793. His pamphlet *A Convention the Only Means of Saving us from Ruin*, was published by Eaton in 1793, and his *Defence ... on a Charge of Sedition*, [1794] was sold by Ridgway. Samuel Parr, his old schoolmaster tried first to restrain and then to assist him (see W. Derry, *Dr Parr* (Oxford, Clarendon Press, 1966), pp. 152–8). He was tried in March 1794 and transported to New South Wales, where he died soon after his arrival.

All these men, except Williams and Watson, were included in Newton's later print, the *Promenade* (figure 17). Several of the men have the cropped hair associated with radicalism. No. 16 is 'Mrs Moore Servant'.

17 *Who Shall Wear the Breeches?*

'R Newton del', published W. Holland, 10 September 1793
247 x 350 (228 x 350)
This print of a battle of the sexes is the kind of subject which Newton enjoyed depicting. This and its pendant (plate 18) are shown on the right wall of Holland's exhibition room (figure 1).

18 *Wearing the Breeches*

'Drawn & Etch'd by R Newton'; published by W. Holland, 6 March 1794
291 395 (272 x 395)
Whitworth Art Gallery, University of Manchester
The publication of the pendant, in which the strapping young wife is shown triumphantly wearing the breeches, was probably delayed because the publishing activity of Holland's business dwindled after a few months, with the death of his wife and the illness of Newton himself, who apparently caught gaol-fever from visiting Newgate. Cross-dressing had been shown in a number of earlier drolls, especially at the time of the invasion scare of 1778 when, under the influence of the Duchess of Devonshire, a number of officers' wives adopted a semi-military attire. The idea obviously intrigued Newton, and he returned to the theme in a later print, *Trying on*

my Brother's Breeches, 2 June 1796, in which one young woman exclaims 'There's a leg and a Thigh for you' as the other shows off her legs encased in tightly fitting men's breeches.

19 *Opening the Ambassador's Ball in Paris*
'Pub by R Newton No 26 Wallbrook', 5 March 1794
247 x 342 (240 x 348)
Andrew Edmunds
The controversial politics of the charismatic Whig leader Charles James Fox, together with his swarthy features and 'five o'clock shadow', meant that he was featured in more satires than any other figure, even George III. His sympathies with the French Revolution and his opposition to war with France gave caricaturists the idea that he could be pictured as ambassador from – or, in this case, to – the French. William Dent showed him as French Ambassador as early as 18 Dec. 1792, BM 1948-2-14-456; George (1959, i: plate 94). In Newton's vigorous plate, which he has lettered himself, a dandified but slightly wary Fox is shown dancing with a hideous revolutionary woman; at the side is a crooked-legged *sans–culotte* in typically Newtonian style. This print, with its humour and movement, is the kind which Newton could produce without Holland's assistance, and he published it himself, from a new address in the City of London.

20 *The Dance in the Kitchen at Amiens*
Dated 3 March 1794, from the edition of Sterne's *Sentimental Journey*, published by W. Holland, with a title page dated 1795
Lit: Abbey *Life*, 250, where the plates are listed
Laurence Sterne Trust, Shandy Hall, Coxwold, York
An edition of Laurence Sterne's final work, with twelve illustrations designed and etched by Newton, probably came out at the time of Holland's release from prison; the plates are dated 3 March 1794 though the date on the title page is 1795. Holland was a devotee of Sterne, and in a typically Sternean gesture wrote a poem on his tombstone, which was in a graveyard near what is now Marble Arch. His edition of the *Sentimental Journey* is now a rare book, and the fact that Holland brought out a new edition with aquatint plates in 1797 may have been because he felt that the illustrations could be improved rather than because it sold particularly well; some of the illustrations have been changed very considerably (see figures 20, 21). Rather confusingly the later edition was published in sheets dated 1792. Holland seems to have bought some unused sheets and to have published the new illustrations in them without providing an up-to-date title page.

21 *A Country Barber's Shop*
Published by W. Holland, 1 March 1794
(420 x 560)
Benjamin Lemer
Newton returned to the subject of the barber's shop, which he had shown in one of his first prints (plate 2), this time giving it a country setting. Whether, as a Londoner, he had seen many country barbers is unlikely. On the wall is one of many prints of *The Vicar and Moses*, a popular song by the Shakespearean scholar George Steevens, in which Moses, the clerk, goes to fetch a country Vicar to bury an infant, and remains drinking with him until after midnight, when they stagger out to the church.

Newton did another print of heads seen in a barber's shop under the title *Sketches in a Shaving Shop*, 16 December 1794.

22 *Progress of an Irishman*
'Drawn and Etch'd by Rich.d Newton', published by W. Holland, 8 April 1794
Lit: BM 8552 (entry based on the copy in the *Hibernian Magazine*, Dec. 1794); Kunzle
(1973: no. 12-14, ill. p. 367)
390 x 522
Kenneth Monkman
This sequence of twenty figures tells the life story of an Irishman:

Top row:	going to School and eating a Potatoe for his Breakfast
	Setting out for the Irish College in Paris to be made a Priest swinging the incence
	Renounces the Church and turns a man of gallantry
	Turns Player
2nd row:	Leave the stage and turns soldier
	Deserts and offers his services to a noted English Gambler on his travels
	Gets as deeply skill'd in the mystery of cards and dice as his master and sets up for himself.
	Fights for a Demirep in high keeping and becoming her favourite
	Sends his Purse with all he has to a friend in distress
3rd row:	Is himself the next hour in Prison for Debt.
	Writes to every fine woman he knows and is relieved by them all
	Comes out with a full purse, makes fierce love to a rich Widow and marries her
	Gets into the Army - gives a Challenge while in liquor to a Brother Officer. Thus ends this strange eventful history.

Newton includes many of the stereotyped characteristics of the Irishman which his audience would expect but his treatment is generally sympathetic, showing appreciation of the man's charm and generosity. Had it been a hostile print, it is unlikely that it would have been copied in the *Hibernian Magazine*. The print was priced at five shillings in Holland's 1794 broadsheet 'Catalogue'.

23 *Progress of a Scotsman*
'Drawn & Etch'd by R Newton'; published by W. Holland, 22 April 1794
Lit: BM 8550, for a full description; Kunzle (1973: no. 12-13, ill. p. 367);
Duffy (1986: plate 98).
405 x 525 (392 x 520)
Kenneth Monkman
In this pendant to plate 22 Newton shows himself less sympathetic to the ambitious Scotsman than he was to the Irishman. He is shown from his first arrival in Edinburgh from the Highlands (Newton cannot of course resist showing his kilt being lifted by the wind), through his transformation from obsequious servant to bullying steward, marriage to a rich widow, entry into parliament and eventual elevation to the peerage. The pushy Scotsman was a constant subject for caricature; see Duffy (1986: *passim*). Anti-Scottish feeling had been displayed in many satires directed against Lord Bute (1713–92), the principal minister in the 1760s, and the same feelings surfaced later in the attacks on Pitt's minister, Henry Dundas, whom Newton was to include in several prints. Resentment at Scotsmen was widespread, since so many did well in business, the professions and the services. There were indeed a number of Scotsmen from relatively humble backgrounds who rose in the world, though it was often as a result of making a fortune abroad, rather than through direct entry into parliament.

24 *A White Serjeant; or Special Messenger!*
'Drawn & Etch'd by R.Newton', 'London Pub April 16 1794 by Willm Holland ...'
Etching and aquatint; 392 x 502
Kenneth Monkman
In Newton's time male conviviality was a feature both of plebeian and aristocratic society. According to Grose, 'a man fetched from the tavern or alehouse by his wife is said to be arrested by the white serjeant'. Newton pictures a situation worthy of a humorous silent film: the furious wife inadvertently hits the servant behind her as she prepares to strike her husband, quite unaware that the happy party around the punchbowl is about to be broken up. This group is clearly of older tradesmen, and, judging from the steel at his waist, the unsuspecting man is a butcher. Most of Newton's prints of the battle of the sexes are, like plates 17 and 18, confined to two figures. This print, listed as costing four shillings in Holland's 1794 'Catalogue', seems to be one of a series with many figures showing dramatic encounters between the sexes; it is similar in format to *Venus Surrounded by Cupids*, 12 Jan. 1793 and *A Row at a Cock and Hen Club*, 1 March 1798.

25 *Undertakers in at the Death!!*
'Drawn & Etch'd by R Newton' 'Pubd April 20 1794 by Willm Holland...'
262 x 415 (238 x 415)
Kenneth Monkman
The subject of death is one which Newton, like Woodward, constantly turned to as a source of humorous situations. Whether he saw death simply as a stock subject or whether he suffered from ill health and was aware of the imminence of his own demise is a matter of conjecture.

26 *Evangelical Portraits - or, Pretty Parsons sitting for their Pictures; or vanity, vanity, vanity, all is vanity !!!*
'Drawn & Etch'd by R.Newton'; published by W. Holland, 20 June 1794
452 x 532
Laurence Sterne Trust
The verses below the title read

> Our Parsons of old to their Flocks were good preachers
> In Public and Private, were good moral teachers
> But now we see plainly, our clerical Elves
> Think of nothing so much as of loving themselves

This amusing plate, with its marvellous image of the fat clergyman clutching the tythe pig (bottom, 2) and its dialogue presumably written by Holland, pokes fun at the popularity of clerical portraiture. By the end of the eighteenth century it was not just the higher clergy who were being portrayed; the increase in the number of portrait painters meant that minor clergy were also being painted, just as were lay people of lower rank. There are two references to the portraits being engraved (top, 2; bottom 1). Portrait prints of popular preachers, many of them Methodist, could be seen in print-shop windows. Prints of lesser-known figures were often distributed as 'private' prints; in bottom, 1, the cleric seems reluctant to pay 'Mr Townley' twenty guineas to engrave a print of his portrait, but would be prepared to sell two hundred copies of such a print to his flock. (This is something of an in-joke; Charles Townley was a genteel artist and engraver who worked on occasion for Holland, see above p. 63, n. 99). This piece of dialogue neatly makes the cleric seem at once close-fisted, vain and arrogant: unprepared to pay out himself, but willing to foist a print of himself on his flock. The clever dialogue has the portrait painters, who are by no means spared by the artist, using a mixture of flattery and disrespectful impatience.

Top row

1 My God, my Lord if you continue dozing I can/ never get on. Keep awake but the quarter of an hour longer and I shall be done

2 What a beautiful Print our dear/Brother Simon Scrape will make from this and what/an ornament for the Parlours of the righteous

3 The very face of/ when he was about twenty and he was counted/ the handsomest man that ever grac'd a Pulpit

Middle row

1 Smile a little Sir youre much too grave/there – a little more – that's it, now you've/ hit it

2 I like to encourage you Frenchmen/ye are all men of genius and can make something of a pretty Portrait

3 You have totally spoil'd by that twist/the whole harmony of your/features. You look as if snuff dropp'd in your eye

Bottom

1 Twenty guineas is a great sum,/but tell Mr Townley if he engraves the head/well I'll take two hundred which I can dispose/of among our pious people

2 A Tythe pig is quite a new idea, but for my/own Part Doctor I see more propriety in it than my grandmother leading a Sheep or/ fondling a Kid

3 Your head a little more erect - there/that's it - never saw anything more/ graceful and fascinating!

This print was priced at five shillings in Holland's 1794 'Catalogue'.

27 *A Night Mare*
'Drawn and Etch.d by Rd Newton', published by W. Holland, 26 October 1794
Etching and aquatint
Lit: BM 8555; Nicolas Powell, *Fuseli: The Nightmare*, (London, Allen Lane, 1973), figure 4
(252 x 317)
Andrew Edmunds
This print derives from the famous picture by Henry Fuseli, *The Night Mare*, which Newton probably knew through the best-selling stipple engraving by Thomas Burke, issued by the engraver-publisher John Raphael Smith, in 1783, George (1959 ii: plate 74); Donald (1996: plate 73). This was burlesqued by a number of other caricaturists; see Powell (1973: *passim*); and Donald (1996: plates 74–6).

28 *'Shepherds I have lost my Waist!'*
'Rd Newton del et fecit', published by W. Holland, 12 November 1794
Lit: BM 8569; Paston (1905: plate xliv as 12 November 1795 with title 'The Rage')
British Museum D 3-702, from Banks Collection
322 x 255 (255 x 232)
This delightful print is one of a number in which Newton shows his interest in the comic possibilities of fashion. This impression is one with early colouring; it was one of the first prints by Newton to enter the British Museum, as part of the collection of Miss Banks, a pioneer collector of ephemera and sister of the naturalist Sir Joseph Banks. The rollicking song, which is reproduced here in full since George does not quote it, was probably entitled *The Rage*, since Isaac Cruikshank used the verses in a print with that title (BM 8570):

Shepherds I have lost my Waist!
Have you seen my Body!
Sacrificed to modern Taste,
Im quite a Hoddy Doddy!

Never shall I see it more,
Till Common Sense returning
My Body to my Legs restore
Then I shall cease from Mourning.

For Fashion I that part forsook
Where Sages place the Belly,
Tis gone – and I have not a nook
For Cheese Cake, Tart, or Jelly!!

Grose defines 'Hoddy Doddy' – 'all a[r]se and no body' – as a short person. Newton has not exaggerated the rise of the fashionable waist (see also plate 40). In 1796 it was reported that 'The Ladies' waists have ascended to the shoulders', *Chester Chronicle*, cited Cunnington (1964: 310).

29 *The Unlucky Discovery*
'Rd Newton del et fecit', published by W. Holland, 21 December 1794
315 x 248 (252 x 248)
Kenneth Monkman
The discovery of illicit lovers *in flagrante* has of course always been a favourite theme in humour, but this print shows a tavern landlady – described as a follower of the methodist preacher George Whitfield – upbraiding not her husband, but her tapster. There is a witty twist at the end of the song:

As Landlady Dobbins a Whitfieldite pure
At Meeting one Sunday delay'd
Coming home unexpected she caught on the floor
Her Tapster with Dolly the Maid.

She flew to the Ladle, the Poker, the Spit –
But at last she began to proceed,
Sure Satan himself, of the bottomless pit,
Will avenge such a damnable deed.

Pack off thou damn'd dog, or I'll give thee a douse,
Avaunt with thy Babylon whore;
What, when I have twenty good beds in my house,
To do such a thing on the floor!!!

This is more a comic print with verses than a song-sheet, but it is worth mentioning that Holland published several song-sheets as well as songbooks. Newton provided some headpieces, such as that to the French revolutionary *Ca ira*, 18 November and 20 December 1792, and *Country and Town*, a song in praise of life in the city by Captain Charles Morris, who is shown among the chimney pots of London, 17 October 1796.

30 *The Blue Devils!*

'Designn'd & Ethd by R.d Newton', published by W. Holland, 10 February 1795

Lit: BM 8745

405 x 272 (368 x 248)

Kenneth Monkman

In this amusing print of a miserable invalid, Newton introduces some intriguing little devils, with one wearing ludicrous top-boots. These are reminiscent of the ones in Gillray's earlier print of Edmund Burke, *Cincinnatus in Retirement*, 1782, see BM 6026; Robinson (1996: plate 29); Donald (1996: plate 65). Newton returned to the theme in *Imps*, 25 November 1796, which has three rows of little devils. This is one print which was known in Victorian times, when much of Newton's *oeuvre* was regarded as indecent. This 'clever design' was the only print mentioned by Samuel Redgrave in the brief entry on Newton in his *Dictionary of Artists of the English School*, 1878.

31 *Tumbling over a Ghost!*

'Drawn & Etch'd by Rd Newton', published by W. Holland, 6 February 1795

340 x 268 (310 x 268)

Kenneth Monkman

32 *British Servants. With Honesty and Fidelity; Against French Servants with Perfidy & Impudence!*

'Drawn & Etch'd by R. Newton', published by W. Holland, April 1795

240 x 692

Kenneth Monkman

The war with France was an excuse for satirists to criticise the idea of employment of French servants, of whom there had long been hundreds in London. This is a less serious attack than some earlier ones, such as L. P. Boitard's *The Imports of Great Britain from France*, 1757 (BM 3653). In his typically subversive way, Newton manages to make fun of the British employers as much as of the French servants and their supposedly corrupting ways.

The seated lady on the left tells the splendidly dressed governess, with her smart hat, enormous muff and little dog: 'You mistook my Advertisement entirely; I advertised for an English Governess who could speak French fluently; not a French Governess who would teach my Girls something more than I wish they should learn.'

In the second scene the matron on the left tells her staff: 'That's right, my good Servants, toss the French rascal well! He says he is famous for managing an Intrigue; I want no such Servant; I'm none of the Wagtail family, nor you Master either.' The Frenchman being tossed in a blanket by the fearsome couple – perhaps the butler and cook – is shown in a typically stereotyped way, emaciated, with a pigtail and patched breeches.

The topic of servants was one for constant discussion among leisured women. When the poet Robert Burns, a working farmer, was taken up by the gentry after the success of his *Poems* published in 1786, he found the constant criticism of servants – many of whom he knew personally – one of the most tedious and insensitive aspects of polite society.

33 *A Magician*

'Design'd & Etch'd by Rd Newton', published by W. Holland, 11 May 1795
245 x 360
Kenneth Monkman

In this delightfully absurd print Newton shows a boy terrified as the magician summons a demon out of the bottle. The cat and dog, with their goggle eyes, make one regret that Newton did not depict more animals.

34 *A Will o' th' Wisp or Jack O' Lantern!*

'Design'd & Etch'd by R. Newton', published by W. Holland, 9 June 1795
248 x 350 (222 x 330)
Kenneth Monkman

In November 1794 Holland published Newton's *A Will o' th' Wisp* (figure 29). The design was clearly a popular one as Newton adapted it into a political print, *A Political Will o' the Wisp*, showing Fox, which he published himself from 26 Wallbrook on 4 June 1795. The print here is very similar to the earlier one with the same title; the church is smaller and the woman does not clutch the man's arm in the earlier version. The plate seems to have been reworked: in some impressions the will o' th' wisp's hair stands up higher and there are changes to the sky.

35 *No Body. Some Body*

'Rd Newton del et fecit.', published by W. Holland, June 1795
298 x 362
Andrew Edmunds

In this plate Newton has fun showing the contrast between the delightful young woman on the left who is 'No Body' and the buxom 'Some Body' on the right. During the 1790s ostrich feathers, worn upright for Court, became the universal mode in evening dress. Just as an earlier generation had found it difficult to manoeuvre with hooped skirts, so feathers now caused considerable difficulties. In 1795 the *Times* reported, no doubt with tongue in cheek, that

> At all elegant Assemblies there is a room set apart for the lady
> visitants to put their feathers on, as it is impossible to wear them
> in any carriage with a top to it. A young lady, only ten feet high,
> was overset in one of the late gales.

Ladies often wore more feathers than shown here; in 1799 the *Ipswich Journal* reported that 'hardly any lady has less than three', quoted Cunnington (1964: 387).

36 *Enjoying an Old Friend*

'Design'd & etcht by Rd Newton', published by W. Holland, 17 July 1795
245 x 350
Andrew Edmunds

In this splendid depiction of the Devil and a clergyman smoking and sharing a bowl of punch the caption reads:

> Come my old Friend I'll give you a Toast.
> May the Devil ride rough shod over the/ rascally part of the creation!

37 *A Clerical Alphabet*

'Drawn and Etch'd by Rd Newton 1795' 'Pubd Willm Holland ... July 22 1795'
'Note – the Idea of this Print originated with M.r W---n, who wrote the 1, 2, 3, 4, 6, 7 and the two last lines – all the rest were written by Mr Holland'
470 x 670 (445 x 670)

Benjamin Lemer

The cooperation of Newton and Holland, aided by a 'Mr W---n', has produced a splendid print which includes most of the clerical 'types' familiar to a late eighteenth-century audience:

A Was Archbishop with a red face
B Was a Bishop who long'd for his place.
C Was a Curate, a poor Sans Culotte.
D Was a Dean who refus'd him a Coat,
E ven grudg'd him small beer to moisten his throat!
F Was a Fellow of Brazen-Nose College
G Was a Graduate guileless of knowledge
H Was a high-flying Priest had a call!
I Was an Incumbent did nothing at all.
K Was King's Chaplain, as pompous as Didd.
L Was a Lecturer dull as a clod
M Was a Methodist Parson, stark mad!
N Was a Non Con and nearly as bad.
O Was Orator, Stupid and sad.
P Was a Pluralist ever a craving.
Q A queer Parson at Pluralists raving!
R Was a Rector at Pray'rs went to sleep.
S Was his Shepherd who fleec'd all his sheep.
T Was a Tutor, a dull Pedagogue
U Was an Usher delighted to flog.
V Was a Vicar who smok'd and drank grog.
W Was a wretched Welch Parson in rags
X Stands for Tenths or for Tythes in the bags
Y Was a young Priest the butt of Lay Wags
Z Is a letter most people call Izzard/and I think what I've said will stick in their gizzard.

It is possible that Mr W--n was Robert Wathen, a well-known wit and amateur actor associated with the profligate Lord Barrymore.

Until the war with France many English prints were still printed on French paper. This impression of the print is on wove paper, watermarked 1794, and made in Kent by James Whatman; it is exceptionally carefully coloured and has been signed in pen on the right-hand corner 'G Villars cold'. Such a signature is most unusual; the colourist was probably either a freelance colourer, or even an artistically minded collector, rather than an employee of Holland's.

38 *Hungry Rats in a Little House*
'R Newton del' in sub.; published by W. Holland, 22 September 1795
249 x 350 (230 x 330)
Andrew Edmunds, from the Starhemberg Coll.
One of the liveliest of Newton's schoolboyish prints.

39 *A Bachelor's Litany*
'Drawn and Etch'd by Rd Newton' 'Invented and written by Willm Holland', published by W. Holland, 4 November 1795
Printed on two plates, each *c*. 362 x 610
Benjamin Lemer
This plate is one of the most splendid of Holland's commentaries on the battle of the sexes, invented and written by him, with accompanying illustrations by Newton. The words of this clever song deserve transcription:

Left-hand plate: top row

Left: From a Wife the spoil'd child of a dull doating mother,
 Who in anyone's breed cannot see such another,
 And who's always prefer'd to her sister and brother,
 Good Lord deliver me! (omitted in transcription after other verses)

Middle: From a Wife without fortune, and proud as the devil,
 Who can't to her husband be commonly civil,
 From one squalling brat by such a great evil,

Right: From a Wife who would put her poor mate on the rack
 To obtain ev'ry day new Fal-lals for her back
 And would lead him a life worse than any poor hack,

Bottom

Left: From a Wife, with her husband can wheedle and fawn,
 Yet would send the next hour his best things to pawn
 To support in high stile her dear Captain Macbrawn

Middle: From a Wife who in reading could ne'er find delight,
 Who ne'er in her house can see any thing right,
 And who scolds her poor servants from morning till night,

Right: From a Wife whose delight is her husband to teaze,
 who in company turns to contempt what he says,
 And whose head teems with scraps of cursd novels and plays,

Right-hand plate: top row

Left: From a Wife who when Stockings and shirts want repair
 sits reading a novel all day in her chair,
 and when spoke to cries out in a rage 'I don't care'

Middle: From a Wife ever boasting of poor proud relations,
 Whose ancestors flourish'd in the courts of great nations
 Who can see merit only in very high stations

Right: From a Wife gadding oft to a pickpocket sale,
 While her husband each day thinks of nought but a jail,
 And who sits unconcern'd when creditors rail,

Bottom row

Left: From a Wife ever scribbling ill nature and scandal,
 Who tries to catch ev'ry thing by the wrong handle,
 And whose tongue never rests while there's snuff in the candle

Middle: From a Wife ever clacking of taste and the graces,
 So slothful herself to judge from her traces,
 Those three lovely beauties ne'er wash their sweet faces!

Right: From a Wife ever cribbing to make up a purse,
 To treat with strong cordials her gossips and nurse,

FROM THIS WORST OF ALL PLAGUES POOR MAN'S GREATEST CURSE !!!
 Good Lord deliver me!

40 *Female Gamblers in the Pillory*
'Rd Newton'; published by W. Holland, 13 May 1796
Lit: BM 8877, entry based on a photograph
380 x 275 (342 x 255)
Andrew Edmunds, from the Starhemberg Coll.

On 9 May 1796 the judge Lord Kenyon, shown on the extreme right, deplored the prevalence of gambling, declaring in the words given on this print that

> If any Prosecutions are fairly brought before me, and the parties are
> justly convicted whatever may be their rank, or station in the country,
> though they should be the first Ladies in the land, they shall certainly
> exhibit themselves in the Pillory!

This was an open invitation to the caricaturists, and within a week Gillray and three others had taken up the theme (BM 8876-80). Gillray's print, *Exaltation of Faro's Daughters* (figure 27), shows two women, Lady Archer and Albina Hobart, Countess of Buckinghamshire, in the pillory, but he makes them into hideous old women. Newton also shows Lady Buckinghamshire, who was notorious for her gambling parties; according to George, the younger woman is Mrs Concannon. Newton has used the opportunity to make her extremely attractive, showing the two women in fashionable turbans, the younger one wearing Prince of Wales's plumes. Two other prints showing exaggerated plumes are *Tippies*, 6 March 1796, and *Cool and Comfortable*, 11 March 1796.

41 *What a Nice Bit!*
'Rd Newton delin', published by W. Holland, 8 July 1796
(220 x 235)
British Museum 1990-1-27-2
The depiction of black women as the object of lustful Britons was not an unknown subject. This burlesque may have been prompted by Gillray's *Cymon & Iphigenia*, 2 May 1796 (BM 8908; Klingender 1944: plate 66), a print published two months earlier, in which a yokel advances on the sleeping 'Iphigenia'. The story had become known through Garrick's adaptation of Dryden's version of the tale by Boccaccio.

42 *Contrasted Lovers*
'R.d Newton delin', published by W. Holland, 3 August 1796
260 x 355
Kenneth Monkman
Here Newton contrasts the preoccupations of a young and an old man.
On the left a moonstruck young man looks at a miniature of his beloved:

> Give me sweet nectar in a Kiss
> And let me taste ambrosial bliss!

On the right the corpulent old fellow clutches a printed sheet headed 'Wine Tax'. Pitt raised the duty on wine by the equivalent of sixpence a bottle in April 1796:

> Give me my Nectar in a Glass
> And as for Kissing–Kiss my A--- !

43 *The Four Stages of Matrimony*
'Drawn & Etch'd by Rd Newton'; published by W. Holland, 15 August 1796
465 x 338
Andrew Edmunds, from the Starhemberg Coll.
This print, with its four compartments charting the progress of a marriage, shows Newton's two styles: the elegance of his first group of lovers is in stark contrast to the other grotesque pairs.

44 *A Flight of Scotchmen/London*
'Design'd and Etch'd by Rd Newton 1796', published by W. Holland, 3 September 1796
332 x 470 (310 x 452)
Kenneth Monkman
This memorable image of Scotsmen descending upon London was later adapted to
show lawyers by C. Williams in *Blessings of Brittain – or A Flight of Lawyers,* published
by T. Tegg; see George (1967: figure 179). Although the main flight of Scotsmen are
landing on London, others are shown landing in Ireland, the West Indies, America
and Germany. Newton could have added Russia, where a number of Scots were in
the Imperial service.

45 *Parsons Drowning Care*
'Desn and Etch'd by R. Newton 1796', published by W. Holland, 10 November 1796
248 x 352
Andrew Edmunds, from the Starhemberg Coll.
In this splendid print of five drinking parsons drowning the unforgettable figure of
'Care', Newton has used his wide repertoire of facial expressions, including goggle
eyes, thick lips and beetle brows. The print takes its place alongside other bold
designs which lack any background, e.g. *An Old Grudge* (figure 18), *Enjoying an Old
Friend* (plate 36), *Pull Devil – Pull Parson*, 9 September 1795, and *Beggar my Neighbour*,
20 April 1796. These all show confrontations, mostly between parsons and abstract
figures. All are amusing enough in their own right to have dispensed with dialogue,
but in each case Holland the publisher has added text. In this example it takes the
form of a drinking song:

> O'er the merry midnight bowls
> Gods how happy we shall be
> Days were made for vulgar souls
> Nights my Boys, for you and me!
>
> Seize the Villain, plunge him in,
> Now the hated miscreant dies
> Mirth and all thy train come in
> Shut out sorrow tears and sighs
>
> Care, thou canker of our joys,
> Now thy tyrant reign is o'er
> Fill the mystic bowl my boys
> Join in Bacchanalian roar.

46 *Billy's Political Plaything*
'Rd N[ewto]n [invt et fecit]', published by W. Holland, 21 November 1796
Lit: BM 8839
(308 x 225)
Andrew Edmunds
Holland laid aside political caricature in the two and a half years after he came out
of Newgate in spring 1794, no doubt apprehensive about getting into trouble again.
He gradually became less cautious at the end of 1796, and issued a few political
satires by Newton, of which this is the first. It is understandably ambiguous, but if
either man still had radical sympathies they are not apparent in this print.
 William Pitt, the Prime Minister, is shown whipping a top surmounted by the head
of Charles James Fox, who is shown sporting a revolutionary rosette. The
parliamentary battle between the two had continued unabated during the 1790s,
with Fox constantly pressing for an end to the war with France. In the summer of

1796 the British government made overtures to the French, but the negotiations broke down in October. By then Fox's following in parliament had dwindled to the point that, in a motion criticising the government for the failure of its peace attempts, he could only raise 37 votes against the government's 212. In this print, which reflects Pitt's supremacy, Newton has given him one of the bitterest expressions in any of his satires.

47 *A Priest Ridden Village*

'Rd Newton del et fecit 1796', published by W. Holland, 29 November 1796
248 x 345 (222 x 332)
Andrew Edmunds, from the Starhemberg Coll.
This is one of Newton's most ludicrous and memorable burlesques, full of typically Newtonian touches, such as the way one of the riders in the centre is fondling his steed's breast.

48 *Madamoiselle Parisot*

'Sketched at the Opera by Rd Newton', published by W. Holland
Lit: BM 8893, as 1796; Wagner (1990: 289, figure 56); Mary Grace Smith, *A Loftier Flight, Charles Louis Didelot* (Middletown, Conn., Wesleyan University Press, 1974) p. 54
(290 x 352)
British Museum 1868-8-8-6524
This print shows Newton's growing interest in more realistic portraiture. Newton was obviously very taken by Parisot, a nineteen-year-old French dancer, who made a successful debut in London in spring 1796. The *Morning Chronicle* of 7 March confirms the accuracy of Newton's print: her balance was 'positively magical, for her person was almost horizontal while turning as on a pivot on her toe'. According to Smith she was sympathetically received, not only because of her beauty and skill, but also because her father had been guillotined under Robespierre. Her exposed bosom is not the product of Newton's imagination: she is similarly shown, on the extreme right, in Gillray's *Modern Graces* (BM 8891, 5 May 1796). The clergyman may be taken as a type but the other observer in the box is the libertine Duke of Queensberry.

Wagner suggests that Newton uses the comic and the grotesque in his erotic satires 'as a means to attack, and as an antidote against, their own implicit pornography' and suggests that Newton is ridiculing the dancer's male admirers. Newton also featured the dancer in *Old Goats at the Sale of a French Kid*, 5 May 1796. This shows her on a dais, being auctioned by a puckish figure; in the foreground, standing alongside theatrical characters and another Newtonian clergyman, there are the identifiable figures of Fox, Pitt and Queensberry.

How far Newton is really ridiculing the captivated males' delight is open to debate; there is no doubt, however, about the glee with which the caricaturists later pounced on clerical indignation at French dancers. In March 1798, Shute Barrington, the Bishop of Durham, made an attack on French opera singers as emissaries from France to undermine morality, 'who by the allurement of the most indecent attitudes, and the most theatrical exhibitions, corrupted the people' – an attack which was a green light to Gillray, Cruikshank and Woodward to produce mocking satires; see BM 9297-9301; Smith (1974: figures 13–17).

Parisot was painted by a number of artists, including Masquerier; see Klingender (1944: plate 57), and A. W. Devis. She married a Mr Hughes of Golden Square in 1807 (*Gentleman's Magazine*, 77 (Dec. 1807), 1171).

49 *A Paper Meal with Spanish Sauce*
'Rd Nn des et fecit', published Newton, 14 March 1797
350 x 250
Andrew Edmunds, from the Starhemberg Coll.
Newton had begun to resume political satires for the cautious Holland at the end of
1796 (see plate 46), but after he set up on his own he was able to produce many more,
taking advantage of Pitt's continuing unpopularity. In his first month as an
independent publisher he followed Gillray (see BM 8990, 8995) in attacking the
Government's authorisation of the issue of £1 and £2 notes with this and another
satire, *The New Paper Mill*, 12 March 1797. Ten days later he depicted Pitt being
strung up on the gallows in *The General Sentiment*, 22 March 1797. In *A Paper Meal
with Spanish Sauce*, Newton alludes to the purchase by the Bank of England in 1797
of Spanish-American silver-dollars. These were stamped with the head of George III
and were popularly referred to as 'the head of a fool on the neck of an ass'. They
were circulated to make up for the shortage of silver coins. In the print the coins have
been left uncoloured to show that they are silver.

50 *Mr Follett as the Clown in the Pantomime of Harlequin and Oberon*
'Desnd and Etch'd by Rd Newton', published by Newton, 3 April 1797
BM 9003
350 x 250 (313 x 230)
Andrew Edmunds, from the Collection of the Dukes of Northumberland
In 1797 Newton was able to resume his mocking caricatures of the King; this one is
quite good-natured, and is certainly much milder than *Treason!* (figure 34), which was
to be his final plate of the King. John Follett, Jr (1765-99) was one of the most
popular clowns of his day. The pantomime *Harlequin and Oberon; or, the Chace to Gretna*
was first played at Covent Garden Theatre in 1796. The colouring on this print is
particularly fine. The artist's drawing often served as the pattern for colourists, but
the artists sometimes coloured a few specimen prints themselves, either as patterns
or to be displayed in print-shop windows.

The King and Queen were regular theatregoers, usually on Thursdays, and artists
took advantage of this to take their likenesses.

51 *Self-portrait, holding the print of Mr Follett as the Clown*
Watercolour
Sheet 350 x 250
Wilhelm-Busch-Museum, Hannover
In his final year Newton tried to establish himself as a miniature painter (see figure
36). No examples of his miniature work have been traced, but we are fortunate that
this self-portrait, formerly in the collection of Ronald Searle, has survived.

52 *The First Interview, or an Envoy from Yarmony to Improve the Breed*
'Rd Newton del et fecit'; published by S. W. Fores, 19 April 1797
Lit: BM 9007
248 x 328 (225 x 328), on laid paper
Kenneth Monkman
In 1796 a marriage was arranged between Charlotte, Princess Royal (1766–1828),
the eldest daughter of George III and Queen Charlotte, and Prince Frederick
William Charles (1754–1816), later King Frederick I of Württemberg. After the
announcement Gillray made a caricature of the Prince with the title *For Improving the
Breed*, which emphasised his corpulence, BM 8827; Klingender (1944: plate 97);
Duffy (1986: plate 102). The Prince arrived in London on 15 April and within a few
days several satires had appeared, including another by Gillray (BM 9006); Newton
clearly bases his figure of the Prince on Gillray's first print. A further batch of satires

appeared after the couple's wedding at St James's Palace on 17 May. Interestingly the Prince, like a number of other foreign visitors, bought caricatures on his visits to London, and it seems that he had sufficient sense of humour to have bought copies of this print (information from Andrew Edmunds).

This is one of some five satires by Newton which were published by S. W. Fores after Newton stopped working for Holland. Whereas Holland and other publishers of satires had moved over to using the smoother wove paper, Fores continued to use the rougher and cheaper laid paper.

53 *Head – and Brains*
Lit: BM 9012, also recording a French copy
Watercolour
318 x 272
British Museum 1868-8-8-638

54 *Head – and Brains*
'Rd Nn del et fecit' 'Pub by R Newton Brydges S May 5 1797'
Sheet 305 x 255
Benjamin Lemer
The title of this print implies that Pitt was the brains behind the figurehead of the King. The two had worked together extremely well since 1784, when after much pressure, the King had finally persuaded the twenty-four-year-old Pitt to form a ministry and replace the coalition between Fox, whom the King hated, and Lord North. George was a conscientious, if not always successful, monarch and he and Pitt steered the country through difficult times.

Although there were many satiric attacks on Pitt at the time, Newton's were the most forthright. Another satire against Pitt, *The Devil's Darling*, which shows him being dandled by the Devil (figure 30), bears the same date as this one.

The colourer of this copy of the print was clearly not working from Newton's watercolour.

55 *Drink to me only with thine Eyes*
'R Newton 1797', published by W. Holland, 8 May 1797
220 x 250 (200 x 235)
British Museum 1948-2-14-354
During March 1797, Newton's first month as an independent publisher, he supplied satires to S. W. Fores. His old master Holland did not publish any of his prints between December 1796 and March 1797. During May, however, Holland published four plates by Newton, including one three-sheet print (plate 57). Newton's characteristic use of goggle eyes is seen to excellent effect in this print, which takes its title from the opening lines of the poem by Ben Jonson (1572–1637).

56 *The Full Moon in Eclipse*
'Design'd & Etch'd/ by/ Rd Newton', published by W. Holland, 8 May 1797
248 x 235 (222 x 235)
Andrew Edmunds, from the Starhemberg Coll.
This is one of Newton's most absurd schoolboyish prints.

57 *Cries of London*
'Rd Newton del et fecit 1797', published by W. Holland, May 1797
Two of three plates, each *c.* 220 x 603
Kenneth Monkman
The street traders of London, with their different cries, had long been a topic of

interest to artists. The subject had been brought before the public during the 1790s by the series of glamorised 'Cries' painted by Francis Wheatley, which were exhibited at the Royal Academy and then published as a series of stipple engravings by the printsellers Colnaghi. Here Newton depicts some of the social and political figures who had appeared in many of his earlier prints:

Top

[Burke] Here's my fine Shillelees for Jacobin backs!/ and Irish Brogues for the French Clergy./ Who buys! who buys, ho!
[Duke of Queensberry]: Here is the renowned Plenipotentiary!/ Jenny Sutton! Murock O Blaney!/ and Father Paul, all for a Single/halfpenny - Buy my Ballads
[Duke of Bedford] Long Tails Short Tails, bob/ Tails, of all colours and free/from vermin cut from the/ Sapsculls of Bedfordshire
[Duchess of Gordon] Who buys my Scotch Whisky/ as delicious a Cheery Bounce! G-r--s/ Elixir of Life, only a penny a/ glass
[Pitt] Rare news! bloody news! Ireland is sunk in/ the Bog of Allen! The ragamuffin French Army/ is totally destroyed and the game is up with the/vagabond Jacobins! bloody news! bloody news!
[Fox] Any – bad – Shillings!
[Sheridan] Bill o'the Play, your Honour
[Duke of Norfolk] Rare Norfolk Dumplins/ nice Norfolk dumplins

The third sheet, not shown here, shows the Prince of Wales's crony George Hanger as a seller of sand; Henry Dundas as a seller of Scotch Crowdy; Mrs Archer and the Countess of Buckinghamshire, two of those who ran an aristocratic gambling table (see plate 40).

58 *Buonaparte Establishing French Quarters in Italy*
'Rd Nn del et fecit', 'Pub by R Newton opposite the Pit Door Drury Lane November 9 1797'
248 x 350.
Kenneth Monkman
The name of Buonaparte was virtually unknown in England before his victorious campaign in Italy in the winter of 1796–7. Newton produced a group of three satires on him in 1797; in each he is depicted in an aggressive allegorical way rather than as a realistic figure, even though prints of him were available and the earliest satire of him, produced by Isaac Cruikshank for Fores in March 1797 (BM 8997), was evidently based on a portrait.

59 *New Year's Gifts*
'Drawn and etch'd by Rd Newton', published W. Holland, ? 1 January 1798
Two of three plates, *c.* 250 x 700
Benjamin Lemer
This is one of the largest prints which Newton made for Holland, and it may be the last he made while he worked for him.

Left-hand plate

[pregnant woman]
[outraged recipient of oysters]
[old watchman] O you Wagabone Whore is this your New Year's Gift! I'll get your Back/ a pretty tickling for this in Bridewell.
[parson] Moses, there is a new Year's Gift,/ Take it home and get it dress'd for

your/ Tis as sweet as the tips of a/ Vestal virgin
[sexton] Westal Wirgin! by the life of Pharoah/ it stinks like a corpse in the
Dog Days.
[man looking in mirror] Why what the devil do I see! they/ are not Carbunkles or
warts! dam me they look like Horns! a very/pretty New Year Gift by jingo!
[man holding 'Leakes Pills', used for venereal disease] What shall I say to Vather
and Mither when I get hoam/ Sister Nan, the Methodist will say I've got into the
Devil's/ fiery furnace! and I shall set the whole Willage in a /
Here's a New Year's Gift with the devil to it!
[old Scotsman] O the sweet Gift! how like its own/ dear papa!
[young wife] And so it is, Sir, as like as two Peas/ and you should not mind
the jokes of the/ Parson, who says it is more like the Irish Captain.
[old woman] Thee, my sweet little God Son, ther's my/ New Year's Gift, a
beautiful crooked Halfpenny./ I have left you in my Will my Bible and
Prayer/ Book and a nice new Guinea! and tell your/
Mama I've left her all my comfortable under/ Petticoats.

The third plate, of which there are fragments in the Bibliothèque Nationale, includes
a scowling convict in irons, and an indignant young woman expecting her husband
to settle £300 worth of bills as her New Year's gift; the right-hand portion, which has
Holland's name as publisher, shows a stout woman being whipped behind a cart; this
may be based on Gillray's imaginative depiction of Lady Buckinghamshire being
whipped: *Discipline à la Kenyon*, 25 March 1797 (BM 9079), and the print is therefore
tentatively dated to early 1798, though if Gillray's design is based on Newton's,
rather than vice versa, it must be earlier.

60 *Consistancy!! – or Rival Clowns in the New Pantomime of Harlequin & Quixote*
'Drawn from life & Etch'd by Rd Newton'; published by Newton ' at his Original
Print Warehouse', 8 January 1798
(355 x 460)
Benjamin Lemer
Harlequin and Quixotte was an afterpiece devised by the actor and manager John
Cartwright Cross, and first performed at Covent Garden on 26 December 1796,
with its final performance on 2 February 1798. The cast included Pietro Bologna
(fl. 1786–1814) as Sancho, his son John Peter Bologna (1775–1846) as Harlequin
and Follett (see plate 50). The scale of this print is like that of *A Bugaboo*, (plate 7),
unexpectedly large.

61 *The Celebrated Mr John Cussans in the Character of Jerry Sneak*
'The Face Sketch'd at Sim's at a late / Dinner by Richd Newton 1798/Price Two
Shillings Cold', published by Newton, 5 April 1798
Lit: BM 9292 (a later state showing him as a waiter)
(305 x 202)
BM 1948-2-14-335, with the title cut off and pasted at the top of the print
This print suggests that Newton was keen to produce more etched studies, a mixture of
portrait and mild caricature, of the kind which Robert Dighton was later to make
popular. John – or William – Cussans, a well-known London 'character' who had a small
private income, appeared as Jeremy Sneak with a new song for a single performance of
The Mayor of Garratt at the Haymarket on 26 March 1798, but does not seem to have
otherwise appeared on the stage. Some of Cussans's exploits are recounted in J. T.
Smith's amusing memoir, *Nollekens and his Times*. This was the last print which Newton
issued himself. Cussans is said to have won a wager that he 'would serve as a waiter for
three months without being at any time out of humour'; this plate was later changed,
probably after Newton's death, to show him as a waiter and reissued (BM 9292).

62 *The Male Carriage or New Evening Dilly*
Etching and aquatint, published by W. Holland, 17 September 1798
(268 x 222)
Andrew Edmunds
The bawdy text on this print, probably composed by Holland, compares this lady of
the town with a passenger conveyance:

> The Male Carriage or New Evening Dilly sets out for Soho at 8 o'clock every
> evening; stops at Drury Lane and Covent Garden to take in, or if desired, will
> receive in the Yard of St George, and go easy over the Stones, and for the
> accommodation of the Public will also take up and let down in any part of the
> Town – Inside Passengers to pay £1.1.0 allow'd to carry two Stone – The Carriage
> fresh painted, lined with Crimson velvet; fine hair seat, of remarkable pleasant
> pace, well guarded and kept in good order – The Axle-Tree warranted from taking
> fire let the motion be ever so quick. The standing rule to pay before entrance.
> None permitted to get up behind. Performed by Derriere Harris and Co.

63 *After Mass*
Watercolour
Sheet 305 x 405
Kenneth Monkman
This splendidly robust picture of a fight has been given this title by Kenneth
Monkman, because the book on the ground is open at the order of Mass; whether
Newton intended this drawing to show brawling Irishmen is a matter of conjecture.
It is painted on the back of the proof of a sporting print, which may have been
discarded by the Hixon family, copperplate printers who seem to have shared the
house in Brydges Street where Newton had his shop at the end of his life. No print
is known to exist of this drawing. Had Newton lived he would probably have
supplemented his earnings by the sale of such drawings to other printsellers; in
1797–8 ten of his watercolours, several of which have survived, were engraved as
'drolls' – that is, social satires – by the firm of Laurie and Whittle.

64 *William Holland and his wife*
Detail from *Promenade in the Stateside of Newgate*, 5 October 1793
Henry E. Huntington Library and Art Gallery, San Marino, California
For full image see figure 17, and see also pp. 37–9.

Figure 28 *Progress of a Lawyer*
'Drawn and etch'd by R.d Newton 1795', published W. Holland, 10 July 1795.
c. 475 x 666
Kenneth Monkman
This print, with its 27 different depictions of the lawyer – who is recognisable as the
Chancellor, Lord Thurlow – follows that same formula as earlier '*Progresses*':

Top
Make your Maiden Speech/ in a Debating Society Prove at Coachmaker's Hall/
that Law is the Support of the State
Show your consequence in a Coffee House
Prove to a Parson that Law/ is better than Gospel
Study the Law till you are stupified/ but still think it the quintessence of genius!
Be called to the Bar

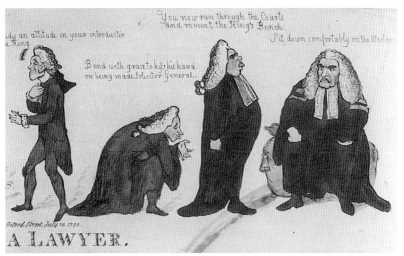

Figure 28 *(detail)*

Make love to a clever Attorney's/ wife and be sure tell her you are/an Irishman
Get introduced to her/ Husband
Swear he is the only honest/ man upon the Roll!

Middle
Tell him what you'll do for him/ when you are Attorney General
Return him thanks for your/ first Brief./ ... trip to Westminster Hall
Plead hard for your client and/ thunder about the liberty of the Press
Come off victorious and return thanks/ to the Jury
In your first Circuit get/ introduced to a Knight/ of the Shire
Strut before the Court-house/ and make the Country People Stare!
Plead hard for a rich, oppressive/ Landlord; the Scourge of the County
Get into Parliament through/ his interest and forget all/ your old Friends!

Bottom
Stand near the Treasury Bench
Bow to the Minister on his entrance
Prove in your Maiden Speech/ that the whole host of Opposition/are Asses!
Accept a present for your Services/ like an honest man
Flatter the Chancellor and/ get to be Kings Council
Study an attitude in your introduction/ to the King
Bend with grace to kiss his hand/ on being made Solicitor General
You now run through the Courts/ and mount the King's Bench
Sit down comfortably on the Woolsack.

Appendix

Chronological checklist of prints by and after Newton

This list is primarily of single-sheet prints, but includes prints in pamphlets (62, 74) and books with plates by Newton (61, 112, 232, 291; lack of space precludes the listing of the titles of the 84 plates in these); it excludes two plates in a periodical, discussed above, p. 47. Until the spring of 1797 Newton's publisher was, unless stated otherwise, William Holland, 50 Oxford St, and therefore his name is not included in entries until 1797. The transcription of titles in this list follows Dr George's practice in the British Museum *Catalogue of Satires* of giving titles in capitals; this avoids the awkwardness of trying to transcribe titles in which upper and lower case lettering are intermingled. It should be added that Newton generally used superscript for the final letter when abbreviating his name but no attempt has been made to reproduce this here.

Abbreviations
aq.: aquatint; col.: coloured; et.: etching; ill.: illustrated; N: Richard Newton; pub.: published; s.: shilling; sub.: subject, i.e. the image. Prints are etchings, unless otherwise stated; dimensions are given in millimetres, height before width; dimensions given in brackets are those of the subject. The great majority of Newton's prints are hand-coloured.

Principal public collections consulted, with acknowledgements for their help to the staff members named
BM: British Museum (Antony Griffiths and the staff of the Department of Prints and Drawings). BM plus a number refers to entries in the British Museum *Catalogue of Satires*; these prints can also be seen on the microfilm published by Chadwyck-Healey, Cambridge, in 1978. BM plus a number in square brackets refers to satires bought from F. Klingender in 1948, which have the acquisition number 1948-2-14-[]. A list of some 1,200 satires acquired since the publication of the *Catalogue* is available for inspection in the BM Print Room; these prints are not on the microfilm.

BN: Bibliothèque Nationale, Paris.

HEH: Henry E. Huntington Library, San Marino, California (Tom Lange).

Hope: Hope Collection, Ashmolean Museum, Oxford.

LC: Library of Congress, Washington, DC; see Elena Gonzalez, *British Political and Social Cartoons 1655-1832: A Checklist ... of the cartoons in the Prints and Photographs Division ... not in the published catalogs of the B.M.*, typescript, Library of Congress, 1968. A microfilm of these prints can be consulted in the BM Print Room.

LST: Laurence Sterne Trust, Shandy Hall, Coxwold, York (Julia Monkman).

LWL: Lewis Walpole Library, Farmington, Conn. (Joan Hall Sussler).

MRPC: Museum of the Royal Pharmaceutical Company of Great Britain, Lambeth.

WBM: Wilhelm-Busch-Museum, Hannover (Gisela Vetter-Liebenow).

WIHM: Wellcome Institute for the History of Medicine, London (William Shupbach).

YCBA: Yale Center for British Art, New Haven (Scott Wilcox).
If no locations are given, information is based on prints in private collections. Four

otherwise unrecorded prints (not seen), which were in the Collection of Anthony de Rothschild, are listed here from the typescript catalogue of his collection, 1937, in the BM Print Room (abbreviated as A. de R.).

A number of Newtons in Russia are described in L. Dukelsyaya, *English Caricatures of the Eighteenth Century* (Moscow, 1967, in Russian), brought to my attention by Omek Marks, but I became aware of this too late to include references in this Checklist.

Holland's 'Catalogues of Books, Pamphlets and Prints' cited:
[1791]: In *Wit and Mirth; or, Tom D'Urfey's Pills to Purge Melancholy*, published post 21 September 1791.
[1792]: In *Grand Battle at Cambridge*, pp. 19–24, published 31 August 1792.
[1792(2)]: At end of Paine's *Address to the Republic of France*, published post 10 November 1792.
[1794]: Letterpress broadsheet, *c.* autumn 1794 (see pp. 43–44 above)

1790
1. AN APPARITION; 1 May 1790; 2s [1794 as 'by Woodward'].
Probably not by N, but see 1 Oct. 1792 for others in set by N; LC; MRPC.

2. DISINTERESTED LOVE; 1 Nov. 1790; 2s [1792], see 3 Sept. 1793 for pendant.
'G.M.Woodward del'; LC, 333 x 258; probably not by N. (BM [-342] is a reversed version with verses either side of title rather than below it).

1791
3. A SKETCH FROM HIGHLIFE; 27 May 1791.
'R.d N' in sub.; YCBA; 280 x 355 (248 x 332)

4. AN ESCAPE A LA FRANCOIS!; 1 July 1791.
BM 7886 as [N]; YCBA; (257 x 725)

5. AN AMOROUS IRISH BARRISTER PERFORMING A PRINCIPAL CHARACTER IN A NEW AFTERPIECE CALLED THE DISAGREEABLE SURPRIZE !!! ; 'Pub.d by Paddy Whack', July 1791.
BM 8005 as [N]; 260 x 365 (243 x 365).

6. FRENCH DISCERNMENT; OR, A BUMBLING DISCOVERY!; I July 1791.
BM 8006 as [?N]; (257 x 320).

7. ABSOLUTION; 6 July 1791.
Unsigned; 220 x 285 (193 x 268)

8. LONG FACES; OR, THE FIRST MEETING OF THE NATIONAL ASSEMBLY AFTER THE KING'S ESCAPE; 7 July 1791.
(352 x 442).

9. A BOUILLI IN THE NEWEST TASTE A LA FRANCOIS!; 14 July 1791.
?N; BM 1987-5-16-8; YCBA (248 x 355).

10. SUMMER AMUSEMENT AT FARMER G-'S NEAR WINDSOR ; 9 Aug. 1791; 3s [1792].
BM 7897 as [?N], but probably by Byron and with his lettering; HEH; YCBA; Paston (1905, plate clxx); 350 x 524 (310 x 485).

11. FRIAR BACON & HIS BRAZEN HEAD; 10 Aug. 1791.
BM 7898 as [?N], 345 x 250 (275 x 240); YCBA.

12. CROPP'D LOUNGERS IN BOND ST 1791; 16 Aug. 1791; 2s [1791].
BM 8040 as [?N] but possibly by Byron; 252 x 355 (220 x 338).

13. AN ASTONISHING PARAGRAPH!; 18 Aug. 1791.
YCBA; 248 x 354 (220 x 335)

14. CROPS AND BANDELURES IN ST. JAMES'S STREET; 15 Sept. 1791; 2s
[1791].
280 x 405 (248 x 405).

15. SEPTEMBER IN LONDON – ALL OUR FRIENDS OUT OF TOWN!!!, 21
Sept. 1791; 2/6 [1792]; [1794 Cat: 'All our Friends out of Town; or September in
London. A crowd of Courtezans at a Pawnbrokers, by Newton', 3s]; (plate 1).
BM [-375]; c.272 x 475 (250 x 475); related to the watercolour, 330 x 470, formerly
in the Gilbert Davis Collection, now in HEH.

16. AN IRISH SALUTE IN ST GILES'S!; 3 Oct. 1791.
'R. Newton del'; BM [-368]; 235 x 187 (195 x 172).

17. CROPS GOING TO QUAD; 5 Oct. 1791.
YCBA; LC; 276 x 428 (256 x 410).

18. A CROP SHOP; 8 Oct. 1791 (plate 2).
'RN Del'; 248 x 355 (215 x 330).

19. MEDITATIONS ON A JORDAN; 28 Oct. 1791.
HEH; YCBA 284 x 428 (248 x 402).

20. THE TAR AND THE JORDAN!; pub. 'Rich.d Newton, Old Bailey' (figure 5).
BM 9712 as c. Nov 1791, but possibly earlier; 248 x 350 (222 x 345); YCBA.

21. A VISIT TO THE R---L COLE PIT; pub. 'Rich.d Newton G.t Portland St', 30
Nov. 1791.
BM 7924 as [?N], but probably by Byron, and with his lettering; 215 x 335 (197 x
330); YCBA.

22. THE SOLDIER ARRIVED AND THE MUSTER OF CREDITORS;
1 Dec. 1791.
(A. de R).

1792
23. THE DUCHESS OF YORK'S FOOT; pub. 'Rich.d Newton, N.o 50 [?]
G.t Portland' St, 1 Jan. 1792.
BN.

24. A BATCH OF PEERS; 6 Jan. 1792 (figure 8).
Unsigned, by or after Byron, possibly etched by N; plate 275 x 403.

25. DRILLING FOR THE MILITIA; 20 Jan. 1792.
'Rd Newton del'; BM [-348]]; (194 x 197).

26. A FRENCHMAN PLUNDERED; 20 Jan. 1792.
'R.d Newton' 'Rowlandson Del'; BM [-360]; (212 x 272).

27. NO SWALLOW WITHOUT AN OPENING; 31 Jan. 1792.
BM 8060 as [N]; YCBA; (212 x 272).

28. FRONTISPIECE TO THE WAX WORK AND MATRIMONIAL RECORDS IN
WESTMINSTER ABBEY; 20 Feb. 1792.
BM 8064 as [N]; (240 x 450); HEH.

29. TRAINING YOUNG MEN OF HONOUR IN IRELAND; 26 March 1792.
'R.d Newton del' in sub.; c.250 x 400 (235 x 400).

30. LES COMBATTANTS D'AMOUR; 1 April 1792.
'RN' in bottom right corner; (295 x 540).

31. A FORCIBLE APPEAL FOR THE ABOLITION OF THE SLAVE TRADE, 2 April 1792 (plate 3).
'R Newn' 'Etch'd by R.Newton'; c.380 x 510; BN.

32. PRACTICAL CHRISTIANITY; 2 April 1792
[a smaller version of the preceding].
George 1938, p. 898 as [N], (130 x 197) and as in BL, 2.g.10.

33. CONTRIBUTING TO THE SINKING FUND; 3 April 1792.
BM 8078 as [N]; YCBA; 342 x 457 (452 x 428).

34. THE NOTTINGHAM CHRONICLE, 5 April 1792.
BM 8172 as [N], (225 x 202), supposedly 'a Miss Sherwin of Nottingham'.

35. PLUCK'D PIGEONS; 1 May 1792.
'R.d Newton del'; YCBA; (270 x 466).

36. ARMING IN THE DEFENCE OF THE FRENCH PRINCES OR THE PARTING OF HECTOR AND ANDROMACHE; 8 May 1792.
BM 8084 as [N], ill. Donald (1986, figure 185); HEH; YCBA; 345 x 380 (330 x 375). Lit: Donald (1986: 373–4).

37. JUSTICE AND HUMANITY AT HOME; 10 May 1792.
BM 9685 on basis of photo of Minto Wilson impresssion, now in HEH; (355 x 498).
Named on BM 8090, 18 May 1792, as one of a set with:

38. CRUELTY AND OPPRESSION ABROAD (not located) and

39. THE BLIND ENTHUSIAST (not located), price 10/6d.

40. THE COMBUSTIBLE BREECHES; 11 May 1792; 2/6 [1792]; (plate 4).
425 x 520 (425 x 490).

41. PSALM SINGING AT THE CHAPEL *****[Royal]; 17 May 1792.
BM 8089 as [N]; 248 x 352 (205 x 325); YCBA.

42. WONDERFUL NEWS FROM SERINGAPATAM; 18 May 1792; 3/6d ['With Mr Merry's excellent lines under each figure', 1794 Cat].
BM 8090 as [?N], Kunzle (1973: no. 12-11, ill. p. 365) (340 x 525).

43. THE FALSE ALARM; 20 May 1792.
BM 8091 as [N]; YCBA; 285 x 397 (258 x 380).

44. A BLOW-UP AT BREAKFAST!; 20 May 1792 (figure 10).
BM 8092 as [N]; YCBA; 412 x 278 (387 x 280).

45. A PROCLAMATION IN LILLIPUT; 22 May 1792 (plate 5).
YCBA; 350 x 462 (310 x 445).

46. SCENE IN THE ROAD TO RUIN; May 1792, pub N, 'G.t Portland St', May 1792.
'R.d N' in sub; BM 8083; YCBA; 250 x 350 (215 x 330).

47. POLITICAL BOXING; OR, AN ATTACK AT THE WOOL-SACK; May 1792.
BM 8097 as [N]; YCBA; (265 x 395).

48. TASTING A NORFOLK DUMPLING; 1 June 1792 (plate 6).
Klingender (1944: plate 86); 252 x 352 (232 x 352).

49. A BUGABOO!!!; 2 June 1792 (plate 7).
BM 8102 as [N]; Wardroper (1973: plate 27); Bindman (1989: no. 69, ill. p. 116); YCBA; (345 x 448); there is a preliminary drawing, WBM.

50. PRELUDE TO THE RIOT IN MOUNT STREET; 6 June 1792.
BM 8170 as [N]; (340 x 430).

51. THE WINDSOR MILKMAN; OR, ANY THING TO TURN A PENNY;
12 June 1792.
BM 8106 as [N]; YCBA; 370 x 242 (342 x 242); there is a preliminary drawing
(R. Searle Coll.).

52. MATRIMONIAL SPECULATION [8 pairs in two rows]; 15 June 1792.
BM [-385], catalogued from a photograph as BM 8219; (480 x 745).

53. CONTENT AND DISCONTENT ; 21 June 1792 (plate 8).
BM [-333] bottom half only; YCBA; 445 x 305 (425 x 305).

54. MICHAEL DRIVING SATAN OUT OF PARADISE; 23 June 1792.
'R.d N del'; YCBA; (254 x 450).

55. THE SOAP'D POLE AT THE HAM COMMON FETE. 1792/ OR JEFFEY'S
ATTEMPT FOR THE ANGOLA PRIZE; 28 June 1792.
'R.d N'in sub; BM [-341]; (430 x 265).

56. DAINTY NICE SPRATS, HO!; 8 July 1792.
'R N del'; YCBA; 352 x 250 (310 x 220).

57. AN OLD MAID, TREATING A FAVORITE CAT TO A DUCK AND GREEN
PEAS; 20 July 1792.
'Design'd & engrav'd by R Newton'; YCBA; Klingender (1944: plate 80); 244 x 270
(224 x 256).

58. THE LIBERTINE RECLAIM'D OR JOHN BULL BULLIED; 10 ['10'
reversed] Aug. 1792.
Unsigned; Pierpont Morgan Library, New York (Peel Collection), ill. Robinson
(1996: plate 175); YCBA; plate 250 x 350.

59. LOUIS DETHRON'D; OR HELL BROKE LOOSE IN PARIS !!!;
16 Aug. 1792, 2s [1792].
Unsigned; BM 1989-9-30, Bindman (1989: 47 as N, ill. p.47); YCBA; 248 x 362.

60. NYMPHS BATHING; by 31 Aug. 1792; 2/6 [1792].
Klingender (1944: plate 62, as N, 1792).

61. *Elements of Bacchus: or, Toasts and Sentiments, given by distinguished Characters.*
Illustrated with Forty Portraits in Aquatinta, of the most celebrated vivants in Great Britain.
With a variety of Anecdote and remarkable Traits, prefixed to each portrait. Written and
designed by George Murgatroyd Woodward. London: Published by William Holland, 1792;
83 [+5] pp; 4o; £1/1/0 plain; £1/11/6 coloured [1792]. Listed in 62. These undated
plates, signed simply 'G. M. Woodward delin', were probably etched by Newton,
but this is not certain. André Simon owned a copy of the work and reproduced 20
of the plates in his *Bottlescrew Days*, 1928.

62. GRAND BATTLE AT CAMBRIDGE, 1792, BETWEEN DOCTOR
BOOKWORM, AND PETER MUSGRAVE, THE TAYLOR!; 31 Aug. 1792 ['3'
reversed]; 1/6d [1792 (2)] (figure 7).
Signed in sub. 'R Newn'; sheet 204 x 245 ; folding frontis. to *The Battle between*
Doctor Farmer and Peter Musgrave, pamphlet. Emmanuel College, Cambridge; Trinity
College, Cambridge. There is a preliminary watercolour (figure 6).

63. STURDY BEGGARS COLLECTING FOR THE EMIGRANT FRENCH CLERGY; 30 Sept. 1792; 3s [1792 (2)].
BM [-369], Bindman (1989: 218, ill. p. 208); 406 x 530 (370 x 510).

64. THE SHEPHERD AND THE ANIMATED BOTTLE; 1 Oct. 1792.
BM [-367]; (245 x 400).
A set of 5, of which the first 4 are after Woodward, pub. 1 Oct. 1792; 2s each [1792(2)].

65. FAIRIES.
'Etchd by R. Newton'; BM [-336]; 368 x 248 (300 x 222).

66. LAYING A GHOST!!
358 x 248 (305 x 230).

67. AN HOBGOBLIN.
'Etched by R. Newton', BM [-346]; 368 x 255 (310 x 225).

68. A SPRITE.
368 x 250 (318 x 230).
(These four are listed together with AN APPARITION; see 1 May 1790, in the 1794 Cat.; the next is listed separately, but immediately after the others.)

69. RESURRECTION MEN (figure 12).
'Design'd & Etchd by RNewton'; 360 x 248 (318 x 230); MRPC.

70. A PARTY OF THE SANS CULOTTE ARMY MARCHING TO THE FRONTIERS; 1 Oct. 1792; 2/6d [1792(2); 1794].
BM 8123, Bindman (1989: no. 82a, ill. p. 46); BN (Jouve 1983, plate 1); c.218 x 680 (185 x 680).

71. THE DUKE OF BRUNSWICK ATTACKING THE REAR OF THE SANS CULOTTES; 2 Oct. 1792; 2s. [1792(2); 1794].
Bindman (1989: no. 82b, ill. p.125); YCBA; 278 x 430.

72. AFFRIGHTED TRAVELLERS; OR, THE ILLUMINED TURNIP!, 10 Oct. 1792; 3/6d [1792(2); 1794] (figure 13).
'Design'd & Etch'd by Rich.d Newton' 'John Hassell Aquatinta'; BM[-1005], 370 x 445 (312 x 403); LC.

73. PRUSSIAN BOBADILS RETURNING TO BERLIN !!!!!!; 26 Oct. 1792.
BM 8126 [N]; YCBA; 270 x 428.

74. THE BOY AND THE JAILER (? correct title), frontis. to *Pathetic Particulars of a Poor Boy sentenced to suffer Seven Years Solitary Imprisonment in Gloucester Jail; with a Print of the Boy and the Jailer*, pamphlet; 6d. [1792 (2)]; the date on the print is Oct. 1792; see Turner (1996: Appendix C).

75. A LITTLE WIDER; 1 Nov. 1792.

76. A LITTLE FARTHER; 1 Nov. 1792.
Both: 'Design'd & Etch'd by R.Newton'; LC (75, 76); BM [-1008] (76); c. 390 x 310 (318 x 250).

77. THE THIEVES DETECTED AT LAST, OR, A WONDERFUL DISCOVERY AT THE WINDSOR FARM; 8 Nov. 1792.
BM 8129 as [N]; YCBA; 260 x 342 (222 x 327).

78. MARCHE DES MARSEILLOIS; 10 Nov. 1792.
'R Newton' in sub.; Bindman (1989: 83b, ill. p. 126); BM 1988-10-1-4; 395 x 248 (115 x 248) (*Inventaire de la Coll. M. Michel Hennin* (Paris, 1882), 11,367, with date of publication).

79. THE HAUNTED CELLAR; 10 Nov. 1792; 3/6 [1792(2)];
4s [1794 as pendant to next].
'Design'd by G M Woodward' 'Etch'd by R.Newton' 'J.Hassell Aquatinta'; et. & aq.;
370 x 495 (290 x 420).

80. ONE TOO MANY; 10 Nov. 1792; 3/6d [1792 (2)]; 4s. [1794: pendant to
previous]; (plate 9).
'Design'd & Etch'd by R.Newton' 'J Hassell Aquatinta'; et. & aq.; BM 8209; BN;
Klingender (1944: plate 92); (305 x 429).

81. A DOCTOR IN PURGATORY!; 11 Nov. 1792; 4s [1794]; (figure 14).
'G.M.Woodward delin'; lettered as 79; with 6 lines of verse, 'Those spectres ...' from
Garth's Dispensary Canto vi'; c. 475 x 415 (395 x 375).

82. CA IRA [contorted fiddler at top of song sheet engraved on separate plate]; 18
Nov. 1792.
Bindman (1989: no. 83a as N); based on a song-sheet of 1790; 162 x 224.

83. LIBERTY AND EQUALITY; 20 Nov. 1792 [4 scenes]; [probably 3s]; (plate 10).
YCBA; 420 x 340.

84. A VISIT TO THE GRANDFATHER. HOW DO GRANDPA?; Nov. 1792.
'Design'd & etch'd by R. Newton'; YCBA; 274 x 380 (232 x 334).

85. A MASCULINE DOE; 8 Dec. 1792.
'R.d Newton del'; BM 8173; (178 x 128).

86. CA IRA – OR JOHN BULL STUDYING THE GRACES; 20 Dec. 1792.
'Ecthd by R Newton'; YCBA; 342 x 245 (298 x 245).

87. A REAL SAN CULOTTE!!; pub. N, 'Gt Portland St', Dec. 1792; (plate 11).
BM [-350]; 355 x 250.

88. A SHOT AT A COCK; OR, AN ALARM OF ASSASSINATION; some time
in 1792.
'R.d N del'; BM 8153; YCBA; 292 x 412 (260 x 395).

1793
89. BOTH SIDES OF THE WATER; 10 Jan. 1793.
'R.d N.n del pro bono pub'; YCBA; 242 x 350 (222 x 350).

90. VENUS SURROUNDED BY CUPIDS!; 12 Jan. 1793.
'Drawn & Etch'd by R. Newton'; et & aq; BN.

91. PROGRESS OF A PLAYER; 11 Feb. 1793; 6s [1794]; (plate 12).
'Designed & Etch'd by R Newton'; BM[-339], Kunzle (1973: ill. p.365); outer line
around sub. 440 x 580 (380 x 530). Lit: Kunzle (1973: no. 12-12). Two preliminary
drawings are at Windsor (Oppé 687).

92. PROGRESS OF AN AUTHOR; 6s [1794, as pendant to above]; (not found).

93. PRELUDE TO CRIM CON AND THE FINALE! [6 pairs on two rows]; 20 Feb.
1793; 5s [1794 Cat; as after Woodward].
BM 8385 as [N]; ; YCBA; (452 x 655).

94. EXECUTION OF LOUIS THE XVI ...; 20 Feb. 1793.
'Designd & Etchd by R Newton' 'Aquatinta by J Hassell'; Musée Carnavalet, Paris,
Bindman 1989, 112, ill. p.139 as (500 x 603).

95. A SERIOUS THOUGHT OF A PLAIN ENGLISHMAN, in 1793; pub. N,
50 Oxford St, Feb. 1793.
YCBA; 246 x 350 (200 x 328).

96. THE EMBARKATION OF THE GUARDS AT GREENWICH ON THEIR EXPEDITION FEBRUARY 25 1793; possibly pub. March 1793; 7/6d [1794 Cat.:'drawn and etched by Newton'].
(445 x 610).

96A. AFTER; 1 March 1793, or ?1795 (see no. 195).
(235 x 340).

97. FAST-DAY!; 19 April 1793; 2s [1794]; (plate 13).
'Design'd & Etched by R Newton'; et. & aq.; BM 8323, ill. George (1967: figure 70); ?48 x 352 (228 x 337).

98. PADS AND BOSOMS; OR, BEAUTY AND MODESTY GOING TO CHURCH; 26 April 1793.
HEH, from Minto Wilson Coll.

99. MAKING A FREEMASON!; 25 June 1793; (plate 14);
'Design'd & Etch'd by Richard Newton'; BM 8386; *Folly and Vice*, exhibition catalogue (London, South Bank Centre, 1989), ill. p. 28; 270 x 422 (245 x 397).

100. JOHN TAYLOR, VERGER TO THE LODGE OF BLACK FRIARS, AT THE FOX, BLOOMSBURY/ MOST WORTHY FATHER – T-IS PAST ELEVEN O'CLOCK; 9 July 1793.
'etchd by R.Newton'; YCBA; (265 x 225).

101. A PEEP INTO THE STATE SIDE OF NEWGATE 1793; 12 July 1793 (figure 16).
'Drawn and Etch'd by Richard Newton'; (255 x 510)

102. THE ASSASSINATION OF MARAT BY CHARLOTTE CORDE; 24 July 1793.
BM [-1010]; 415 x 277 (380 x 277).

103. FUNERAL PROCESSION OF MARAT [2 rows]; 25 July 1793; 2/6d [1794].
'R.d Newton' in sub.; 308 x 495 (267 x 495).

104. SOULAGEMENT EN PRISON; OR, COMFORT IN PRISON; 20 Aug. 1793; 10/6d [1794] (see plate 16).
'Drawn from life, and Etched by Richard Newton'; BM 8339 (entry based on photograph of the print); N's watercolour (plate 16) is in LWL; Lit: Bindman (1989: no. 193, ill. p.191).

105. INTERESTED LOVE; 3 Sept. 1793 (pendant to DISINTERESTED LOVE after Woodward, see 1 Nov. 1790); (plate 15).
Design'd & Etch'd by R.Newton.'; et & aq., with verses signed 'W. H.' in lettering of the Hassell type; BM[-343]; BN; 335 x 248 (268 x 230).

106. WHO SHALL WEAR THE BREECHES?; 10 Sept. 1793 (see 6 March 1794); (plate 17).
'R Newton del'; 247 x 350 (228 x 350).

107. PROMENADE IN THE STATE SIDE OF NEWGATE; 5 Oct. 1793; 7/6d [1794] (figure 17).
'Design'd & Etched by R.Newton'; BM 8342 (1st state with Captain Wilbraham, as '21' on extreme right), (BM 1867-3-9-377, uncol), Bindman (1989: no. 194, ill. p. 192). 2d state, with Daniel Holt replacing Wilbraham (BM J.3-70, uncol); HEH, coloured; 475 x 732 (415 x 720) (figure 17). 3d state, with aquatint added, plate apparently cut down to 385 x 710, without title, Guildhall Library, London.

108. O DEAR WHAT CAN THE MATTER BE; 6 Nov. 1793.
'R Newton Del'; LC; 350 x 267 (295 x 250).

109. A COUNTRY BARBER'S SHOP; 1 March 1794; 5s [1794]; (plate 21).
'Drawn & Etch'd by R Newton'; (420 x 560).

110. BABES IN THE WOOD; 1 March 1794; 2s [1794]; (figure 19).
'Drawn & Etch'd by R.d Newton'; BM 8554; HEH (lacking date); 255 x 312 (242 x 298).

111. BABES IN THE NURSERY; 1 Mar. 1794; 2s [1794]; pendant to preceding.
'Drawn & Etch'd by R Newton'; BM [-1004].

112. *Sterne's Sentimental Journey ... with Twelve Illustrative Prints, design'd and etch'd by Richard Newton*; 3 Mar. 1794; (plate 20; figure 20).
'Designed & Etch'd by R.Newton for Holland's Edition .. ; title page dated 1795; YCBA (Abbey *Life*, 250).

113. OPENING THE AMBASSADOR'S BALL IN PARIS.; pub. N, 'No 26 Walbrook' 5 March 1794 (plate 19).
BM [-338]; LC; YCBA; plate 247 x 342.

114. WEARING THE BREECHES; 6 March 1794 (sequel to WHO SHALL WEAR THE BREECHES?, 10 Sept. 1793); (plate 18).
'Drawn & Etch'd by R Newton'; LC; Whitworth Art Gallery, University of Manchester, ill. Donald (1996: p. 8); Wagner (1988, fig. 37); 291 x 395 (272 x 395).

115. THE MISERS ECONOMY!!! ; 10 March 1794.
'R Newton del' in subject; BM [-365] without title; YCBA; 240 x 345 (215 x 322).

116. A CLERICAL REBUKE AND PAROCHIAL REPLY; 12 March 1794; 0s [1794].
'G.M.Woodward' in subject; not signed by N, but possibly etched by him; 280 x 415 (267 x 392).

117. PROGRESS OF AN IRISHMAN; 8 April 1794; 5s [1794]; (plate 22).
'Drawn and Etch'd by Rich.d Newton'; HEH; BM [-372]; (the BM entry, BM 8562, which gives the title as PROGRESS OF AN IRISH EMIGRANT, is based on a copy in the *Hibernian Magazine*); 390 x 522. Lit: Kunzle (1973: no. 12-14, ill. p. 366).

118. A WHITE SERJEANT; OR SPECIAL MESSENGER!; 16 April 1794; 4s [1794]; (plate 24).
'Drawn & Etch'd by R Newton'; BN; HEH; 392 x 502.

119. UNDERTAKERS IN AT THE DEATH!!; 20 April 1794; 2s [1794]; (plate 25).
'Drawn & Etch'd by R Newton'; BN; 262 x 415 (238 x 415).

120. PATRIOTISM. MY ASS IN A BAND BOX; 21 April 1794.
'R.d Newton' in sub; YCBA; 248 x 350.

121. PROGRESS OF A SCOTSMAN; 22 April 1794, 5s [1794]; (plate 23).
'Drawn & etch'd by R Newton'; BM 8550; BN; HEH; 405 x 525 (392 x 520). Lit: Kunzle (1973: no. 12-13, ill. p. 367).

122. THE TWO FOXES [title in letterpress]; pub. N, 26 Wallbrook, 3 May 1794 ('4' reversed).
Two views at the top of a letterpress song-sheet; plate 355 x 255.

123. HARRIS'S LIST; OR, CUPID'S LONDON DIRECTORY; 24 May 1794.
'R.Newton del' 'Etchd by R Newton'; HEH; LC; (364 x 289).

124. ALL OF ONE MIND OR A MUTUAL AGREEMENT AMONGST TRAVELLERS; 28 May 1794.
'Drawn & Etch'd by R Newton 1794'; YCBA; 262 x 382 (240 x 368).

125. A CURTAIN LECTURE!; 29 May 1794; 2s [1794]; (figure 24).
'Drawn & Etch'd by Rd Newton'; 355 x 475 (318 x 450).

126. ADVERTISEMENTS ILLUSTRATED [3 sheet print; 4 groups on each plate];
7 June 1794; 10/6 [1794].
The left-hand plate is BM 8549, 'I Nixon Esqr delin', as [? I. Cruikshank]; the
centre plate is BM 8548; the right is BM [-344], with groups 'A Cleaver Horse'; 'Mr
Daub's Likeness'; 'Miss Mousers Cat'; 'A Hack Parson'; 'Etch'd by R.Newton'; each
plate *c*. 255 x 635, i.e. 10 x 25 in.

127. EVANGELICAL PORTRAITS – OR, PRETTY PARSONS SITTING FOR
THEIR PICTURES; OR VANITY, VANITY, ALL IS VANITY!!! [9 groups in 3
rows] ; 20 June 1794; 5s [1794]; (plate 26).
'Drawn & Etch'd by R. Newton'; 452 x 532.

128. ADMIRAL HOWE TRIUMPHANT; 20 June 1794.
'Rd Newton del'; BM 8470; (228 x 397).

129. WHICH WAY SHALL I TURN ME; 1 July 1794; 3s [1794].
'Richard Newton del'; BN; (Klingender 1944: plate 73); LC.

130. WHICH WAY SHALL I TURN ME; ?1 July 1794; 3s [1794 Cat: 'A companion
to do, a pretty woman between an old man chinking a purse, and a handsome young
officer who has nothing to offer but love']; not located.

131. A PEEP INTO BREST WITH A NAVEL REVIEW! ; pub. N,
26 Wallbrook, 1 July 1794.
'Drawn & Etch'd by R.Newton'; LWL, Bindman (1989: no. 183, ill. p. 185);
LC; (275 x 302).

132. A LESSON FOR SPENDTHRIFTS BY DR JOHNSON
[8 compartments]; 1 Aug. 1794.
'Drawn & Etched by R.Newton'; BM[-373], ill. in col. in R. Simon (ed.), *A Rake's
Progress*, exhibition catalogue (London, Soane Museum, 1997), p. 23, BN; Colonial
Williamsburg, 1954-129; (355 x 625). Lit: Kunzle (1973: no. 12-15, ill. p. 365).

133. A DANCE ROUND THE POLES; pub. N, 26 Wallbrook, 5 Aug. 1794.
BM 8483; 272 x 400 (245 x 380).

134. A VISIT TO BEDLAM; 7 Aug. 1794.
'Designd and Etchd by R Newton'; 355 x 248 (317 x 247).

135. PREFACE TO BAD NEWS; 11 Aug. 1794.
'Drawn and Etchd by Rd Newton'; 355 x 275 (*c*.255 x 275).

136. IL Y PASSERA – I CAN SWALLOW IT; 25 Sept. 1794 (4 reversed).
Plate 350 x 247.

137. MEN OF PLEASURE IN THEIR VARIETIES [8 compartments]; 1 Oct. 1794.
'Drawn & Etch'd by R. Newton'; BM 8551; (390 x 602); pencil drawing of [3] *A
Sham Arrest*, 320 x 215, WBM.

138. THE LIFE OF MAN [16 groups in 4 rows on 2 sheets]; 12 Oct. 1794.
'Drawn & Etch'd by R Newton'; BM 8552, Kunzle (1973: ill. pp. 368–9); each plate
c. 510 x 350. Lit: Kunzle (1973: 12–16). There are 2 preliminary drawings for the
extreme right-hand groups on the top two rows in a private coll. For 2 unused
drawings by Newton see Kunzle 1973, ill. p. 370; for these and 2 others in the R.
Searle Coll. see *Cartoons and Caricatures*, exhibition catalogue (London, Arts
Council, 1962), 32 a-d.

139. CONUNDRUM [12 plates]; 20 (or 29) Oct. 1794.
LC (plates 3, 6, 8); each plate (*c*. 115 x 145).

140. A DANCE IN THE TEMPLE OF HYMEN; 25 Oct. 1794; £1/1/0
[1794]; [3 sheet].
'A Sailor's Wedding A Soldier's Wedding'; 'A Beggar's Wedding A Scotch
Wedding'; 'A Welch Wedding An Irish Fortune Hunter's Wedding';
'Drawn & Etchd by R.Newton' on left-hand plate; Trinity College, Dublin (ex info.
Charles Benson). Three plates, each c.255 x 660. There is a drawing for *Scotch
Wedding* (R. Searle Coll.). It is possibly an even larger print: another group, *A
Miser's Wedding*, may be part of it.

141. A NIGHT MARE; 26 Oct. 1794; (plate 27).
'Drawn and Etch.d by R.d Newton'; BM 8555, ill N. Powell, *Fuseli: The Nightmare*
(London, Allen Lane, 1973), fig. 4; LWL; (252 x 317).

142. QUEEN CATHERINE'S DREAM; 4 Nov. 1794.
'R.d N.n Pro Bono Publico'; BM [-370]; YCBA; (247 x 295)

143. 'SHEPHERDS, I HAVE LOST MY WAIST!' ; 12 Nov. 1794; (plate 28).
'R.d Newton del et fecit'; BM D3-703, from Banks Coll.: BM 8569; Paston (1905:
plate xliv as 12 Nov. 1795 and having the title 'The Rage'); 322 x 255 (255 x 232).

144. A WILL O' TH' WISP; 15 Nov. 1794 (figure 29).
'R Newton del et fecit'; BM [-347] as 1 Nov. 1794; LWL; 255 x 322 (225 x 305).

145. DESTRUCTION/ A /WICKED ATTORNEY'S /COAT OF ARMS;
1 Dec. 1794; (figure 23).
'W.Holland Inv.t' ' R.Newton fecit'; BM [-369], cut within plate mark to 575 x 385.

146. SKETCHES IN A SHAVING SHOP [12 compartments]; 16 Dec. 1794.
'Drawn & Etch.d by R.d Newton'; BM 8553, plate 382 x 555; WIHM.

147. THE UNLUCKY DISCOVERY; 21 Dec. 1794; (plate 29).
'R.d Newton del et fecit'; 3 verses beginning 'As Landlady Dobbins ...';
315 x 248 (252 x 248).

148. CHRISTMASS BOXES [4 compartments]; 25 Dec. 1794.
'Drawn & Etch'd by R.d Newton'; BM [-349]; 257 x 310 (252 x 310).

149. THE TRIUMPHAL PROCESSION OF MERRY CHRISTMASS TO
HOSPITALITY HALL; 25 Dec. 1794.
'R Newton del et fect'; BM [-999];.

150. A SALT WATER SALUTE; 29 Dec. 1794.
'Drawn & etch'd by R.d Newton'; Victoria & Albert Museum; YCBA; 350 x 248
(320 x 248).

151. AN OLD GRUDGE; pub. N, 26 Wallbrook [?1794; apparently undated];
(figure 18).
'Desingd and etch'd by R.d Newton'; BM [-355]; LC; YCBA; plate 286 x 346.

152. BOND STREET PROMENADE; 1794 (no month or day).
'Newt[]' in subject; plate 255 x 355.

1795
153. HER ROYAL HIGHNESS THE PRINCESS OF WALES; Jan. 1795.
'R.d N.n del et fecit' in sub.; 270 x 230 (238 x 205).

154. TUMBLING OVER A GHOST!; 6 Feb. 1795; (plate 31).
'Drawn & Etch'd by R.d Newton'; 340 x 268 (310 x 268).

155. THE BLUE DEVILS!; 10 Feb. 1795; (plate 30).
'Design.d & Ethd by Rd Newton'; BM 8745; YCBA; 405 x 272 (368 x 248); there is a copy pub. by Sidebottom, WIHM.

156. AMUSEMENT IN A TWOPENNY LODGING; 19 Feb. 1795.
'Design'd & Etch'd by Rd Newton'; LC; (238 x 340).

157. THE OLD MAIDS OCCASIONAL CONCERT; 1 March 1795.
'Drawn & Etch by R Newton'; LWL.

158. ONE OF THE SWINISH MULTITUDE [3 compartments]; 6 March 1795.
'Rd Newton del et fecit'; BM 8628; Klingender (1944: plate 116); (228 x 137).

159. A WITCH; 8 March 1795.
'Drawn and Etch.d by Newton'; LWL.

160. HIBERNIAN SAGACITY AND SANG FROID!; 3 April 1795.
'Drawn & Etch'd by R Newton'; BM 8747; LWL; YCBA; 285 x 382 (238 x 385).

161. BRITISH SERVANTS. WITH HONESTY AND FIDELITY; AGAINST FRENCH SERVANTS WITH PERFIDY & IMPUDENCE!; April 1795; (plate 32).
'Drawn & Etch'd by R.Newton'; YCBA; plate 240 x 692.

162. THE PRINCESS'S CURTSEY; April 1795 [16 figures].
Plate 647 x 260. Lit: D. Hill, *Eighteenth Century Life*, vii, 3 (1982), 48-53, ill. part of the print (6 figures).

163. NATIONAL CHARACTERISTICS PLATE 1; 6 May 1795 (see 12 July 1796).
'Plate 1 G.M.Woodward del.' 'Etch'd by Newton'; HEH; 310 x 625.

164. A MAGICIAN; 11 May 1795; (plate 33).
'Design'd & Etch'd by R.d Newton'; 245 x 360; BN.

165. TRICKS UPON TRAVELLERS; 13 May 1795.
'Design'd and Etched/ by R.d Newton'; BM 8746; YCBA; plate 248 x 345.

166. TALK OF THE DEVIL AND HE'LL APPEAR; 19 May 1795.
'Drawn and etch'd by R.d Newton' in sub.; et & aq; BM[-1001]; HEH, lacks title; 367 x 448 (322 x 405).

167. A POLITICAL WILL O' THE WISP; pub. N., 26 Wallbrook, 4 June 1795.
'R.d Newton del et sculp'; BM [-371]; YCBA; plate 335 x 503.

168. CONTRASTED WALKERS; 6 June 1795.
(A. de R. ii, p.105).

169. A WILL O' TH' WISP; OR JACK O' LANTERN!; 9 June 1795; (plate 34).
'Design'd & Etch'd by R.Newton'; 248 x 350 (222 x 330).

170. MIDNIGHT REVELS; 10 June 1795.
'John Nixon 1795' 'Etch'd by R Newton'; BM 8751, etching only; BN; LC, with added aquatint, Godfrey (1984: plate 33); 445 x 320 (420 x 300).

171. DESMOULINS AND LUCILLE [title in letterpress at head of letterpress broadside dated 20 June 1795]; 10 June 1795.
'R.Newton et'; BM[-377], related to Newton's watercolour, BM 1871-8-12-1675, Bindman (1989: no. 151, both ill. p. 161); 546 x 347.

172. AN IRISH FORTUNE HUNTER ON A JOURNEY TO BATH; 16 June 1795.
'Design'd & Etch'd by Newton 1795'; LWL; plate 258 x 388.

173. ON A JOURNEY TO A COURTSHIP IN WALES; 16 June 1795; (figure 25).
'Designed & Etch'd by R.d Newton 1795'; BM [-352]; HEH; LC; LWL; (262 x 410).

174. WARMING THE LEGS; 26 June 1795.
'Drawn by R Newton' 'Engraved by Townley'.

175. NO BODY. SOME BODY; June 1795; (plate 35).
'R.d Newton del et fecit'; plate 298 x 362.

176. BUY MY PRETTY GUINEA PIGS! ; pub. N, 26 Wallbrook, 1 July 1795.
BM 8663; 342 x 240 (350 x 248).

177. THE DEVIL'S DARNING NEEDLE; 2 July 1795 (for another of the same title
see 6 March 1797).
'R Newton 1795/ del et fecit'; BM [-356], sheet 295 x 145; LWL, based on a
drawing there.

178. PROGRESS OF A LAWYER; 10 July 1795; (figure 28).
'Drawn and etch'd by Rd Newton 1795'; not in Kunzle (1973); *c.* 475 x 666.

179. ENJOYING AN OLD FRIEND; 17 July 1795; (plate 36).
'Design'd & etched by R.d Newton'; BN; LST; LC; YCBA; plate 245 x 350.

180. A CLERICAL ALPHABET; 22 July 1795; (plate 37).
'Drawn and Etch'd by R.d Newton 1795' 'Note – The Idea of this Print originated
with Mr W--n, who wrote the 1, 2, 3, 4, 6, 7 and the two last lines – all the rest were
written by Mr Holland'; BM [-374]; LST; LWL; 470 x 670 (445 x 670).

181. SAMPLES OF SWEETHEARTS AND WIVES [8 compartments];
23 July 1795.
'Drawn and Etch'd by R.d Newton 1795'; LWL; (445 x 570).

182. CONTRASTED HUSBANDS; July 1795.
'R.d Newton 1795'; LC.

183. THE THRIFTY WIFE; July 1795.
'R Newton del et fect' in sub; BM [-357], 278 x 203 (190 x 203); with song 'sung at
Vauxhall by Mr Dignum, written by M. P. Andrews Esq.'.

184. PULL DEVIL – PULL PARSON; 9 Sept. 1795.
'Design'd and Etch'd by Newton 1795'; BN; YCBA; plate 250 x 350.
A related drawing is at Windsor (Oppé 453, ill.).

185. TOO MUCH OF ONE THING GOOD FOR NOTHING;
12 Sept. 1795; (figure 26).
'Design'd & Etchd by R.d Newton 1795'; BN; Wagner (1990, figure 88);
plate 255 x 355.

186. HUNGRY RATS IN A LITTLE HOUSE; 22 Sept. 1795; (plate 38).
'R Newton del' in sub.; LC; 249 x 350 (230 x 330).

187. SUPPORTED BY VOLUNTARY CONTRIBUTIONS; 25 Sept. 1795
[pair to JUST ..., 17 Oct. 1795].
'Drawn & Etchd from Life by Rd Newton'; 265 x 182 (232 x 148).

188. SATURDAY NIGHT; OR, A COBLER SETTLING THE WEEK'S ACCOUNT
WITH HIS WIFE; 6 Oct. 1795 ['6' reversed].
'R.d Newton 1795'; Hermitage 298360, acquired 1815, ill. L. Dukelskaya
(compiler), *The Hermitage: English Art* (Leningrad, 1979), plate 171 (in col.);
255 x 352 (222 x 325).

189. JUST ARRIV'D FROM FRANCE; 17 Oct. 1795
[pair to SUPPORTED..., 25 Sept. 1795].
'Drawn & Etchd from Life by Rd Newton 1795'; 270 x 170 (235 x 132).

190. A BACHELOR'S LITANY [12 compartments]; 4 Nov. 1795; (plate 39).
'Drawn and Etch'd by Rd Newton' 'Invented and written by Willm Holland'; two plates each *c.* 362 x 610, compartments *c.* 127 x 177.

191. THE FATE OF MONOPOLISTS. OR A DANCE AT FIDLERS GREEN (above: 'A Farmer A Corn Factor A Baker'); 10 Nov. 1795.
Plate 350 x 250.

192. SPECTACLES FOR REPUBLICANS; 24 Nov. 1795.
'Rd Newton fecit'; BM 8695; plate 270 x 375 (two ovals each *c.*190 x 165).

193. BLACK EYED LOVERS; Nov. 1795; 'Holland's Caricature Exhibition is now open ...'[? last mention on a print]; 'Drawn & Ecthd by Rd Newton'; 355 x 245 (275 x 228).

194. A SOSCIABLE ['s' crossed out] MEETING; OR, OLD FRIENDS WITH NEW FACES!!! ; Dec. 1795.
BM 8709 as [?N]; (210 x 345).

195. BEFORE; '1795' [see 1 March 1793].
'Rd Newton Designd et fecit'; BM 8744; plate 248 x 350.

1796
196. A SCOTS CONCERT!; 4 Feb. 1796.
'Drawn & etchd by R. Newton'; et. and aq.; BM [-340]; YCBA, Godfrey (1984: no. 119, plate xii in col.); 390 x 522 (360 x 501).

197. HOBGOBLIN VAGARIES! PLATE 1; Feb. 1796.

198. HOBGOBLIN VAGARIES! PLATE 2; Feb. 1796.

199. WITCHES, PLATE 3; Feb. 1796.
'Drawn and [3: '&'] Etch.d by Newton 1796'; 4 compartments each; 1: LC, bottom half only; 2: BM [-345]; 3: BM [-1006]; plates *c.* 430 x 340.

200. COOL AND COMFORTABLE FOR THE WINTER OF 1796; 1 March 1796.
'R.d Newton del et fecit,'; BN.

201. REMOVING AN EXECUTION FROM THE HOUSE OF OLD NURSE; 1 March 1796.
'Drawn & Etch'd by R Newton'; (395 x 515).

202. TIPPIES OF 1796; 6 March 1796.
'R.d Newton del et fecit'; LWL.

203. HEIGH HO! FOR A HUSBAND; 8 April 1796.
'R. Newton delin'; a crayon manner print probably by Townley; see 26 June 1795. Plate 230 x 325.

204. LUNATICKS OUT OF BEDLAM; 15 April 1796.
'Rd Nn 1796'; LC, 292 x 380, border.

205. CANINE VENGEANCE, OR THE EFFECTS OF THE DOG TAX; 19 April 1796.
'Rd Nn 1796' in sub.; BN; YCBA; plate 280 x 368.

206. BEGGAR MY NEIGHBOUR; 20 April 1796.
'Designed and Etched by R.Newton 1796'; BM [-366]; LC.

207. [Beheading]; 26 April 1796.
Untitled; 'Rd Newton del et f '; YCBA; 190 x 236 (165 x 215).

208. SCOTCH FENCIBLES; 28 April 1796.
'R. Nn'; YCBA; 245 x 346 (232 x 346).

209. THE BIRTH OF THE ROSE [Mlle Rose, wife of C-L.Didelot, standing on a rose]; 29 April 1796.
'Rd Newton del et fecit'; HEH; LC; ruled border 386 x 398.

210. OLD GOATS AT THE SALE OF A FRENCH KID [Mlle Parisot]; 5 May 1796.
'Rd Nn del et fecit'; BN; HEH, from Minto Wilson Coll; LC; (278 x 398).

211. FEMALE GAMBLERS IN THE PILLORY; 13 May 1796; (plate 40).
'Rd Newton'; BM 8877, based on photograph; 380 x 275 (342 x 255).

212. THE BATTLE OF BANGOR; [? Holland], 26 May 1796.
BM 8881as [N]; (292 x 410).

213. TRYING ON MY BROTHERS BREECHES/ ' There's a thigh for you'; 2 June 1796.
'Rd Newton del'; BN; LC; 350 x 245 (318 x 222); reissued with dialogue above the figures.

214. WHAT A NICE BIT! ; 8 July 1796; (plate 41).
'Rd Newton delin'; BM 1990-1-27-2; (220 x 325).

215. NATIONAL CHARACTERISTICS; 12 July 1796 (see 6 May 1795) [10/6d, *Morning Herald*, 27 Sept. 1797].
Probably after Woodward; et. and aq.; LC; 300 x 683.

216. DANCES OF DEATH [3 sheet print with 30 groups]; 12 July 1796.
'Drawn and etched by Richard Newton ' 'the Writing and some of the Ideas by Wm Holland'.

217. A PRESENT OF A HAUNCH OF VENISON! ; 31 July 1796.
'Rd Nn del et fecit'; YCBA; plate 350 x 248.

218. CONTRASTED LOVERS; 3 Augt. 1796; (plate 42).
'Rd Newton delin'; BN; LC; plate 260 x 355.

219. THE FOUR STAGES OF MATRIMONY [4 compartments]; 15 Aug. 1796; (plate 43).
'Drawn and Etch'd by Rd Newton'; LC; 456 x 338.

220. THE SAILORS AND THE POUNDED ASS; Aug. 1796.
'Drawn & Etchd by Rd Newton 1796' in sub.; YCBA; plate 350 x 355.

221. A FLIGHT OF SCOTCHMEN/LONDON; 3 Sept. 1796; (plate 44).
'Design'd and Etch'd by Rd Newton. 1796'; BN; LWL; 332 x 470 (310 x 452).

222. DAYS OF PROSPERITY; OR CONGRATULATIONS FOR JOHN BULL!!; Sept. 1796.
305 x 280 (255 x 250).

223. COUNTRY AND TOWN/ A FAVORITE SONG BY CAPTN MORRIS; 17 Oct. 1796.
'R. Newton'; headpiece to engraved 11 verse song; LC; (150 x 285).

224. JOHN BULL IN PARIS, BETWEEN A SHOWER AND A STINK!!; 10 Nov. 1796.
'Rd Newton del et fecit'; BN; (230 x 330).

225. PARSONS DROWNING CARE; 10 Nov. 1796; (plate 45).
'Design'd & Etch'd by R.d Newton'; BM [-1003]; BN; LC; YCBA; *Folly and Vice*, exhibition catalogue (London, South Bank Centre, 1989), ill. p. 40; plate 248 x 352.

226. BILLY'S POLITICAL PLAYTHING; 21 Nov. 1796; (plate 46).
'Rd Newton invt et fecit'; BM 8839 (308 x 225).

227. IMPS [3 rows of absurd figures]; 25 Nov. 1796.
'Invented Drawn & Etchd/ by R.d Newton'; BN.

228 A PRIEST RIDDEN VILLAGE; 29 Nov. 1796; (plate 47).
'Rd Newton del et fecit 1796'; 248 x 345 (222 x 332).

229. THE OPERA-HOUSE BANTUM; 23 Dec. 1796.
'Etch'd at the Opera by Rd Newton'; HEH, ex coll. Minto Wilson; plate *c.*400 x 265.

230. WILLIAM THE CONQUEROR'S TRIUMPHAL ENTRY!!!; Dec. 1796.
'Rd N. 1796'; BM 8843, ill. George (1959: pl. 11); (400 x 272).

231. MADAMOISELLE PARISOT; [1796]; (plate 48).
'Sketched at the Opera by R.d Newton'; BM 8893; Wagner (1990: fig. 56, from Fuchs, 1906, after p. 448, as 1802); (290 x 352).

1797

232. SENTIMENTAL JOURNEY (figures 21, 22); book with 12 etchings with aquatints after, and ?by, Newton, pub. Holland, 1 Jan. 1797, issued in sheets pub. by J. Good and S. Harding, 1792; LST.

233. THE DEVILS DARNING NEEDLE; pub. N, 'Bridges St, opposite Drury Lane Play House', 6 March 1797 [for another print with the same title see 2 July 1795].
'R. Nn invent et fecit'; 305 x 240 (278 x 217).

234. THE NEW PAPER MILL OR MR BULL GROUND INTO 20 SHILLING NOTES!; pub. N, 'No 13 Brydge St', 12 March 1797.
'Des. and Etch'd by Rd Nn'; BM 8998; plate 248 x 350.

235. A PAPER MEAL WITH SPANISH SAUCE; pub. N, 'Bridgys St, Covent Garden', 14 March 1797; (plate 49).
'Rd Nn des et fecit'; BM[-362], 350 x 250.

236. OVER WEIGHT – OR THE SINKING FUND – OR THE DOWNFALL OF FARO; pub. S. W. Fores, 14 March 1797.
'Rd Newton del et fecit'; BM 9080; HEH; YCBA; 275 x 375 (252 x 360).

237. THE ENGLISH BULL BAITING; pub. N, '13 Brydges St, Strand', 22 March 1797.
'Rd Nn des et fecit'; BM [-364], 248 x 350 (205 x 338).

238. THE GENERAL SENTIMENT; pub. S .W. Fores, 22 March 1797.
'Rd Newn des et fecit'; BM 8999; WBM; YCBA; 350 x 245 (320 x 227).

239. THE INS AND THE OUTS OR THE JESUITS TREATMENT OF HIS FRIENDS; pub. S. W. Fores, 25 March 1797.
'Rd Newn des et fecit'; BM 9000; HEH; Hope; YCBA; (222 x 413).

240. THE RETORT COURTEOIS OR THE DISLOYAL ADDRESS RETURNED WITHOUT CEREMONY; pub. S. W. Fores, 27 March 1797.
'Rd Newn del et fecit'; BM 9001; HEH; YCBA; 255 x 357 (228 x 338).

241. REHEARSING THE COUNTESS OR THE DARBY DANGLE; pub. N.
'No 13 Bridges St', 29 March 1797.
'Rd Newton invent et fecit'; 350 x 248 (348 x 230).

242. BUONAPARTE THE MODERN ALEXANDER ON HIS JOURNEY ROUND
THE WORLD; pub. 1 April 1797.
'Rd Newton desd et fecit'; BN.

243. MR FOLLETT AS THE CLOWN IN THE PANTOMIME OF HARLEQUIN
AND OBERON; pub. N, 'Bridges St', 3 April 1797; (plate 50).
'Desnd and Etch'd by Rd Newton'; BM 9003; 350 x 250 (313 x 230) .

244. DARBY AND JOAN OR THE DANCE OF DEATH; pub. N, 'Bridges Street',
7 April 1797; (figure 32).
'Rd Newton des. et fecit'; BM 9075.

244A. WISDOM, STRENGTH AND BEAUTY; pub.N, '13 Bridges St', 18 April 1797.
'Design'd & Etch'd by Rd Newton'.

245. THE FIRST INTERVIEW, OR AN ENVOY FROM YARMONY TO
IMPROVE THE BREED; pub. S. W. Fores, 19 April 1797; (plate 52).
'Rd Newton del et fecit'; BM 9007; BN; HEH; 248 x 345 (225 x 328).

246. PUSH ON KEEP MOVING [below design]/ MAY EVERY HONEST MAN
TURN OUT A ROGUE [above design]; pub. N, 27 April 1797.
'Rd Newton des. et fecit'; BM 9010; (393 x 235).

247. 'WHAT MEANS THIS NEW PAIN IN MY BREAST?' [asked by large gin-
drinking woman]; pub. Holland, 3 May 1797.
'Rd Newton del et fecit'; LC, without title; 250 x 238.

248. THE DEVIL'S DARLING; pub. N, 5 May 1797; (figure 30).
'Rd Newton des et fecit'; BM 9011; (260 x 195).

249. HEAD – AND BRAINS; pub. N, 5 May 1797; (plate 54).
Plate c. 305 x 255; BM 9012, entry based on watercolour in BM,
c. 318 x 272 (plate 53).

250. THE FULL MOON IN ECLIPSE; pub. Holland, 8 May 1797; (plate 56).
'Design'd & Etch'd/ by/ Rd Newton'; 248 x 235 (222 x 222).

251. DRINK TO ME ONLY WITH THINE EYES; pub. Holland,
8 May 1797; (plate 55).
'R Newton 1797'; BM [-354], 220 x 250 (200 x 235); LC; LWL; YCBA; Godfrey
(1984: no. 120, ill. p. 92).

252. A REWARD FOR PAST SERVICES; pub. N, 12 May 1797.
'Rd Newton des et fecit'; YCBA; 348 x 250 (340 x 235).

253. POOR SAWNEY IN SWEETBRIARS; pub. Holland, May 1797; (figure 35).
'Rd Newton del et fecit'; LC; 255 x 212 (230 x 222).

254. CRIES OF LONDON [3 sheets each with 4 figures]; pub. Holland,
May 1797; (plate 57).
'Rd Newton del et fecit 1797'; BM [-1009]; BN; LC; WBM; each plate c. 220 x 603.

255. REMOVING EXCRESENCES FROM JOHN BULL; pub. Holland, May 1797.
Plate 255 x 240; LC (as 1791).

256. POT-LUCK; pub. Holland, May 1797.
'Rd Newton inv et fecit 1797'; YCBA; 352 x 250 (325 x 225).

257. A FLAT BETWEEN TWO SHARPS!; pub. N, 'Brydges St', 6 June 1797.
'Rd Newton del et fecit'; 335 x 230 (335 x 230).

258. A BATTLE OUT OF THE HOUSE; pub. Holland,.15 June 1797.
BM 9022, unattributed; Brewer (1986: plate 60 as ?N).

259. THE INEXHAUSTABLE MINE! ; pub. N, 22 June 1797; (figure 31).
'Rd Newton designd et fecit'; BM 9025; (320 x 230).

260. AFTER DUTY; pub. N, 'at his Caricature shop Brydges Street', 12 July 1797.
'Rd Newton del et fecit', ill. Fuchs (1904: between pp. 128–9 in col.).

261. THE DANGER OF CRIM CON!; pub. W. Holland, 14 July 1797.
'Woodward delin', possibly etched by N; et. & aq.; LC; (232 x 200).

262. A BOND STREET SAILOR IN 1797; pub. N, 'at his Original Print
Warehouse', 28 July 1797.
'Rd Newton des. et fecit'; BM [-1002]; 350 x 250 (323 x 258).

263. RETALIATION! ; pub. N, 'at his Print Warehouse Bridges Street',
2 Aug. 1797.
'Invented drawn & etch'd by Rd Newton'; YCBA; plate 350 x 247.

264. THE BIRTH OF BILLY BUGABOO!; pub. N. 'at his Original Print Shop',
13 Aug. 1797.
'Rd Newton desin et fecit 1797'; BM 9029; YCBA; 354 x 248 (320 x 220).

265. MR C THE PUFFING PAINTER ... A ROYAL ACADEMEAN BY HIS OWN
APPOINTMENT [i.e. A. Charles; see S. McKechnie, *British Silhouette Artists*
(London, Sotheby's, 1978), pp. 382–7]; pub. N, 'Brydges St', 8 Aug. 1797;
(not seen: A. de R. ii, p. 13).

266. THEIR NEW MAJESTIES! ; pub. N, '13 Bridges St', 12 Sept. 1797.
'Rd Newton desn et fecit 1797'; BM 9032; (320 x 225).

267. METHOD OF MAKING PEACE [Fox and Sheridan beheading Pitt, Dundas
awaiting his turn]; 19 Sept. 1797; (not seen: A. de R. ii, p. 80)).

268. BEAUTY IN A COAL SKTTTEE BONNET; pub. N, Sept. 1797.
'R Newton des et fecit'; LC; (250 x 151).

269. STURDY BEGGARS OR SUPPORTED BY INVOLUNTARY
CONTRIBUTIONS! ['in' crossed out]; pub. N, '13 Bridges St', 13 Oct. 1797.
'Design'd drawn & etch'd by Rd Newton'; BM 9033; (235 x 332).

270. THE TAYLORS REVENGE ON THE PARSON; pub. N, 13 Brydges St,
15 Oct. 1797.
'Designed & Etched by Richard Newton'; ill. E. Fuchs, *Illustrierte Sittengeschichte ...*
(Munich, A. Langen, 1912), p. 39.

271. BUONAPARTE ESTABLISHING FRENCH QUARTERS IN ITALY; pub. N,
'opposite the Pit Door Drury Lane Play House', 9 Nov. 1797; (plate 58).
'Rd Nn del et fecit'; plate 248 x 350.

272. BUONAPARTE THE AMBASSADOR FOR PEACE; pub. N, 'Bridges Street',
13 Nov. 1797.
'Richd Newton des et fecit 1797'; BN.

273. LEARNING TO MAKE APPLE DUMPLINGS; pub. N, '13 Brydges St', 27
Nov. 1797; (figure 33).
'Rd Newton des et fecit'; BM 9041; (345 x 230).

274. MORE VISITORS TO JOHN BULL, OR THE ASSESS'D TAXES!!!; pub.
Holland, 1 Dec. 1797.
BM 9043, unattributed; possibly after N, or Woodward.

275. TRIA JUNCTA IN UNO OR A MINISTERIAL MODE OF PAYING TRIPLE
TAXES; pub. N, Dec. 1797.
'Rd Newton fecit des 1797'; BM 9052; (248 x 350).

276. [Unidentified old man walking with stick to right; circular building behind]
'RN Sculpt 1797' 'MGW Delt 1797' [? G. M. Woodward]; LC, no title or publisher;
plate 217 x 142.

1798
277. NEW YEAR'S GIFTS [3 sheet print]; pub. Holland, ?1 Jan. 1798; (plate 59).
'Drawn and Etch'd by Rd Newton'; plates *c.* 250 x 700; BN.

278. CONSISTANCY!! -- OR RIVAL CLOWNS IN THE NEW PANTOMIME OF
HARLEQUIN & QUIXOTE; pub. N, 'at his Original Print Warehouse',
8 Jan. 1798 (plate 60).
'Drawn from life & etch'd by Rd Newton'; (355 x 460).

279. AN ATLAS ! OR THE STRONG MAN!!! ; pub. N, 18 Jan. 1798.
'Invented drawn & Etched by Richd Newton 1797'; BM 9159, plate 350 x 245
(on the verso of BM 1868-8-8-6688 is a rough sketch: *A Genteel Apartment to Let*).

280. THEY ARE COMING OR DELIVER YOUR MONEY; pub. N, 'at his
Warehouse', 13 Bridges St, 16 Jan. 1798.
'Richd Newton des et fecit 1797'; BM 9158; (238 x 340).

281. 'SOLA VIRTUS INVICTA – VITUE (*sic*) ALONE IS INVINCIBLE'; pub. N,
26 Feb. 1798.
'Designd Drawn & Etch'd by Rd Newton 1798'; BM 9177, cut to (245 x 350).

282. A ROW AT A COCK AND HEN CLUB; pub. N, 1 March 1798.
'Drawn & Etchd by Rd Newton 1798'; et. and aq.; BM 9309, based on a photo;
Museum of London, ill. George (1967: figure 57); (342 x 465).

283. RESISTING THE COMMON ENEMY; pub. N, 3 March 1798.
'Design'd & Etchd by Rd Newton 1798' 'likenesses taken by R Newton
for half a guinea'.

284. TREASON!!! ; pub N, 'at his Original Print warehouse',
19 March 1798; (figure 34)
'Designd & Etch'd by Rd Newton'; BM 9188, ill. Brewer (1986: plate 110),
and Donald (1996: plate 173); (310 x 240).

285. THE CELEBRATED MR JOHN CUSSANS IN THE CHARACTER OF
JERRY SNEAK; pub. N, 5 April 1798 (plate 61).
'The Face/ Sketch'd at Sims's at a late/ Dinner by Richd Newton 1798/ Price Two
Shillings Col.d.'; BM [-335], with title cut off and pasted at top of print. BM 9292 is
a later state showing him as a waiter; (305 x 202).

286. A POLITICAL HYPOCONDRIAC!!; pub. Holland, 18 April 1798.
BM 9195, unattributed; LWL; LC, Godfrey (1984: no. 122, as by N,
but this is doubtful).

287. THE DUEL [above]; OH! WHAT A PITY THAT HE DID NOT HIT HIS
WAISTCOAT [below] ... 'vide Morris's Songs'; 18 May 1798.
'R Newton delin'; plate 250 x 350.

288. THE MALE CARRIAGE OR NEW EVENING DILLY; pub. Holland, 17 Sept. 1798 (plate 62).
Et. and aq.; (268 x 222).

289. O DEAR WHAT CAN THE MATTER BE; pub. Holland, 6 Nov. 1798.
'R Newton Del'.

290. DOCTOR JOLLUP AND SALLY GREEN; pub. Holland, 20 Nov. 1798.
Unsigned, but probably after N; aq., title in letterpress above verses dated 1 Nov. 1798; LWL; (240 x 365).

291. *Tom Jones*, 20 book illustrations, aqs. pub. W. Holland, 1 Jan. 1799.
YCBA, uncol. (Abbey: *Life*, 241).

DATE NOT ASCERTAINED

292. A SAVIOUR OF THE NATION BETWEEN TWO THIEVES.
'Designed & etch'd by R. Newton'; YCBA; 348 x 250 (325 x 230).

POSTHUMOUS PRINTS PUBLISHED BY HOLLAND POSSIBLY AFTER N

293. MACBETH; pub. Holland, 1 Jan. 1799.
Et. and aq.; LWL; (303 x 405).

294. FUNKING THE TAX GATHERER; pub. Holland, 2 April 1799.
(380 x 510).

295. A SMOKING CLUB; pub. Holland, 1 May 1799.

296. A FETE AT CUM[BERLAN]D HOUSE ...; pub. Holland, 17 Aug. 1799.
BM 9453 as [?N]; aquatint; (230 x 370).

PRINTS POSSIBLY BY NEWTON, DATES NOT ASCERTAINED

297. THE WINDSOR BOAR & SOW DRIVING TO MAWBEYS MARKET
[Pitt driving 2 pigs with the faces of the King and Queen].
YCBA, unsigned, without pub. or date, but probably pub. Holland, 1792–3.
There is a smaller reversed version of the design by Gillray (ex info. A. Edmunds).

298. FARO AND HER HOST QUAFFING THE RED SEA/ ORIGIN OF THE RED SEA [unwitting guests drinking urine]; ?Newton; unsigned and without publisher; plate 250 x 355.

299. MATRIMONY/ A FEW MINUTES BEFORE/ A FEW HOURS AFTER
[2 compartments] 'G.M.Woodward Delin'; possibly etched by N.

DROLLS AFTER NEWTON

8 x 10 inches, published by Laurie and Whittle after watercolours by N (titles in capitals): plates *c* 205 x 250 (170 x 235)

300. A STORY OF A LITTLE PARSON AND THE SAILOR, 12 April 1797; ('179' in left corner). 'Jno Page Fecit'; LWL, after a watercolour there.

301. THE SAILOR AND THE LONG-BACK'D HORSE; 10 June 1797 ('180'; LWL.

302. A SEA CAPTAINS DESCRIPTION OF A FOX CHACE; 10 June 1797 ('181').

303. LAWYERS AND COUNTRYMAN; 10 June 1797 ('182'); LWL, after a drawing there.

304. THE CHIMNEY SWEEP AND BARBER; 19 Aug. 1797 ('195'); LWL.

305. AN AGREEABLE GROUP OF YOUNG GENTLEMEN,/ OTHERWISE OLD BACHELORS TURN'D ASSES; 22 Aug. 1797 ('196'); LWL.

306. AN OLD BUCK TRYING ON PANTALOONS; 13 November 1797 ('203'); BM 9112; LWL.

307. WIGS ALL THE RAGE, OR A DEBATE ON THE BALDNESS OF THE TIMES; 24 May 1798 ('217'); LWL.

308. A NEW WAY OF CURING A QUINSEY; BM 9331.

PRINTS AFTER NEWTON PUBLISHED BY THOMAS TEGG

309. AN UNDERTAKERS VISIT!; 26 Feb. 1807 ('297').
'R Newton'.

310. SOLICITING A VOTE; *c*. 1810.
'Newton, del et. s.'; HEH; (240 x 340).

311. A GOING! A GOING!; 10 June 1809 ('95').
Etched by Rowlandson after Newton; BM 12152; MRPC, *The Bruising Apothecary*, exhibition catalogue (London, Pharmaceutical Press, 1989), no. 68 (ill.).

312. LAUNCHING A FRIGATE; 1 Feb. 1809 ('67'); (figure 37).
'Newton Del Rowlandson scul'; BM 11461; HEH; (230 x 325)

313. A GHOST IN THE CELLAR; 11 July 1811.
Etched by Rowlandson.

314. GIVING UP THE GHOST, OR ONE TOO MANY; ('292').
Etched by Rowlandson after Newton; BM 12153 as [?1813]; WIHM.

315. THE DANCE AT AMIENS, 'Rowlandson sculp'; frontispiece to *Beauties of Sterne/ Embellished by Caricatures, by Rowlandson/ from original drawings by Newton/* London. T. Tegg. BM 11518; (90 x 153); BL C.117.b.64.

316. LA FLEUR AND THE DEAD ASS.
'Rowlandson sculp'; plate to the above work; BM 11519; (90 x 150).

317. YORICK FEELING THE GRISETTE'S PULSE, Rowlandson, loosely based on the 1794/7 illustrations, from *A Sentimental Journey*, a new ed. pub. Tegg, 1809.

318. YORICK AND FATHER LORENZO, from the same work; 1809.

SOME OTHER PRINTS AFTER NEWTON

319. LA FLEUR'S DEPARTURE FROM THE INN (above: STERN'S JOURNEY).
Etching, signed 'M' in sub.; 238 x 302 (215 x 285).

320. LA FLEUR IN THE COUNT'S KITCHEN (pendant to above).
Signed 'DM' in monogram in sub.

Index of titles

Note: exclamation marks at the end of titles have been omitted

Absolution, 6 July 1791

Admiral Howe Triumphant, 20 June 1794

Advertisements Illustrated [after Nixon], June 1794

Affrighted Travellers, 10 Oct. 1792 (figure 13)

After, 1 Mar 1793, or ?1795.

After Duty, 12 July 1797

All of One Mind ..., 28 May 1794

An Agreeable Group of Young Gentlemen, 22 Aug. 1797

An Amorous Irish Barrister ..., July 1791

Amusement in a Twopenny Lodging, 19 Feb. 1795

An Apparition [after Woodward], 1 May 1790

Arming in the Defence of the French Princes ..., 8 May 1792

An Astonishing Paragraph, 18 Aug. 1791

An Atlas, 18 Jan. 1798

The Assassination of Marat by Charlotte Corde, 24 July 1793

Babes in the Nursery, 1 March 1794

Babes in the Wood, 1 March 1794 (figure 19)

A Bachelor's Litany, 4 Nov. 1795 (plate 39)

A Batch of Peers, 6 Jan. 1792 (figure 8)

A Battle out of the House, 15 June 1797

The Battle between Dr. Farmer ... (pamphlet), 31 Aug. 1792

The Battle of Bangor, 26 May 1796

Beauty in a Coal Sktttee Bonnet, Sept. 1797

Before, see end 1795

Beggar my Neighbour, 20 April 1796

A Beggar's Wedding, see 25 Oct. 1794

[Beheading], 26 April 1796

Billy's Political Plaything, 21 Nov. 1796 (plate 46)

The Birth of Billy Bugaboo, 13 Aug. 1797

The Birth of the Rose, 29 April 1796

Black Eyed Lovers, Nov. 1795

The Blind Enthusiast, see 10 May 1792

A Blow-up at Breakfast, 20 May 1792 (figure 10)

The Blue Devils, 10 Feb. 1795 (plate 30)

Bond Street Promenade, see end 1794

A Bond Street Sailor in 1797, 28 July 1797

Both Sides of the Water, 10 January 1793

A Bouilli in the Newest Taste a la Francois, 14 July 1791

British Servants ..., April 1795 (plate 32)

A Bugaboo, 2 June 1792 (plate 7)

Buonaparte Establishing French Quarters in Italy, 9 Nov. 1797 (plate 58)

Buonaparte the Ambassador for Peace, 13 Nov. 1797

Buonaparte the Modern Alexander ..., 1 April 1797

Buy my Pretty Guinea Pigs, 1 July 1795

Ca Ira [song-sheet], 18 Nov. 1792

Ca Ira - or John Bull Studying the Graces, 20 Dec. 1792

Canine Vengeance, or the Effects of the Dog Tax, 19 April 1796

The Celebrated Mr John Cussans ..., 5 April 1798 (plate 61)

The Chimney Sweep and Barber, 19 Aug. 1797

Christmass Boxes, 25 Dec. 1794

A Clerical Alphabet, 22 July 1795 (plate 37)

A Clerical Rebuke and Parochial Reply [after Woodward], 12 March 1794

The Combustible Breeches, 11 May 1792 (plate 4)

Consistancy!! – or Rival Clowns ..., 8 Jan. 1798 (plate 60)

Content and Discontent, 21 June 1792 (plate 8)

Contrasted Husbands, July 1795

Contrasted Lovers, 3 Aug. 1795 (plate 42)

Contrasted Walkers, 6 June 1795

Contributing to the Sinking Fund, 3 April 1792

Conundrum, 20 Oct. 1794

Cool and Comfortable for the Winter of 1796, 1 March 1796

Country and Town [song-sheet], 17 Oct. 1796

A Country Barber's Shop, 1 March 1794 (plate 21)

Cries of London, May 1797 (plate 57)

Cropp'd Loungers in Bond St 1791, 16 Aug. 1791

Crops and Bandelures, 15 Sept. 1791

Crops going to Quad, 5 Oct. 1791

A Crop Shop, 8 Oct. 1791 (plate 2)

Cruelty and Oppression Abroad, see 10 May 1792

A Curtain Lecture, 29 May 1794 (figure 24)

Dainty Nice Sprats, Ho!, 8 July 1792

The Dance at Amiens, date not ascertained; see no. 314

A Dance in the Temple of Hymen, 25 Oct. 1794

A Dance round the Poles, 5 Aug. 1794

Dances of Death, 12 July 1796

The Danger of Crim Con, 14 July 1797

Darby and Joan or the Dance of Death, 7 April 1797 (figure 32)

Days of Prosperity; or Congratulations for John Bull, Sept. 1796

Desmoulins and Lucille, 10 June 1795

Destruction/ A/Wicked Attorney's/Coat of Arms [after Holland], 1 Dec. 1794 (figure 23)

The Devils Darling, 5 May 1797 (figure 30)

The Devil's Darning Needle, 2 July 1795, 6 March 1797

Disinterested Love [after Woodward], 1 Nov. 1790.

A Doctor in Purgatory [after Woodward], 11 Nov. 1792 (figure 14)

Doctor Jollup and Sally Green, 20 Nov. 1798

Drilling for the Militia, 20 Jan. 1792

Drink to me only with thine Eyes, 8 May 1797 (plate 55)

The Duchess of York's Foot, 1 Jan. 1792

The Duel, 18 May 1798

The Duke of Brunswick attacking ... the Sans Culottes, 2 Oct. 1792

Elements of Bacchus (book), see 21 Aug. 1792

The Embarkation of the Guards ... February 25 1793, ?March 1793

The English Bull Baiting, 22 March 1797

Enjoying an Old Friend, 17 July 1795 (plate 36)

An Escape a la Francois, 1 July 1791

Evangelical Portraits, 20 June 1794 (plate 26)

Execution of Louis the XVI, 20 Feb. 1793

Fairies [after Woodward], 1 Oct. 1792

The False Alarm, 20 May 1792

Faro and her Host, date not ascertained, see no. 297

Fast-Day, 19 April 1793 (plate 13)

The Fate of Monopolists ..., 10 Nov. 1795

Female Gamblers in the Pillory, 13 May 1796 (plate 40)

A Fete at Cum[berlan]d House ..., Aug. 1799

The First Interview, or an Envoy from Yarmony ..., 19 April 1797 (plate 52)

A Flat between Two Sharps, 6 June 1797

La Fleur and the Dead Ass, date not ascertained; see no. 315

A Flight of Scotchmen, 3 Sept. 1796 (plate 44)

A Forcible Appeal for the Abolition of the Slave Trade, 2 April 1792 (plate 3)

The Four Stages of Matrimony, 15 Aug. 1796 (plate 43)

French Discernment, or, a Bumbling Discovery, 1 July 1791

A Frenchman Plundered [after Rowlandson], 20 Jan. 1792

Friar Bacon & his Brazen Head, 10 Aug. 1791

Frontispiece to the Wax work ... in Westminster Abbey, 20 Feb. 1792

The Full Moon in Eclipse, 8 May 1797 (plate 56)

Funeral Procession of Marat, 25 July 1793

Funking the Tax Gatherer, 2 April 1799

The General Sentiment, 22 March 1797

A Ghost in the Cellar, 11 July 1811

Giving up the Ghost, or One too Many, ?1813

A Going! A Going, 10 June 1809

Grand Battle at Cambridge 1792, 31 Aug. 1792 (figure 7)

Harris's List ..., 24 May 1794

The Haunted Cellar [after Woodward], 10 Nov. 1792

Head – and Brains, 5 May 1797 (plate 53)

Heigh Ho! For a Husband, 8 April 1796

Her Royal Highness the Princess of Wales, Jan. 1795

Hibernian Sagacity and Sang Froid, 3 April 1795

An Hobgoblin [after Woodward], 1 Oct. 1792

Hobgoblin Vagaries, Feb. 1796 [2 plates]

Hungry Rats in a Little House, 22 Sept. 1795 (plate 38)

Il y Passera – I can swallow it, 25 Sept. 1794

Imps, 25 Nov. 1796

The Inexhaustable Mine, 22 June 1797 (figure 31)

The Ins and the Outs ..., 25 March 1797

Interested Love, 3 Sept. 1793 (plate 15)

An Irish Fortune Hunter on a Journey to Bath, 16 June 1795

An Irish Fortune Hunter's Wedding, see 25 Oct. 1794

An Irish Salute in St Giles's, 3 Oct. 1791

John Bull in Paris, between a Shower and a Stink, 10 Nov. 1796

John Taylor, Verger to the Lodge of Black Friars, 9 July 1793

Just arriv'd from France, 17 Oct. 1795

Justice and Humanity at Home, 10 May 1792

La Fleur in the Count's Kitchen, date not ascertained; see no. 318

La Fleur's Departure from the Inn, date not ascertained; see no. 319

Launching a Frigate, 1 Feb. 1809

Lawyers and Countryman, 10 June 1797

Laying a Ghost [after Woodward], 1 Oct. 1792

Learning to make Apple Dumplings, 27 Nov. 1797 (figure 33)

Les Combattants d'Amour, 1 April 1792

A Lesson for Spendthrifts by Dr Johnson, 1 Aug. 1794

The Libertine reclaim'd or John Bull bullied, 10 Aug. 1792

Liberty and Equality, 20 Nov. 1792 (plate 10)

The Life of Man, 12 Oct. 1794

A Little Farther, 1 Nov. 1792

A Little Wider, 1 Nov. 1792

Long Faces ..., 7 July 1791

Louis Dethron'd; or Hell Broke Loose in Paris, 16 Aug. 1792

Lunaticks out of Bedlam, 15 April 1796

Macbeth, 1 Jan. 1799

Madamoiselle Parisot, see end 1796 (plate 48)

A Magician, 11 May 1795 (plate 33)

Making a Freemason, 25 June 1793 (plate 14)

The Male Carriage or New Evening Dilly, 17 Sept. 1798 (plate 62)

Marche des Marseillois [song-sheet], 10 Nov. 1792

A Masculine Doe, 8 Dec. 1792

Matrimonial Speculation, 15 June 1792

Matrimony [after Woodward], date not ascertained; see no. 298

Meditations on a Jordan, 28 Oct. 1791

Men of Pleasure in their Varieties, 1 Oct. 1794

Method of Making Peace, 19 Sept. 1797

Michael Driving Satan out of Paradise, 23 June 1792

Midnight Revels [after Nixon], 10 June 1795

The Misers Economy, 10 March 1794

A Miser's Wedding, see 25 Oct. 1794

More Visitors to John Bull, or the Assess'd Taxes, 1 Dec. 1797. [possible]

Mr C the Puffing Painter, 8 Aug. 1797

Mr Follett as the Clown, 3 April 1797 (plate 50)

National Characteristics Plate 1 [after Woodward], 6 May 1795

National Characteristics [probably after Woodward], 12 July 1796

The New Paper Mill ..., 12 March 1797

A New Way of Curing a Quinsey, c.1798

New Year's Gifts, ?1 Jan. 1798 (plate 59)

A Night Mare, 26 Oct. 1794 (plate 27)

No Body. Some Body, June 1795 (plate 35)

No Swallow Without an Opening, 31 Jan. 1792

The Nottingham Chronicle, 5 April 1792

Nymphs Bathing, by 31 Aug. 1791

O Dear What can the Matter be, 6 Nov. 1798

Oh! What a Pity ..., 18 May 1798

An Old Buck trying on Pantaloons, 13 Nov. 1797

Old Goats at the Sale of a French Kid, 5 May 1796

An Old Grudge, see end 1794 (figure 18)

The Old Maids Occasional Concert, 1 March 1795

An Old Maid, Treating a Favorite Cat ..., 20 July 1792

On a Journey to a Courtship in Wales, 16 June 1795 (figure 25)

One of the Swinish Multitude, 6 March 1795

One Too Many, 10 Nov. 1792 (plate 9)

Opening the Ambassador's Ball in Paris, 5 March 1794 (plate 19)

The Opera-House Bantum, 23 Dec. 1796

Over-Weight – or the Sinking Fund ..., 14 March 1797

Pads and Bosoms; or Beauty and Modesty going to Church, 26 April 1793

A Paper Meal with Spanish Sauce, 14 March 1797 (plate 49)

Parsons Drowning Care, 10 Nov. 1796 (plate 45)

A Party of the Sans Culotte Army Marching to the Frontiers, 1 Oct. 1792

Patriotism, 21 April 1794

A Peep into Brest with a Navel Review, 1 July 1794

A Peep into the State Side of Newgate, 12 July 1793 (figure 16)

Pluck'd Pigeons, 1 May 1792

Political Boxing, May 1792

A Political Hypocondriac, 18 April 1798 [doubtful]

A Political Will 'o the Wisp, 4 June 1795

Poor Sawney in Sweetbriars, May 1797 (figure 35)

Pot-Luck, May 1797

Practical Christianity, 2 April 1792

Preface to Bad News, 11 Aug. 1794

Prelude to Crim Con and the Finale, 20 Feb. 1793

Prelude to the Riot in Mount Street, 6 June 1792

A Present of a Haunch of Venison, 31 July 1796

A Priest Ridden Village, 29 Nov. 1796 (plate 47)

The Princess's Curtsey, April 1795

A Proclamation in Lilliput, 22 May 1792 (plate 5)

Progress of an Author, see 11 Feb. 1793

Progress of an Irishman, 8 April 1794 (plate 22)

Progress of a Lawyer, 10 July 1795 (figure 28)

Progress of a Player, 11 Feb. 1793 (plate 12)

Progress of a Scotsman, 22 April 1794 (plate 23)

Promenade in the State Side of Newgate, 5 Oct. 1793 (figure 17)

Prussian Bobadils returning to Berlin, 26 Oct. 1792

Pull Devil – Pull Parson, 9 Sept. 1795

Push on Keep Moving, 27 April 1797

*Psalm Singing at the Chapel *****[Royal]*, 17 May 1792

Queen Catherine's Dream, 4 Nov. 1794

The Rage, see 12 Nov. 1794

A Real San Culotte, Dec. 1792 (plate 11)

Rehearsing the Countess or the Darby Dangle, 29 March 1797

Removing an Execution from the House of Old Nurse, 1 March 1796

Removing Excresences from John Bull, May 1797

Resisting the Common Enemy, 3 March 1798

Resurrection Men, 1 Oct. 1792 (figure 12)

Retaliation, 2 Aug. 1797

The Retort Courteois ..., 27 March 1797

A Reward for Past Services, 12 May 1797

A Row at a Cock and Hen Club, 1 March 1798

The Sailor and the Long Back'd Horse, 10 June 1797

A Sailor's Wedding, see 25 Oct. 1794

The Sailors and the Pounded Ass, Aug. 1796

A Salt Water Salute, 29 Dec. 1794

Samples of Sweethearts and Wives, 23 July 1795

Saturday Night; or, a Cobler Settling the Week's Account ..., 6 Oct. 1795

A Saviour of the Nation between Two Thieves, date not ascertained; see no. 292

Scene in the Road to Ruin, May 1792

Scotch Fencibles, 28 April 1796

A Scotch Wedding, see 25 Oct. 1794

A Scots Concert, 4 Feb. 1796

A Sea Captains Description of a Fox Chace, 10 June 1797

A Sentimental Journey (book), 3 Mar. 1794 and 1 Jan. 1797

September in London – all our Friends out of Town, 21 Sept. 1791 (plate 1)

A Serious Thought of a Plain Englishman, Feb. 1793

The Shepherd and the Animated Bottle, 1 Oct. 1792

'Shepherds I have lost my Waist...', 12 Nov. 1794 (plate 28)

A Shot at a Cock; or, An Alarm of Assassination, see end 1792

A Sketch from Highlife, 27 May 1791

Sketches in a Shaving Shop, 16 Dec. 1794

A Smoking Club, 1 May 1799

The Soap'd Pole at the Ham Common Fete, 28 June 1792

A Sociable Meeting, Dec. 1795

'Sola Virtus Invicta' – 'Vitue [sic] alone is invincible', 26 Feb. 1798

The Soldier Arrived and the Muster of Creditors, 1 Dec. 1791

A Soldier's Wedding, see 25 Oct. 1794

Soliciting a Vote, c.1810; see no. 309

Soulagement en Prison; or Comfort in Prison, 20 Aug. 1793 (plate 16)

Spectacles for Republicans, 24 Nov. 1795

A Sprite [after Woodward], 1 Oct. 1793

A Story of a Little Parson and the Sailor, 12 April 1797

Sturdy Beggars collecting for the Emigrant French Clergy, 30 Sept. 1792

Sturdy Beggars or Supported by Involuntary Contributions, 13 Oct. 1797

Summer Amusement at Farmer G------'s near Windsor, 9 Aug. 1791

Supported by Voluntary Contributions, 25 Sept. 1795

Talk of the Devil and He'll Appear, 19 May 1795

The Tar and the Jordan, see Nov. 1791 (figure 5)

Tasting a Norfolk Dumpling, 1 June 1792 (plate 6)

The Taylors Revenge on the Parson, 15 Oct. 1797

Their New Majesties, 12 Sept. 1797

They are Coming or Deliver your Money, 16 Jan. 1798

The Thieves Detected at Last, 8 Nov. 1792

The Thrifty Wife, July 1795

Tippies of 1796, 6 March 1796

Tom Jones (book), 1 Jan. 1799

Too Much of One Thing Good for Nothing, 12 Sept. 1795 (figure 26)

Training Young Men of Honour in Ireland, 26 March 1792

Treason, 19 March 1798 (figure 34)

Tria Juncta in Uno or a Ministerial Mode of Paying Triple Taxes, Dec. 1797

Tricks upon Travellers, 13 May 1795

The Triumphal Procession of Merry Christmass ..., 25 Dec. 1794

Trying on my Brother's Breeches, 2 June 1796

Tumbling over a Ghost, 6 Feb. 1795 (plate 31)

The Two Foxes [song-sheet], 3 May 1794

Undertakers in at the Death, 20 April 1794 (plate 25)

An Undertakers Visit, 26 Feb. 1807

The Unlucky Discovery, 21 Dec. 1794 (plate 29)

Venus Surrounded by Cupids, 12 January 1793

A Visit to Bedlam, 7 Aug. 1794

A Visit to the Grandfather, Nov. 1792

A Visit to the R---l Cole Pit [pub. by N but probably by Byron], 30 Nov. 1791

Warming the Legs, 26 June 1795

Wearing the Breeches, 6 March 1794 (plate 18)

A Welch Wedding, see 25 Oct. 1794

What a Nice Bit, 8 July 1796 (plate 41)

'What means this new pain in my Breast?', 3 May 1797

Which way shall I turn me, 1 July 1794 (2 prints)

A White Serjeant; or Special Messenger, 16 April 1794 (plate 24)

Who shall wear the Breeches, 10 Sept. 1793 (plate 17)

Wigs all the Rage ..., 24 May 1798, no. 306

William the Conqueror's Triumphal Entry, Dec. 1796

A Will o' th' Wisp, 15 Nov 1794 (plate 34); 9 June 1795 (figure 29)

The Windsor Milkman, or any thing to turn a Penny, 12 June 1792

The Windsor Boar & Sow ..., date not ascertained; see no. 296

Wisdom, Strength and Beauty, 18 April 1797

A Witch, 8 March 1795

Witches, Feb. 1796

Wonderful News from Seringapatam, 18 May 1792

Yorick and Father Lorenzo, 1809

Yorick feeling the Grisette's pulse, 1809

Chronology of events in Newton's lifetime

Date	General events	N[ewton]'s activities [those of his colleagues in brackets]
1777		Birth of Newton
1780	Gordon Riots in London	[Gillray at start of career as satirist]
1782		[Fores established shop]
1783	First ministry of William Pitt	[Holland published Gillray prints from 66 Drury Lane]
		[Cruikshank arrives in London]
1784	Westminster election	[Rowlandson's celebrated satires]
1786		[Holland moves to 50 Oxford St]
1787	Proclamation against seditious writings	
	Proclamation Society founded	
	George III's madness; Regency crisis	
1789	Fall of Bastille, 14 July	
1790	Fête de la Fédération, 14 July	[F. G .Byron in France for Fête]
	Burke's *Reflections*, Dec.	N probably joined Holland's firm
1791	Paine's *Rights of Man*, Part 1, Feb.	[Gillray's *Rights of Man*, 23 May] First signed satire *A Sketch from Highlife*, 27 May N living near Old Bailey?
	Flight of French royal family, June	N publishes a print ?for Byron from Gt Portland St, Nov.
		[Gillray's *An Excrescence*, Dec. (fig. 4)]
1792	London Corresponding Society, founded, (Jan).	[Death of Byron, Feb]
	Paine's *Rights of Man*, Part 2, Feb.	Anti-royal prints (pls 4, 5, 7, 8, 10)
	George III's Proclamation, 21 May	First large narrative, *Wonderful News*, 18 May [Gillray's *John Bull's Progress*, June, figure 15]
		First comic prints with aquatint (figs. 12 and 13)
	Abolition of French monarchy, 21 Sept.	[Arrest of Holland, 17 Dec.]
1793	Execution of Louis XVI, 21 Jan.	[Fores publishes subsidised anti-French prints] First Progress: *... of a Player*, 11 Feb. (plate 12)
		[Gillray's *Zenith of French Glory*]
	French declare war on Britain, 1 Feb.	N's *Execution of Louis the XVI*
		Holland sentenced to a year in prison
	National Fast, 19 April Beginning of Terror, May	*Fast-day*, 19 April (plate 13) [Holland's second indictment, 10 May]
		[Death of Mrs Holland]

	Assassination of Marat, 13 July	*Soulagement en Prison*, Aug. (pl. 16)
	Execution of Marie Antoinette, 16 Oct.	*Promenade in the State Side* (fig. 17)
		?N catches gaol fever
1794	Howe's victory ('Glorious 1st of June')	
		N illustrates the *Sentimental Journey*, 3 Mar. (pl. 20)
	Execution of Robespierre, 28 July	N's output of social satires increases
		Advertisements ... after Nixon, June
		Publishes *A Peep* .. from 26 Wallbrook, 1 July
		Watercolour of Holland's exhibition, ?autumn (fig. 1)
	Treason Trials, Oct–Nov	*The Life of Man*, 12 Oct. *Dance in the Temple of Hymen*, 25 Oct. Etches *Destruction* for Holland, Dec (fig. 23)
1795	Prince of Wales's marriage to Caroline	
		Buy my pretty Guinea Pigs!, last print pub. from 26 Wallbrook, July
	Pitt very unpopular; poor harvest	[Gillray's *British Butcher*, 6 July]
		Progress of a Lawyer, July (fig. 28)
		A Bachelor's Litany, 4 Nov. (pl. 39)
	'Gagging' Acts, against Treasonable Practices and Seditious Meetings	N etches *Spectacles for Republicans*, 24 Nov. (Nov.–Dec.)
1796	Bonaparte's victories in Italy	Prints of Parisot (plate 48)
	Westminster election, May/June	*Dances of Death* (3-sheet print)
	Peace overtures to French, July–Oct.	Resumes political prints with *Billy's Political Plaything*, Nov. (pl. 46)
1797	Victory off Cape St Vincent	Inactive period, Jan. – Feb.
	Mutinies at Spithead and Nore, April	Begins to publish prints from 13 Brydges St, March
		Etches some plates for Fores, March – April (pl. 52)
		Prints on Bonaparte, April *Cries of London*, 3-sheet print for Holland, May (pl. 57)
	French invasion of Ireland (Dec)	[Gillray receives secret pension]
1798		*New Year's Gifts* ? Jan (pl. 59)
	French plan to invade England	N's *They are coming or deliver your money*, Jan.
		N publishes *Treason!*, his last political print, Mar. (fig. 34)
	Rebellion in Ireland (May – July)	?N unwell; publishes last print himself, April
	Nelson's Victory of the Nile (1 Aug.)	[Gillray's work for *Anti-Jacobin Review*]
		N's death, 8 Dec.
1799	Bonaparte seizes power L.C.S. dissolved	N's *Tom Jones* pub. by Holland

Select bibliography

Abbey *Life, Life in England in Aquatint and Lithography 1770–1860 ... from the Library of J. R. Abbey* (London, Curwen Press, 1953; reprinted, Dawson, Folkestone, 1972; Los Angeles, Wofsey, 1991); this collection is now at the Yale Center for British Art, New Haven.

BM, *Catalogue of Political and Personal Satires ... in the British Museum* (London, Trustees of the British Museum, 1870–1954); (vi (1784–92), 1938; vii (1793–1800), 1942), both compiled by M. D. George.

Bindman, David (1989) *The Shadow of the Guillotine: Britain and the French Revolution* exhibition catalogue (London, British Museum Publications).

Brewer, John (1986) *The Common People and Politics* (Cambridge, Chadwyck-Healey).

Cunnington, C. W. and P. (1964) *Handbook of English Costume in the Eighteenth Century* (London, Faber, 2nd edn).

Donald, Diana (1986) 'Characters and Caricatures', in N. Penny (ed.) *Reynolds*, exhibition catalogue (London, Royal Academy), pp. 355–93.

Donald, Diana (1996) *The Age of Caricature: Satirical Prints in the Reign of George III* (New Haven and London, Yale University Press).

Duffy, Michael (1986) *The Englishman and the Foreigner* (Cambridge, Chadwyck-Healey).

Fuchs, Eduard (1904) *Das Erotische Element in der Karikatur* (Berlin).

George, Dorothy (1925) *London Life in the Eighteenth Century* (London, Kegan Paul, 1925); reissued, Harmondsworth, Penguin, 1965).

George, M. D., (1938), *see* BM

George, M. D., (1942), *see* BM

George, M. D., (1959) *English Political Caricature*, vol. i, to 1792, vol. ii, 1793–1832 (Oxford, Clarendon Press).

George, M.D., (1967) *Hogarth to Cruikshank: Social Change in Graphic Satire* (London, Allen Lane).

Godfrey, Richard (1984) *English Caricature 1620 to the Present*, exhibition catalogue (London, Victoria and Albert Museum).

Grose, Francis (1796) *A Classical Dictionary of the Vulgar Tongue* (3rd ed. 1796), ed. E. Partridge (London, 1963).

Hill, Draper (1965) *Mr Gillray the Caricaturist* (London, Phaidon).

Hill, Draper (1966) *Fashionable Contrasts: Caricatures by James Gillray* (London, Phaidon).

Hill, Draper (ed.) (1976) *The Satirical Etchings of James Gillray* (New York, Dover; London, Constable).

Klingender, F. D. (1944) *Hogarth and English Caricature* (London, Pilot Press).

Kunzle, David (1973) *History of the Comic Strip, Vol. 1, The Early Comic Strip* (Berkeley and London, University of California Press).

Oppé, A. P. (1950) *English Drawings at Windsor Castle: Stuart and Georgian Periods* (London, Phaidon)

Paston, George (1905) [E. M. Symonds], *Social Caricature in the Eighteenth Century* (London, Methuen; reprinted New York, Blom, 1968).

Robinson, Nicholas K. (1996) *Edmund Burke: A Life in Caricature* (New Haven and London, Yale University Press).

Thale, Mary (1983) *Selections from the Papers of the London Corresponding Society 1792–1799* (Cambridge, Cambridge University Press).

Turner, Simon (1996) '*English Political Graphic Satire in the 1790s: The Case of Richard Newton*', MA dissertation (History of Art Dept., University College, London).

Wagner, Peter (1990) *Eros Revived: Erotica of the Enlightenment in England and America* (London, [Secker & Warburg, 1988] Paladin).

Wardroper, John (1973) *Kings, Lords and Wicked Libellers: Satire and Protest 1760–1837* (London, John Murray).

Werkmeister, Lucyle (1967) *A Newspaper History of England 1792–1793* (Lincoln, University of Nebraska Press).

Index

This index excludes the titles of prints by Newton, which are listed in the Index of Titiles in the Appendix. Titles of prints by others are indexed under the relevant artist only.

Address to the Republic of France,
 see Paine, Thomas
Aitken, James, 115
Angelo, Henry, 1-2, 12
apprenticeship, 24, 61 n56
aquatint, 32, 120
Archer, Lady, 131, 137

Banks, Miss Sarah Sophia, 125
Barrymore, Richard Earl of, 12, 46
Bedford, Duke of, 115, 136, pl. 57
Bedlam, 149
Boitard, L. P., 127
Bologna, John and Pietro, 138, pl. 60
Bonaparte, Napoleon, 51, 137, 156, 157, pl. 58
Bowles, Carrington, print publisher, 10
Brandoin, Charles, 42
Bretherton, James, print publisher, 11
Broadley, A. M., 51
Brunswick, Duke of, 145
Buckinghamshire, Albina, Hobart, Countess of, 50, depicted by N, 121, 137, 138
Bunbury, Henry, caricaturist, 2, 25, 43, 115, makes satires respectable, 11
 Kitchen of a French Post House, 11
 Long Minuet, 11
 Propagation of a Lie, 11
Burke, Edmund, 19, 136, pl. 57
 Reflections on the Revolution in France, 26
Burney, Fanny, 10-11
Burns, Robert, 18, 116, 127
Bute, Earl of, 123
Byron, F. G., 22, 25-6, 60 n48, N published a print for, 27-8, death, 27, work as an etcher revealed, 43
 A Batch of Peers, fig. 8
 Battle of the Angels, 26
 La Chute du Despotism, 25
 Clerical Exercise, 31
 Contrasted Opinions, 26
 English Slavery, 19, fig. 9

 French Federation, 61 n64
 Meeting an Old Friend ... , 19
 Puritanical Amusements, 26
 Visit to the R-- 1 Cole Pit, 27-8

Carey, W. P., 16
Caroline, Princess of Wales, 150
Catherine, Empress of Russia, 150
Charles, A., 53, 157
Charlotte, Princess Royal, 53, 135, pl. 52
Charlotte, Queen, 11, 30, 49, 118, figs. 8, 10, 31, pl. 4
Clarence, Duke of, 28
colouring of prints, 50, 130, 135, becomes usual by early 1790s, 13
Combe, William, 16
Concannon, Mrs, 131
Corday, Charlootte, 147
Cowper, William, 17
cropped hair, 115, 121
Cross, J. C., 138
Cruikshank, Isaac, 17, 23, 137
 John Gilpin's Race, 17
Cussans, John, 53, 158, pl. 61

Darly, Mary and Matthew, 11
Dent, William, 12, 122
Derby, Earl of, 50, 155, 156, fig. 32
Desmoulins, Camille, 45
Devonshire, Georgiana, Duchess of, 12, 121
Dickinson, William, 11
Dighton, Robert, 53
drolls, 10, 159-60
Duncan, Lady Mary, 10
Dundas, Henry, 49, 51, fig. 31
D'Urfey, Tom, 27

East India Company, 19
Eaton, D. I., 37, 121
Edmunds, Andrew, 22
Edwin, John, 18
Edwin's Pill, songbook, 18
Evelina, novel (Burney), 11

Farmer, Richard, 29, 144
Farren, Elizabeth, 50
Female Flagellants, 16, 116
Female Jockey Club, 121
Fitzherbert, Maria, 11, 17, 20
flagellation literature, 16
Follet, John, 53, 135, 156
Fores, S. W., 17, 32, 50, 135, 137
Fox, C. J., 12, 14, 47, 122, 133, 137,
 pls 19, 46, 58
Frederica, Duchess of York, 27-8, 142
Frederick, Duke of York, 11, 43
freemasonry, 147, pl. 14
French Revolution, 25-6
Frost, John, 37, 121, figs. 16, 17, pl. 16
Fuchs, Eduard, 55
Fuseli, Henry, 125

Garrick, David, 14
Garth, Samuel, 33, fig. 11
Gay, John, 14
George III, 11, 53, figs. 8-11, 33, 34,
 pls. 4, 5, 7, 8, 10, 50, 53
George, M. D., 2, 8, 47, 55
George, Prince of Wales, 11, 17, 20,
 43-4, 117
Gerrald, Joseph, 37, 121, pl. 16
ghosts, see under Newton
Gillray, James, 1, 12, 17, 20, 43,
 Barbarities in the West Indias, 116
 Cincinattus in Retirement, 127
 Contemplations upon a Coronet, 50
 Cymon & Iphigenia, 132
 Exaltation of Faro's Daughters, 131, fig. 27
 An Excrescence, fig. 4
 Fashionable Contrasts, 28
 For Improving the Breed, 135
 Hopes of the Party, 30, fig. 11
 John Bull's Progress, 35, fig. 15
 Lubber's Hold, 28
 Modern Graces, 134
 Morning after Marriage, 20
 Sale of English Beauties, 16
 Vices Overlook'd, 117
 Wife and No Wife, 17
Gordon, Jane Duchess of, 31, 117, 136,
 pls. 6, 57
Gordon, Lord George, 37, 38, 121,
 figs. 16, 17, pl. 16
Grose, Francis, 17, 117, 125

Hangar, George, 137
Harris's List, pamphlet, 115
Hastings, Warren, 18

Hassell, John, 33, 118, 119, 145, 146,
 figs. 13, 14
Hickey, William, 12
Hill, Draper, 56
Hixon, W., J., & R., 55
Hogarth, William, 10, 18, 115, 118
Holland, William, pl. 64
 arrest, 34
 and F. G. Byron, 19, 22
 and W. P. Carey, 16
 catalogues of prints, 18, 19, 27, 43-4,
 141
 and I. Cruikshank, 23
 designer of prints, 26, 44, fig. 23
 his exhibition, 7-9, 18-19, 42-3, 44
 and Gillray, 17, 20
 imprisonment in Newgate, 36-41
 indecent prints, 18
 'Holland's' script on prints, 16, 61
 n49
 moves on Oxford St, 17
 and Nixon, 22
 political pamphlets, 34
 Pathetic Particulars, 34
 publishes long prints, 18-19
 publishes political pamphlets, 34
 publishes song-books, 18
 radical sympathies, 25
 sells caricatures in albums, 19, 43-4
 and Woodward, 23, 26
 writer of poems and songs, 16-17
 writes dialogue on prints, 17, 46
Holland Mrs, 36, 38, fig. 16, pl. 64
Holt, Daniel, 37, 38, 121, pl. 16
Howe, Admiral Richard, 149
Hoyle, Edmund, 120
Humphrey, Hannah, 20

indecent prints, 18, 60 ns 39-40

Jockey Club, pamphlet, 121
John Bull, 156, fig. 31
Johnson, Dr Samuel, 16, 149
Jonson, Ben, 136
Jordan, Dorothy, 14, 19, 28, 119
Jordan, J. S., 117
Jordan's Elixir, 19
Jouve, Michel, 39

Kenyon, Lord, 131
Klingender, Francis, 4, 55

Laurie & Whittle, 50, 139, prints after
 N, 159-60

Lawrence, Thomas, 29
Letter to Dundas, pamphlet, see Paine, Thomas
Letter to the Adressers, pamphlet, see Paine, Thomas
Lloyd, Thomas, 37, 121, pl. 16
London Corresponding Society, 37, 121
The Louisad (Pindar), satirical poem, 16
Loutherbourg, P. J., 43

McGill, Donald, 1
Mackenzie, Henry, 18
Macan, T. T., 37, 38, fig. 16, pl. 16
Man of Feeling (Mackenzie), novel, 18
Marat, 147
Merry, Robert, 32
Morland, George, 18
Morning Chronicle, 17
Morning Post, 121
Morris, Charles, 18, 121, 154, 158
Murray, Lord William, 37, fig. 17
Musgrave, Peter, 29, figs. 6, 7

Newgate, 36-8
Newton, Richard, sr, 14, 15, 28, 49
Newton, Richard,
 addresses: Old Bailey (? 1791), 28;
 Great Portland St (Nov. 1791-Dec. 1792), 27-8, 118;
 26 Wallbrook (March 1794-July 1795), 39, 47; 13 Brydges St (March 1797-April 1798), 49, 52, 155-8
 and F. G. Byron, 27-8, 29-30, 61 n49,
 death, 53
 drawings and watercolours by, 25, 45, 117, 119, 135, 142, 146, 149, 151, pls. 16, 53, 63; watercolour of an exhibition, fig. 1; self-portrait, pl. 51
 first prints, 25
 and Gillray, 312, prints on the same topics, 28, 50, 116, 131, 132, 138
 goggle eyes in his prints, 52
 and Holland, passim, as possible apprentice, 24, reliance on for larger prints, 46, 52
 as independant publisher, 49-53
 as miniature painter, 53
 and John Nixon, 44-5, 149
 publishes prints while working for Holland, 27-8, 34, 39
 subject of prints: aristocratic society,

31, 117,131, 136, figs. 32, pls. 6, 40, 57
battles of the sexes, figs. 24, 26, 121-2, 124, 126, 130-1, 132, 137, pls. 17, 18, 24, 29, 39, 41-3, 55, 56, 59
clergy, 118, 119, 120, 124-5, 129-30, 132-3, figs. 18, pls. 10, 13, 15, 26, 36-8, 45, 47
country people, fig. 19, pl. 21
courtesans, 115, fig. 37, pls. 1, 62
death, 46, 124, pl. 25
fashion, 115, 125-6, 128, pls. 2, 28, 35
French, 127, 141, 142, 145, pl. 32
ghosts and spectres, 32-3, 118, 127, 128, figs. 8, 12-14, 29, pls. 9, 27, 30, 33-4
Irish, 123, 141, 142, pl. 22
literary illustrations, figs. 20-2, pl. 20
political prints, 116-18, 122, 133, 134, 135-6, figs. 23, 30-1, 34, pls. 4, 5, 7-11, 19, 46, 49, 53-4, see also:
 Dundas Pitt;
'Progresses', fig. 28, 118-19
radicals in Newgate, 120-1, figs. 16, 17, pl. 16
royal satires, 31-2, 135, pl. 52; see also Charlotte; George III
Scots, 52, 123, 132, fig. 35, pl. 23, 44
slave trade, 142, 143, pl. 3
theatre, 134, 138, pls. 48, 50, 60, 61
Welsh, 45, fig. 25
and Woodward, 23, 32-3, 144, fig. 14
Nixon, John, 22, 41, 43, 44-5, 151
 Country Dance, 22, 27
 Kind Phyllis, 22
 Progress of Passion, 32
 Royal Dipping, 22
Nixon, Richard, 22
Norfolk, Duke of, 31, 117, 137, pls. 6, 57

Opie, John, 62 n74

Paccherotti, G., 11
Paine, Thomas, 26, 31, 34, 117, 120, 121
 Letter to the Addressers, 34
 Rights of Man, 26, 31, 34, 118
 Letter to Dundas, 34
Parisot, Mlle, 45, 49, 52, 134, 154, pl. 48
Parr, Samuel, 121
Paston, George, 55
Pathetic Particulars ... , pamphlet, see Holland

Peacock, George, 16
Pettit, John, 18, 23
Pigott, Charles, 37, 121, pl. 16
Pitt, William, 8, 12, 16, 30, 47-8, 49,
 115, 133, 134, 136-7, figs. 8, 30, 31,
 34, pls. 5, 7, 46, 49, 53-4, 56
'Pindar, Peter', 16, 38, 51, fig. 17; N
 dedicates print to, 51
 The Lousiad, 16
Place, Francis, 29
Princess Royal, see Charlotte, 53, 135,
 pl. 52
Proclamation Society, 12

Queensberry, 12, William Duke of, 134,
 136, pl. 57

Redgrave, Samuel, 55, 127
Reflections on the Revolution in France,
 see Burke
Reynolds, Sir Joshua, 115
Ridgway, James, 34, 121, figs. 16, 17,
 pl. 16
Rights of Man, pamphlet, see Paine
The Rolliad, satirical poem, 16
Rose, Mlle, 154
Rowlandson, Thomas, 1, 12, 19, 23, 55,
 142, fig. 37
Royal Academy, 14, 42, 53
Royal Proclamation, of 1787, 12; of
 1792, 29, 30, 116, 117

Salisbury, Earl of, 118
Sayers, James, 12
Sentimental Journey, novel, see Sterne
Sheridan, R. B., 12, 14, 19, 137, pl. 57
Society of Artists, 15
Sporting Magazine, 47
Stahremburg, Count, 21-2
Steevens, George, 122
Sterne, L., 2, 16-17, 32, 122, 148, 155;
 Sentimental Journey illustrated by N,
 40-1, figs. 20-22, pl. 20; Holland's
 edition of *Tristram Shandy,* 41
Symonds, H. D., 37, 121, figs. 16, 17,
 pl. 16

Taylor, John, 147
Tegg, T., 55, 132, prints after N, 160,
 fig. 37
Thurlow, Edward Lord, 32, 117
Tom Jones (Fielding), novel, illustrated
 by N, 53

Tooke, J. H., 38, fig. 17
Townley, Charles, 47, 124
Townshend, George, 10
Townshend, Lord John, 15
Tristram Shandy, see Sterne

Van Butchell, M., 38, fig. 17
Vicar and Moses (Steevens), song, 122
Villars, G., 130

Wagner, Peter, 15, 134
Wales, Caroline, Princess of,
 see Caroline, Princess of Wales
Wales, George Prince of, see George,
 Prince of Wales
Wathen, Robert, 45, 130
Watson, Dr Robert, 37, figs. 16, 17
Westminster Election, of 1784, 16, 43
Whatman, James, 130
Wheatley, Francis, 136
Wigstead, Henry, 19-20
 Propagation of Truth, 19-20
Wilberforce, William, 12, 116
Wilbraham, Captain, 38, fig. 17
Wilkes, John, 10
Williams, Charles, 132
Williams, William, 121, pl. 16
Wolcot, John, see Pindar, Peter
Woodward, G. M., 23, 26, 31, 32-3, 43,
 120, 141, 144, 145, 146, 147, 151,
 154, 158, fig. 14; influence on
 Newton, 23
 A Doctor in Purgatory, 33, fig. 14
 Liliputtian World, 26
 Prelude to Crim Con, 61 n57
Wright, Thomas, 55
Württemberg, Prince Frederick of 53,
 135, pl. 52

York, Duchess of, see Frederica,
 Duchess of York
York, Duke of, see Frederick,
 Duke of York

Zenobia, Count A., 38, fig. 17